WARM GLASS

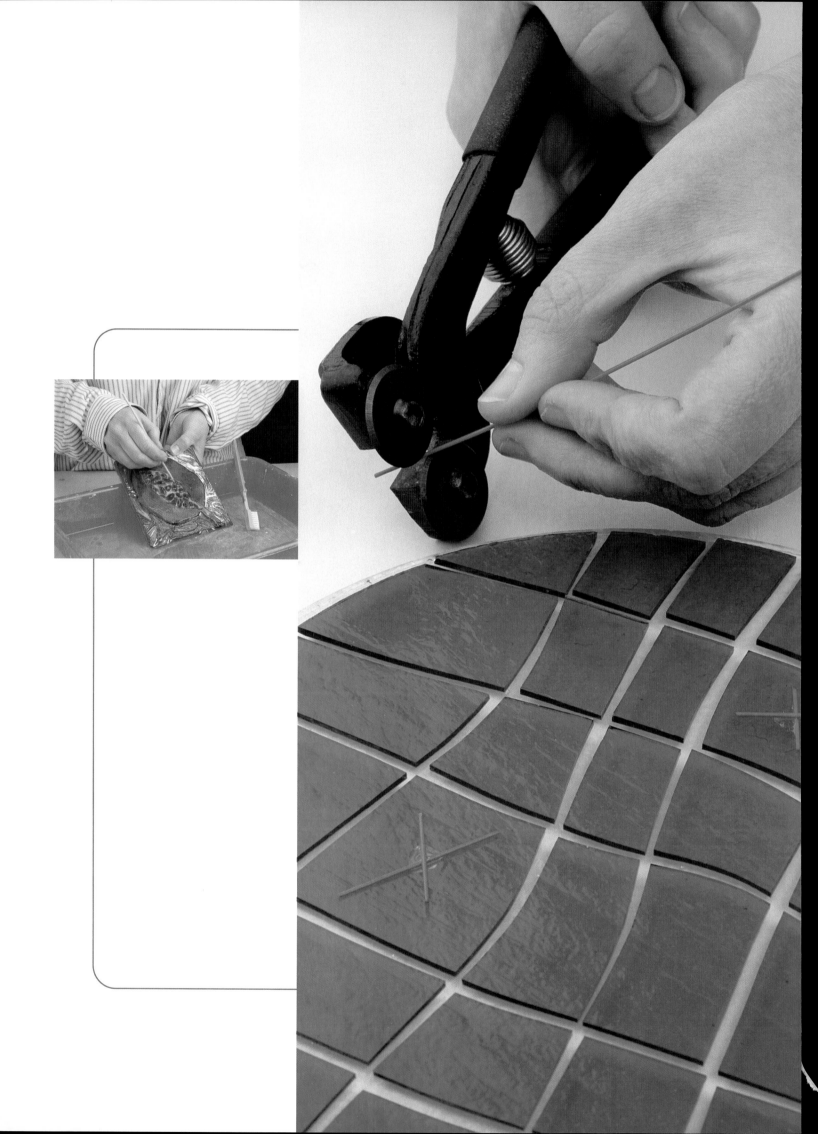

WARM GLASS

A Complete Guide to Kiln-Forming Techniques

Fusing • Slumping • Casting

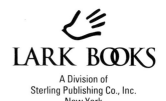

LARK BOOKS

A Division of
Sterling Publishing Co., Inc.
New York

Philippa Beveridge **Ignasi Doménech** **Eva Pascual**

Library of Congress Cataloging-in-Publication Data

Beveridge, Philippa.
 Warm glass : a complete guide to kiln-forming
techniques : fusing, slumping, casting / Philippa
Beveridge, Ignasi Doménech, Eva Pascual.
 p. cm.
 Includes bibliographical references and index.
 ISBN 1-57990-655-9 (hardcover)
 1. Glass craft. 2. Glass fusing.
 3. Firing (Ceramics) 4. Glass art.
Doménech, Ignasi. II. Pascual, Eva. III. Title.
TT298.B495 2005
748--dc22
 2004019271

10 9 8 7 6 5 4 3 2 1

Published by Lark Books,
a division of Sterling Publishing Co., Inc.
387 Park Avenue South,
New York, NY 10016

Originally published under the title *El Vidrio*
Parramon Edicions, S.A. Gran Via des les Corts
Catalanes, 322-324 08004 Barcelona, Spain
© 2003 Parramón Ediciones, S.A.—
World Rights

English Translation © 2005, Lark Books,
a Division of Sterling Publishing Co., Inc.,
67 Broadway, Asheville, NC 28801
phone: 828-253-0467

Translation from the Spanish: **Eric A. Bye**, M.A.
Technical Consultant: **Robert Gardner**

Distributed in Canada by Sterling Publishing,
c/o Canadian Manda Group,
165 Dufferin Street,
Toronto, Ontario, Canada 3H6

WARM GLASS
A Complete Guide to Kiln-Forming Techniques:
Fusing • Slumping • Casting

Editorial Director: Maria Fernanda Canal
Editor: Tomás Ubach

Editorial Assistant and Image Archive:
Maria Carmen Ramos

Coordination: Eva Pascual

Text:
The History of Glass, Glass, Step-by-Step
Exercises II and III: Ignasi Doménech
Preliminary Considerations, Technical Procedures,
Step-by-Step Exercises I and IV, and Glossary:
Eva Pascual

**Technical Consulting, Practical Exercises,
Firing Cycles, and Graphics:**
Philippa Beveridge

Collection Design: Josep Guasch

Layout and Pagination: Estudi Guasch, Inc.

Photographs:
Nos & Soto, Jordi Carreras, and Ignasi Doménech
in Brief History of Glass, Corbis and Scala

Illustrations: Jaume Ferrès

First Edition: October 2003
© Parramón Editlons, Inc. – 2003
Ronda de Sant Pere 5, 4th Floor
08010 Barcelona, Spain
Division of Norma Publishing Group, Inc.

Production Director: Rafael Marfil
Pre-printing: Pacmer, Inc.

ISBN: 84-342-2554-9
Legal Deposit: NA –1.927-2003
Printed in Spain

Cont

INTRODUCTION, 6

A BRIEF HISTORY OF GLASS, 8

THE NATURE OF GLASS, 22

ents

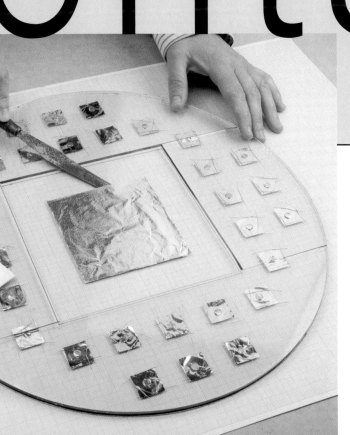

Introduction

Glass is a versatile and fascinating material. Its invention and development is a part of the history of humankind, and it has been held in high regard from the Bronze Age to the present. Its characteristics allow it to be used to make objects that are impossible to create from any other material. The early development of glass art allowed artisans to imitate gems, precious stones, and other valuable items. Glass techniques and processes resulted in new items and objects that differed greatly from ceramics, mosaics, and lapidary work. Blown glass, developed during the first century B.C., eventually overshadowed these techniques. Nevertheless, these older ways of working with glass make it possible to create shapes, textures, transparencies, and colors that aren't possible with blown glass.

This book explores these traditional techniques of making glass objects with a kiln. The main ones—glass melting (fusing), thermoforming (slumping), glass paste (pâte de verre), and glass casting—are shown in full detail. (Glassblowing is not covered in this book because it requires lengthy training and practice exceeding the book's scope.)

Think of this book as a practical manual that gives you detailed information on the history and the techniques of glasswork, along with simple-yet-complete instructions and examples designed to help you understand all the steps each technique requires. This book is intended to serve as both a hands-on guide for beginners working in the art of glass and an effective source of information for professionals.

The book is divided into six chapters. The first contains a brief history of glass from antiquity to the present, with special emphasis on the techniques covered later in the book. The subsequent chapter looks at glass as a material. Since glass is a complex substance with striking characteristics that affect the final results, you need to have some theoretical knowledge of this material's nature, the various kinds of glass, and the different ways of making glass. The third chapter thoroughly explores the materials and tools used to perform various techniques. In the fourth chapter, you'll learn about things to keep in mind before beginning any work with glass—basics such as glass compatibility and annealing cycles. The fifth chapter provides a detailed examination of all the technical procedures involved in glassmaking, along with the main types of finishes (with the exception of enamels, which are so complex they'd require a separate book). The final chapter shows you how to create several projects through step-by-step photos. It's intended to be a sampling of practical work, a valuable guide for the beginner and a source of inspiration for those who already have some experience.

At the end of the book, you'll find an impressive gallery of works made by different glass artisans and artists from around the world, a glossary containing the definitions of the main concepts, and a bibliography for anyone who wants to do more research on the topic.

This book is not the definitive manual on the techniques of working with glass in a kiln; it merely aims to present a thorough, clear vision of a craft that is continually changing and growing. We encourage you to get involved in this vital and interesting field, to investigate and experiment, and to create your own unique works. You'll discover that the distinct features of glass allow you to create works with a very special artistic, even poetic, component resulting from the combination of this wondrous substance with the properties of light.

Philippa Beveridge holds a degree in Landscape Architecture from the University of Greenwich in London. She studied various art techniques at the Escola Massana in Barcelona, Spain, and specialized in glass arts at the Glass Center Foundation in Barcelona, Urban Glass in New York, and Palau del Vidre in France. She has taught glass techniques at various institutions in Spain and the United States (including Syracuse University in New York). Along with teaching, she has progressively developed her own artistic work. She has been honored with numerous one-person and group shows in Spain, the United States, France, and Belgium. In 2003, she won the Juta Cuny-Franz Memorial Award.

Ignasi Doménech Vives holds an undergraduate degree in art history with a specialty in modern and contemporary art and a Master's degree in museology and preservation from the Independent University of Barcelona. His professional career developed around researching art objects, particularly in the area of glass. He has collaborated with various museums in Spain and other countries, documenting collections of decorative arts. He has also published articles on historic and contemporary glass. In recent years he taught courses and served as director of the School of Glass Arts in Barcelona. He has participated in and directed several expositions and conferences on glass.

Eva Pascual i Miró is a graduate of the University of Barcelona with a degree in art history, and specialties in museography, design, and processing from the Polytechnic University of Catalonia, and in preventive conservation from the Independent University of Catalonia. In her professional career, she has held positions in several museums and cultural institutions in Catalonia, working as a researcher and curator. She is the author of many articles on medieval furniture and has collaborated with several museums as an expert in this field. She has also taught many courses on the history, documentation, and restoration of furniture. She is the co-author of several other Parramon books.

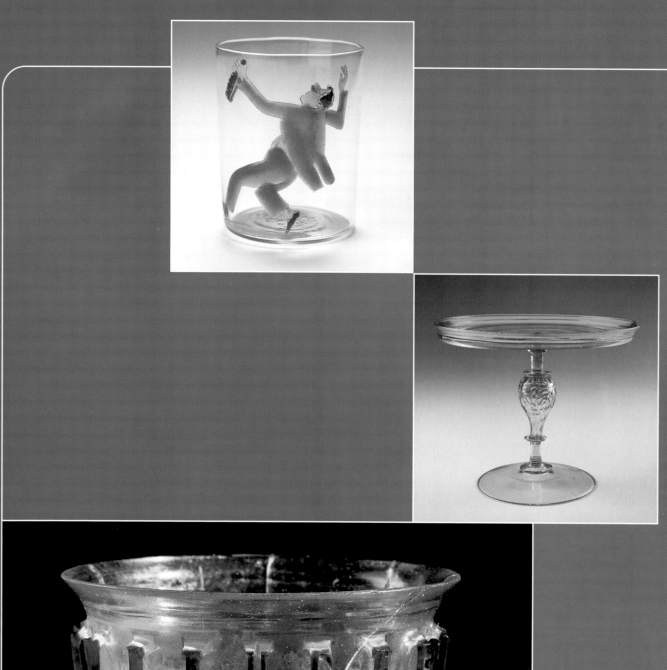

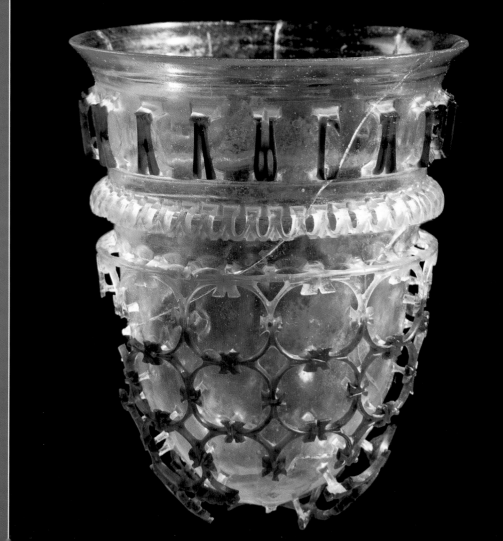

I f you'd like to deepen your appreciation of artistic glass, you must first consider the historic development of this material. A look at the past reveals a landscape filled with technical and aesthetic possibilities that can be applied to contemporary work. As you'll soon see, ancient or seemingly vanished techniques were recovered during various stages in the evolution of glass, providing the foundation for experimentation that led to moments of tremendous originality. In the ancient world, developments in glass reached heights of perfection that, in some cases, still haven't been surpassed. When you look closely at works from different movements and periods of time, such as the Italian Renaissance and Art Nouveau, you'll understand how these periods have served as continuous reference points because of their innovative spirit. Look at the history of glasswork, not with the mindset of an archeologist or an historian, but rather as a springboard for new creative paths. Use your knowledge of the past as a tool to help you develop your own aesthetic that transforms, rather than simply repeats, the work of the past. After all, this material has been around for some 5,000 years, and the history of glass offers a vast catalog of possibilities.

A Brief History
of Glass

The Origins of Glass: Myths and Legends

The discovery of glass is possibly one of the most significant occurrences in human history. Since its discovery, glass has surprised us with its unique qualities: its transparency and translucence, its brilliance, and its ability to fulfill a broad range of functional and aesthetic possibilities and demands. Created from the melting of a common material (sand), glass changes from a fluid to a solid state as it is manipulated, and takes on an astonishing appearance.

Since the beginning of civilization, it has been associated with the most precious minerals. Artisans combined natural materials and melted glass to make beads and prized objects. For centuries these glass artists were thought of as wizards who used secret and complex formulas to produce precious materials in their crucibles. Ancient literature conveys the fascination with and the high value placed on glass. Look at the various words the Greeks used to describe it: *Hyalos* was used not only to describe glass and something moist, brilliant, or wet (including a drop of rain), it was used also to indicate a person's moral qualities of honesty and clarity. The same is true of *Krystallos*, that is, ice or frozen water, which was also used as a synonym for glass or rock crystal.

The Latin word for glass was *vitrum*, which is identified with transparency through its root *uid*, "to see," stressing its ability to be seen through. The use of physical and moral qualities to describe glass shows how it was held in high regard. In fact, it was frequently compared with the most precious stones and minerals. In the book of Job in the Bible, it is mentioned (as crystal): "But where shall wisdom be found? and where is the place of understanding? Man knoweth not the price… The gold and crystal cannot equal it…"

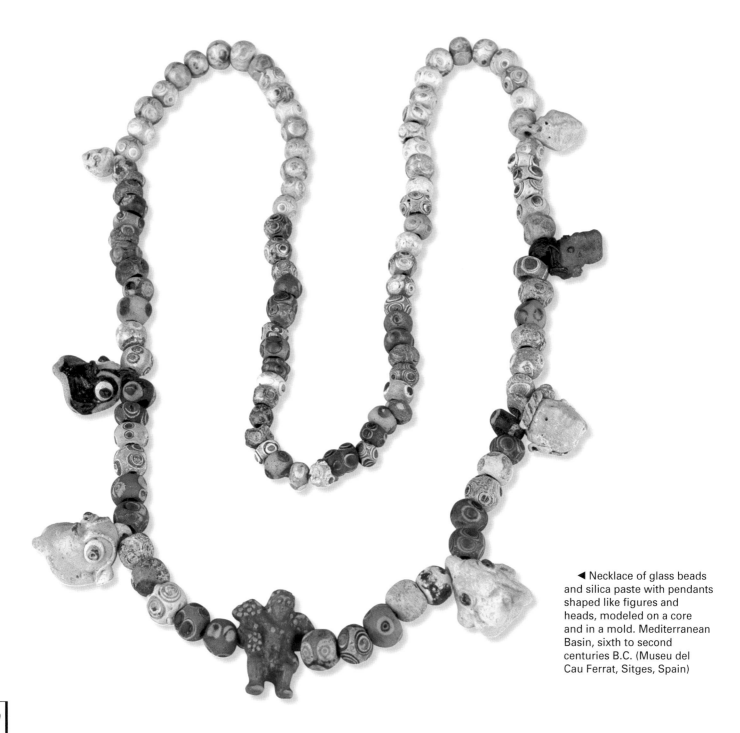

◄ Necklace of glass beads and silica paste with pendants shaped like figures and heads, modeled on a core and in a mold. Mediterranean Basin, sixth to second centuries B.C. (Museu del Cau Ferrat, Sitges, Spain)

Artisans of high social status who secretly carried out their work were the first creators of glass. Thus, the first written records of glass formulas contain cryptograms that made it impossible to use them as recipes and, therefore, made the materials and techniques of glass-making a mystery. A mystic, almost cult-like sense was attributed to this endeavor, and a series of rituals were used for choosing the right spot upon which to construct or light a kiln.

There are various legends concerning how and when glass was invented, but it's difficult to determine the precise moment when it was introduced. For centuries the most familiar and widespread legend considered to be true was the one written by the Roman geographer Pliny the Elder (A.D. 23 to 79) in *Natural History*. He places this event on the eastern Mediterranean coast near the mouth of the Belo River. Pliny wrote, "It is told that some niter merchants, having anchored their ship, were preparing a meal spread out on the shore, and since they couldn't find any stones to hold their pots up, they used lumps of niter from their cargo. When these burned with the sand on the beach, they noticed that streams of an unknown liquid flowed from them, and this was the origin of glass."

This legend, inherited from an earlier, oral tradition, seems plausible because it contains the basic materials that go into glass, but the conditions described could never produce a melt. From the standpoint of modern archeology, it is also inaccurate, since the first known glass dates from the third millennium B.C., in Mesopotamia, during the Bronze Age. Glass was created as the result of experimentation on ceramic glazes. It was used to make small items, such as beads, which were made to imitate precious stones. These early pieces were made from shapes cut from the glass before polishing them. During the second millennium B.C., the glass industry evolved and artisans were able to create hollow objects without having to carve a glass block.

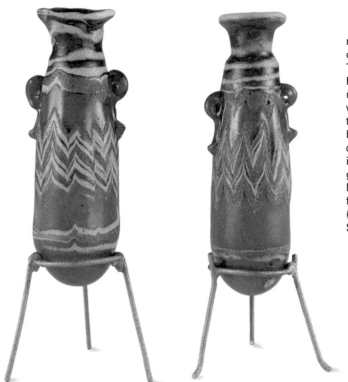

◄ Two Punic urns made using a sand core or preliminary core. These containers, which held perfumes and unguents, were widespread throughout the entire Mediterranean basin from the seventh century B.C. until the invention of blown glass. Eastern Mediterranean, sixth to fourth centuries B.C. (Museu del Cau Ferrat, Sitges, Spain)

Early Techniques

The production of small glass containers began around 1650 B.C. with the introduction of the preliminary core or sand core technique. This was one of the most commonly used and widespread procedures before the advent of blown glass. It involved making a core of sand, clay, and organic materials in the general shape of the vessel's interior. This core was then attached to a metal rod and dipped in the crucible, or covered with glass threads as it was turned on the rod. Afterwards, the object's surface was heated and rolled over an even surface to compress it. Next, various colored threads were applied and combed with a metal tool. Handles, bases, and pouring lips were added as well. Finally, after the indispensable process of annealing, the object was separated from the rod and the core scraped out to empty the inside. This technique was used to create vessels modeled after ceramic ones.

Using molds of various kinds led to new glass techniques based on knowledge borrowed from ceramicists and metal artists, allowing glass artisans to make hollow forms of great beauty and complexity. One of the molding techniques involved pouring melted glass into an open mold before using a metal

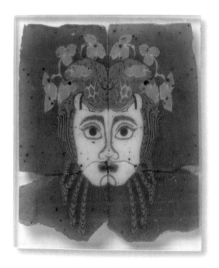

▲ Mosaic plate with mask of Dionysus. These small cane pieces are made of colored threads laid together in a bar to form the design. This band is then sliced to reveal the same pattern on the face of each piece. Probably Egyptian, first century B.C. to first century A.D.

implement to press the viscous mass until it took on the shape of the mold. Later, once the object was annealed, it was taken out of the mold and polished. Glass artists used this technique to imitate precious stones, plates, small reliefs and figures, or small items inlaid in furniture. They also used two-part press-molds to form glass.

A variation in the molding process involved covering the walls of a mold with pulverized glass. When this glass was melted inside the kiln, it conformed to the walls of the mold, taking on its shape. This technique, known as pâte de verre, was widespread in Mesopotamia, Egypt, the Phoenician coast, and Crete.

Around 1500 B.C., Mesopotamian glass artisans began using a technique that resulted in some of the most beautiful glass objects of antiquity: glass mosaic. Although the earliest surviving examples are ancient, the numbers of glass mosaics produced hit their highest levels during the first century B.C. To make a mosaic, pre-shaped glass ele-

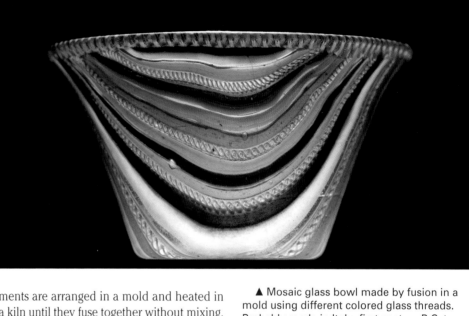

▲ Mosaic glass bowl made by fusion in a mold using different colored glass threads. Probably made in Italy, first century B.C. to first century A.D. (Corning Museum of Glass, Corning, New York)

ments are arranged in a mold and heated in a kiln until they fuse together without mixing. Walls of basins, cups, and other shapes made with this technique show an infinite number of decorative motifs created with colored glass. These preformed elements might be made of sections of monochrome or polychrome rods, fragments of a rectangular cane, or other glass pieces.

These mosaic glass objects are historical proof of a highly evolved industry in the hands of artisans possessing extremely advanced technical knowledge. As you'll see in the following chapters, making mosaic glass is a complicated procedure requiring knowledge of the compatibility of the glasses used, precise control of the temperature of the kiln, and many other considerations. If we compare the technical resources available to glass artisans of antiquity with the extensive facilities of today, it's easy to understand the high social esteem of those artists, the high prices of their creations, and the secrecy and inscrutability that surrounded their work, generation after generation. Their advanced knowledge of physics and chemistry made it possible for them to create objects with unique characteristics, and set them apart from other artisans.

Because mosaic glass required a complicated technique and was impossible to mass-produce, it was abandoned during the first century B.C., shortly

▼ Mosaic glass bowl. Probably made in Italy, first half of the first century B.C. (Corning Museum of Glass, Corning, New York)

after the advent of blown glass. (Nevertheless, Roman glass artists were quick to translate the formal and chromatic qualities of mosaic glass to blown glass.)

The techniques used to make glass before the advent of blown glass developed in the extensive geographic area of Asia Minor, Egypt, and Mycenae. Around the year 1200 B.C., at the end of the Bronze Age, continuous wars led to a crisis situation in the eastern Mediterranean, giving rise to a very conflicted era. These circumstances resulted in a serious economic crisis, and, in particular, the production of luxury items declined. Thus, the creation of glass items almost completely disappeared until the year 900 B.C. Once the conflicts were resolved, and a different political map allowed for new economic stability, glass was reborn with renewed energy. Thus, starting in the ninth century B.C., new production centers arose, first in Persia and later in Syria, Phoenicia, and Greece, as well as in Etruria in the western Mediterranean. Large-scale production, however, didn't develop until the seventh century B.C. when the products of the Phoenician merchants began to spread because they used their glass items as a currency in their transactions throughout the Mediterranean basin.

Uses for Glass in Antiquity

The conquest of Egypt by the Greeks during the Hellenistic Age sparked a glass industry renaissance there. As a result, the kinds of glass made in Alexandria became strong competition for glass made in Sidon, the chief city of Phoenicia. During this period, use of the previously described techniques became widespread, particularly the use of a preliminary core. These techniques were used to create many popular objects that were valued because they were so markedly different from those made of ceramic, metal, or other materials.

In addition to using glass for personal adornment, it was used in the ancient world for preserving, presenting, and storing solid foods and liquids, medicines, salves, and perfumes. Glass was preferred because of its unique shine, color, cleanliness, impermeability, and the fact that, unlike metal and some ceramic vessels, it left no trace of smell or taste. The first containers made of glass held ointments and preserved expensive perfumes and cosmetics. Examples were discovered among choice pieces deposited in graves. Such containers were also used to hold medicinal oils. There is even evidence that glass had a therapeutic function as a medicinal ingredient for gastric illnesses and was ground up for use as a dentifrice.

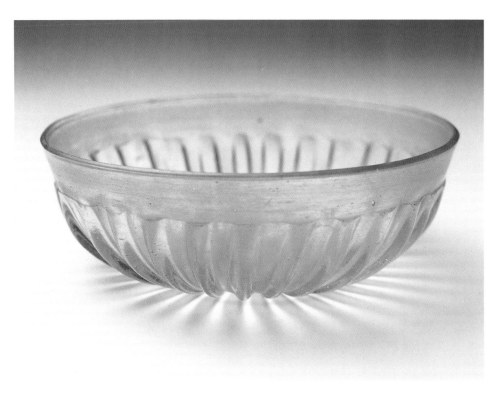

▲ Molded and polished ribbed glass bowl. Eastern Mediterranean or Italy, first half of the first century A.D. (Museu de les Arts Decoratives, Barcelona, Spain)

▲ Glass paste bowl cast in a mold and polished. Eastern Mediterranean or Italy, first half of the first century A.D. (Museu de les Arts Decoratives, Barcelona, Spain)

◄ Glass game pieces. These small pieces show that glass was used for various activities in daily life during antiquity. Eastern Mediterranean, third to first century B.C. (Museu del Cau Ferrat, Sitges, Spain)

The Glassblowing Revolution

The Roman political and economic unification of the Mediterranean that began in the first century B.C. led to a great diffusion of glassmaking techniques as well as many new uses for glass. The number of examples of Roman glass that exist show evidence of a large-scale production that couldn't have existed without the advent of the revolutionary technique of glassblowing in the Syria-Palestine region around the middle of the first century B.C. The process of blowing air through a hollow metal tube into a core of melted glass made it possible to produce items more quickly in a new way. It became possible to standardize production. The whole process was made more economical through the use of molds. Thus, for the first time, glass was competitive with other, less expensive materials, including ceramics, while offering unique characteristics such as transparency and shine. In addition, it was possible to abandon the dependence on previously available shapes, since glassblowing made it possible to create an infinite number of original shapes that could also be enlarged.

Glassblowing was quickly adopted throughout the entire Empire, and, as a result, a large part of society acquired glass and put it to daily use. At the same time, glass artisans began using techniques that joined glassblowing with ancient processes such as mosaic glass. Glassblowers of the Roman era apparently feared losing their prestige as artisans due to low-quality mass production, so, in response, they began to create formative and decorative shapes through inventive processes. These new techniques produced some of the most beautiful and complex pieces of luxury glassware that have ever existed, including cameo glass, diatreta glass, and gilded glass.

Beginning in the first century A.D., the most prominent glass workshops moved from the eastern Mediterranean to cities; and during the following century, shops sprang up in all the provinces of the Empire. Throughout the third century, Roman glass gave rise to regional varieties, and in some cases, to an impoverishment of production. It's interesting to note that some complex and sophisticated techniques arose during times when it wasn't opportune to create expensive luxury items, such as during the low Imperial Era when diatreta glass techniques evolved. As the Empire dissolved, glass continued to be produced in various eastern provinces, although it was of lesser quality than in the western areas. The Byzantine culture, which inherited much of the splendor of Roman culture, continued using techniques from the Romans, such as the application of hot decorative elements, painting, enameling, engraving, cutting, and creating tiles for mosaics.

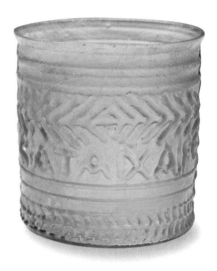

▲ Glass blown in a mold with the Greek inscription, "Drink and be merry." First century A.D. (Museu de les Arts Decoratives, Barcelona, Spain)

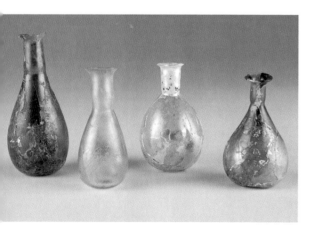

▼ Four blown-glass bottles. Eastern Mediterranean, first or second century A.D. (Museu del Cau Ferrat, Sitges, Spain)

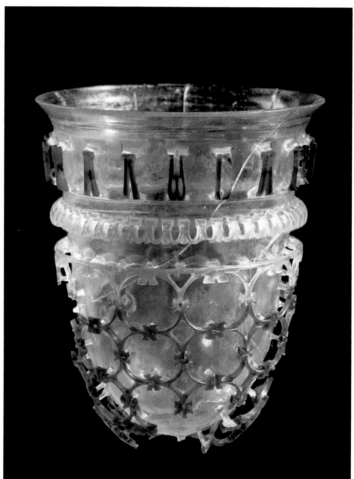

◄ Vessel made of diatreta glass. This complex technique involved cutting pieces with thick walls to create a network of epigraphic or geometrical motifs attached to the surface. Eastern Mediterranean, Italy, or Cologne, fourth century A.D. (Römisch-Germanisches Museum, Cologne, Germany)

A refined material culture in which glass played a significant role developed alongside the birth of Islam in the seventh century. At the start of this process, the production of glass in the eastern Mediterranean lands differed little from that of Rome or Byzantium. However, during the ninth and 11th centuries, mold-blown glass objects in new shapes with circular motifs on their surfaces were produced in Syria/Palestine and Egypt. Similar motifs were used on glassware, engraved with a diamond point. The earliest examples of glass made with Roman techniques, such as cameo glass and mosaic glass, also date from this period. Long-necked bottles as well as painted and gilded glassware are also characteristic of Egyptian and Syrian productions.

The most important development in Islamic glass took place between the 13th and 14th centuries when sophisticated enameled and gilded glass works became widespread. These mosque lamps, jars, and glasses represent one of the highest points of technical development in the history of enameled glass. These Islamic glass works became highly prized in medieval Europe, where the production of glass had been in a period of stagnation since the fall of the Roman Empire. Pilgrimages to the Holy Land, the Crusades, and commerce between both shores of the Mediterranean brought Syrian and Egyptian glass to Europe, where it was highly valued. The Moslem culture's later expansion toward the east resulted in the export of glass objects to countries in India, followed by the knowledge of manufacturing techniques. (Centuries earlier, glass works had already been taken to remote countries such as China via commercial routes.)

The violent invasion of Syria by the Mongol Tamerlane caused a serious setback in the rich Islamic tradition. His troops destroyed the most important glass production centers when they devastated the cities of Aleppo and Damascus. From that moment on, Venice took over the production of luxury glass, and its creations became the most important ones in Europe for more than two centuries. The Venetians transformed glass during the Renaissance, and their pieces became the most highly desired and collected. Even though the production of glass in Venice is documented as early as the seventh century, it was during the early Middle Ages that it experienced its first great impetus. In 1271, the glassmakers' guild published statutes to regulate a prosperous business. The guild's strict laws protected secret formulas and techniques, forbidding any glassmaker to work outside the Republic. Twenty years later, Venice's glass furnaces were moved to the nearby island of Murano, due to frequent fires in glass workshops that were a part of the city's dense urban network.

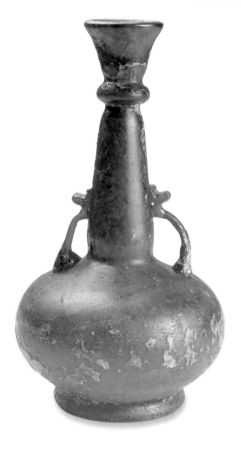

▲ Blown-glass bottle. Syria, 12th to 13th century (Museu de les Arts Decoratives, Barcelona, Spain)

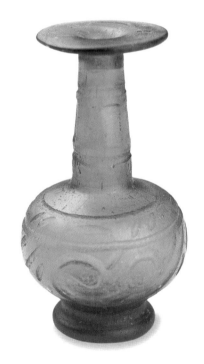

◄ Blown and cut glass flask. Iran, eighth to 10th century (Museu de les Arts Decoratives, Barcelona, Spain)

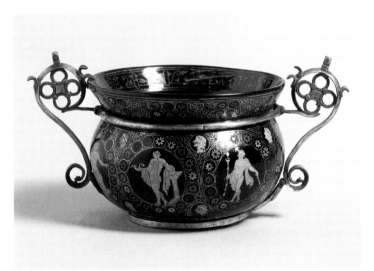

◄ Blown and enameled glass vase with gilded copper setting. Byzantine culture, 10th to 11th century (Treasure of Saint Mark, Venice, Italy)

Murano: The Splendor of Crystal

Throughout the 15th century, some of the most significant work in the history of glass was produced in Murano, Italy. During the Italian Renaissance, glass arts were guided by the same classical influences as other art forms, such as sculpture and architecture. These influences gave new life to the forms and techniques of Roman glass. There was also a strong influence from Islamic glass (particularly in the area of enameled decoration). As a result, the Muranese artisans created forms that were broadly recognized for their innovation, originality, and quality. During the second half of the 15th century, Muranese glassmakers began selling their products throughout the entire Mediterranean basin and in northern European countries.

In 1457 the government of Murano awarded the first prize for creating crystal to Angelo Barovier (1405-1460). He created a formula that transformed the cleaning and purification process of the raw materials, and he adopted the ancient Roman tradition of adding manganese to clarify the vitreous mass. The result of that process was a perfectly clear, crystalline glass that took its name from clear quartz crystal, a translucent mineral. During the same period, blue and green glass was used to emulate precious minerals, increasing the appreciation of Venetian glass. Also, tin oxide was added to glass during the melting process to create a new milky white glass known as *lattimo* (from *latte* or milk) that was esteemed because of its similarity to Chinese porcelain. Another key factor in the success of Murano's factories was the revival of the Roman technique of mosaic glass or *millefiori*.

During the 16th century, important technical innovations broadened their fame and the international distribution of their wares. New techniques such as the making of filigree glass, diamond engraving, and the production of ice glass led to a higher level of sophistication in their products. With the introduction of baroque ideas in the 17th century, their glass creations began to leave behind Renaissance canons and become more complex, with multiple decorative elements.

During the 16th and 17th centuries, glass artisans emigrated to other countries, spreading knowledge of Muranese techniques to Spain, France, England, the Netherlands, and the Tyrolean region. This led to a widespread imitation and interpretation of the famous products of Murano. Glass creations *à la façon de Venise*, or "in the Venetian style," were not simply copies of Venetian originals, but worthy regional contributions.

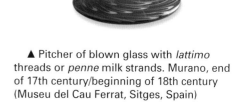

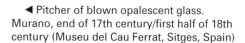

▲ Pitcher of blown glass with *lattimo* threads or *penne* milk strands. Murano, end of 17th century/beginning of 18th century (Museu del Cau Ferrat, Sitges, Spain)

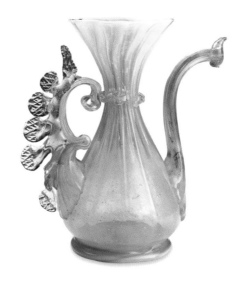

◄ Pitcher of blown opalescent glass. Murano, end of 17th century/first half of 18th century (Museu del Cau Ferrat, Sitges, Spain)

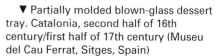

◄ Mold-blown glass bottle with relief of female dancers and milk glass bands on base. Catalonia, second half of 16th century/first half of 17th century (Museu de les Arts Decoratives, Barcelona, Spain)

▼ Partially molded blown-glass dessert tray. Catalonia, second half of 16th century/first half of 17th century (Museu del Cau Ferrat, Sitges, Spain)

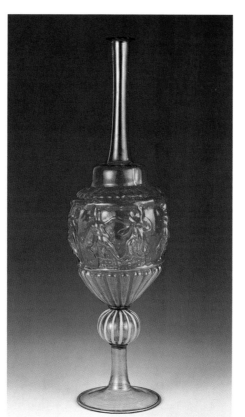

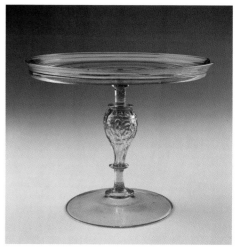

Lead crystal, discovered during the late 17th century by an Englishman named George Ravenscroft (1632-1683), signified a step forward in the history of glass and revolutionized the potential of this material. In 1612, due to the British navy's need for firewood, the English government prohibited the use of wood in glass kilns. Thus, English glassmakers were forced to use charcoal instead. This material was less suited for combustion, often making it impossible to create high-quality crystal items.

Ravenscroft, a merchant who specialized in Murano glass, attempted to use lead oxide or minium to make glass that resembled gems. In 1673, he opened the Savoy Glass Works in London, where he tried to produce a crystalline glass that imitated Venetian glass. Due to an excess of potash, which was used as a flux and caused devitrification, his products were not completely transparent.

Three years later, he discovered that adding minium to the melted glass resulted in a material resembling Venetian crystal, a glass similar to rock crystal. This fulfilled the dream of all glassmakers at that time: to create a material in the crucible similar to this highly valued mineral.

At the end of the 17th century, glass artisans in Bohemia and several German states tried to apply stone cutting and engraving techniques to crystal. In contrast to English or lead crystal, and even lead glass, the lead in Bohemian crystal was replaced by high-quality potash fluxes. To emulate the refined work on gems and hard stones, Central European artisans developed thick-walled shapes in the new crystalline material that could be made into pieces that clearly imitated the cut and engraved rock crystal. Eventually, this discovery led to complex shapes and decorations.

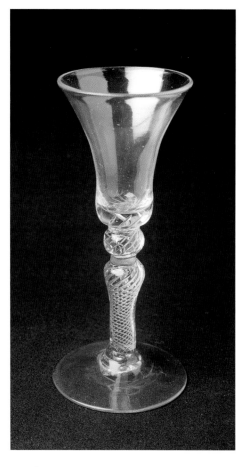

▲ Blown glass with spiral air channels on the stem. England, 18th century (Museu del Cau Ferrat, Sitges, Spain)

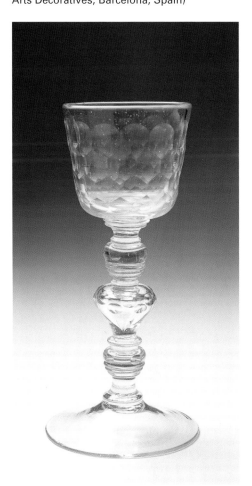

▼ Blown and cut crystal glass. Central Europe, end of 17th century (Museu de les Arts Decoratives, Barcelona, Spain)

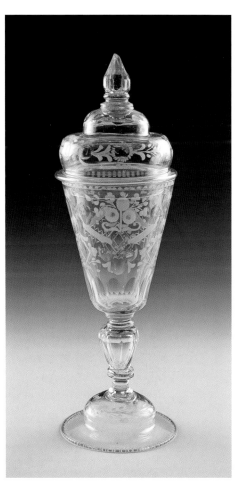

▼ Covered glass of engraved and cut blown crystal. Bohemia, 18th century (Museu del Cau Ferrat, Sitges, Spain)

In the final decades of the 17th century, French glassmakers also used crystal to create lamps, mirrors, and other items. The popularity of this material eventually weakened the prominence of Venetian glass, which, from the Renaissance to that time, had led European glass production. Crystal became more and more recognized during the first half of the 18th century. From the mid-18th century on, Muranese productions lost favor among buyers who considered Central-European glass works more in line with the aristocratic tastes of their day.

As a result, Venetian artisans fought back, transforming their wares into increasingly complex and colorful creations. Nevertheless, the new Bohemian influence prevailed and led to the closing of many Muranese furnaces in the early 19th century—just as the industrialization of glass production was beginning.

From Industrialization to Art Nouveau

► Pair of blown crystal vases, cut, gilded, and enameled with view of the city of Vienna, Austria, ca. 1820-1830 (Museu del Cau Ferrat, Sitges, Spain)

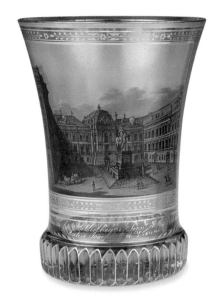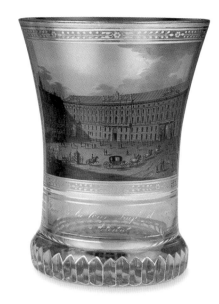

▼ Émile Gallé (Nancy, France) *Wisteria Vase*, cameo glass, early 20th century (Museu de les Arts Decoratives, Barcelona, Spain)

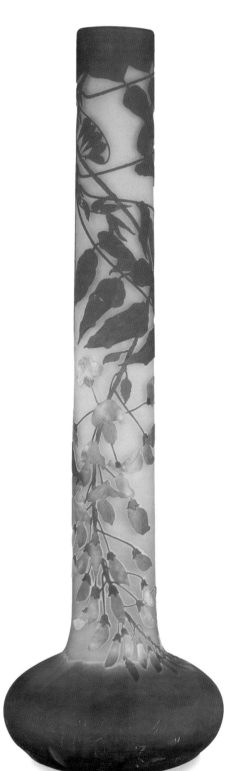

New industrial production techniques, such as pressed glass, were developed in the early 19th century. As a result, mass-produced pieces imitating contemporary Central European cut glass were much cheaper than the originals. Advanced fuels, high-capacity furnaces, and the mechanization of techniques gradually took production out of the hands of the artisans. This change led to various shapes and decorative techniques that are now considered characteristic of the 19th century's eclectic aesthetic in Europe and the United States.

During the second half of the 19th century, reproductions of works from preceding great periods (such as traditional Germanic, Venetian Renaissance, and Baroque) resulted in a historicist style in many English, Bohemian, and Venetian companies. At the same time, less expensive glass pieces were produced industrially, such as pressed glass (introduced around 1830). Decorative techniques, including acid engraving and painting, were mechanized, often resulting in objects of dubious taste.

The birth of the Arts and Crafts movement in Victorian England, championed by William Morris (1834-1896), began the process of restoring dignity to art objects, recovering craft processes, and creating a new taste among consumers for items that deviated from trendy eclecticism. Trades that were in danger of disappearing due to industrialization were given a significant boost, and a few decades later, the foundation was laid for the advent of the Art Nouveau movement. This authentic aesthetic revolution encouraged original craft and art that departed from historical references as a source of inspiration and the less desirable nature of industrial productions. Nature was the greatest source of study and inspiration, and the quality of craft techniques was transferred to mass production. The movement arose during the 1880s in Belgium and France, and it reached a high point during the 1900 Universal Exposition in Paris. It spread quickly to various European countries and the United States, with the common goal of dignifying and elevating art objects to the same stature as sculpture and architecture.

The French glassmaker Émile Gallé (1846-1904) captured the spirit of Art Nouveau. The international success of his work validated the new aesthetic. His influence and work led to the establishment of many workshops and production facilities, both inside and outside France, that were headed by artisans following in his footsteps. He created a new work system that would become universal from that point on in the world of glass: The artist/designer worked closely with skilled glass artisans, relying on them to make the glass while overseeing all phases of the process. This assured that the final result matched the artist's original design and standards, even though the process was partially mechanized.

Gallé's cameo glass technique of cutting various chromatic layers to create startling depth and realism in landscapes rendered him a virtuoso. Other French glass artists, the Daum brothers, also turned to nature for its repertoire of shapes and colors. This group came to be called the Nancy School. A very extensive list of European artists worked in glass during this period. In addition, the important American designer Louis Comfort Tiffany (1848-1933) created original, iridescent pieces inspired by the patina on ancient glass.

The Art Nouveau movement also contributed to the recovery of the pâte de verre or glass paste technique. In the mid-1880s, the Frenchman Henri Cros (1840-1907) was the first to produce sculptures, bas-reliefs, and vases with this lost technique, which hadn't been used for more than 1500 years. Venetian artists were responsible for discovering new expressive possibilities in another ancient technique, mosaic glass.

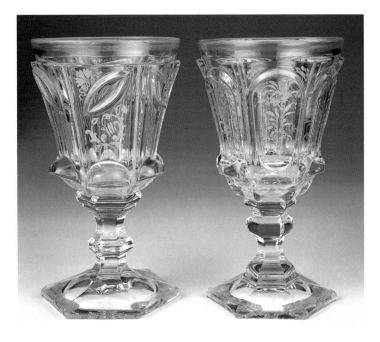

▲ Two glasses of pressed and gilded glass. France, 19th century (Museu del Cau Ferrat, Sitges, Spain)

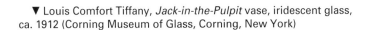
▼ Louis Comfort Tiffany, *Jack-in-the-Pulpit* vase, iridescent glass, ca. 1912 (Corning Museum of Glass, Corning, New York)

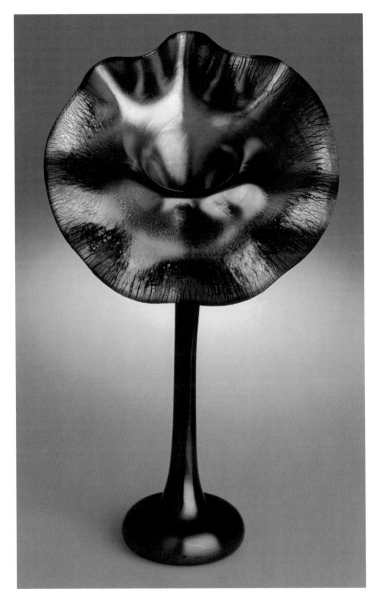

▼ Émile Gallé, *Dragonfly Vase*, cameo glass. Nancy, France, ca. 1900 (Philadelphia Museum of Art, Philadelphia)

From Art Deco to Contemporary Design and Sculpture

At the end of the Modernist movement, around 1910, glass artists chose to condense forms and gradually abandon the sensual lines of Art Nouveau. Instead, they preferred geometric designs, which culminated in the birth of another new aesthetic known as Art Deco (a contraction of the French *art decoratif*). Art Deco reached its peak at the 1925 Exposition of Decorative Arts in Paris.

René Lalique (1860-1945) was a great practitioner of the tenets of this aesthetic. He was a jeweler who adopted Art Nouveau and expressed it through experimental glass paste jewelry. Then he abandoned glass pastes to experiment with blown glass in molds. In the style of Art Deco, he created decorative objects and perfume bottles, utilizing industrial technology but maintaining a high level of handmade quality in his designs and materials.

These precepts laid the foundation for the work of the Bauhaus, a German school founded in Weimar in 1919, whose teachings focused on overcoming the seeming contradiction between standardized mechanical work and the beauty of handwork. This new aesthetic created the basis for contemporary design that strove to produce beautiful as well as functional objects. Throughout the 20th century, these ideals had a broad effect internationally, as glass took on a wide spectrum of uses and designs.

As Modernist and Art Deco glass artists renewed ancient methods and furthered blown glass techniques, they pushed the technical and expressive limits of glass to new heights. These artists used glass in fields previously reserved for materials such as bronze, stone, and ceramics. Glass artists also brought new elements such as color and translucence to sculpture, which made a unique view of the "inner space" of sculptural work possible.

Avant-garde artists turned the search for new materials into one of the basic tenets of their work. Some French and Italian glass products incorporated the designs of well known artists, such as perfume bottles designed by Picasso, Braque, and Dali.

Collaboration between industry and the creative world of artists is one of the major occurrences that led to the Studio Glass Movement in Czechoslovakia at the end of World War II. Stanislav Libensky and Jaroslava Brychtová were pioneers of the international movement. The sculptural work of these two artists inspired countless glass artisans in their country. They successfully applied cutting techniques to technically complex molded glass, creating a distinct and very refined, abstract style.

Contemporary Italian sculpture also borrowed from traditional techniques; specifically, by mastering blown glass, creating pieces that combined clear and colored glass.

Initiatives such as the *Centro Studio Vetro* in Venice were created as places for research and exploration of glass as an art medium. Various centers of this type were created in several European countries during the last third of the 20th century, as well as in the United States, Japan, and more recently, South America. Such centers help spread glass techniques to the growing number of artists and designers attracted by the same qualities and potential of the medium that artists have always found irresistible. As a result, a growing number of glass artists create both beautiful and practical objects, as research into its tremendous possibilities in the creative world continues.

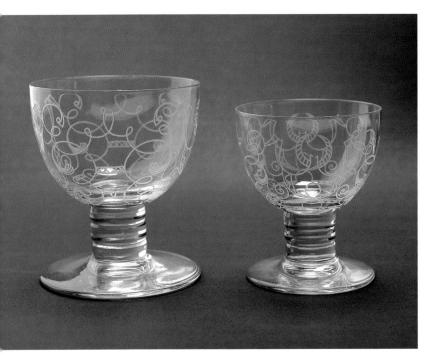

▲ Baccarat, two blown *Champs Élysées* crystal glasses, cut and engraved, 1934 (private collection)

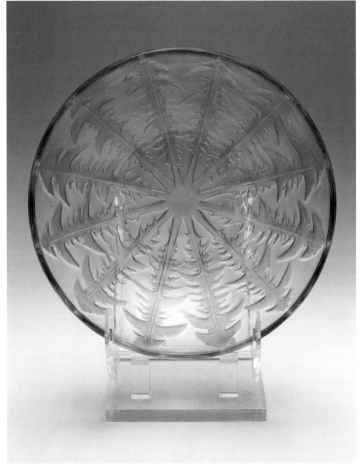

▶ René Lalique, *Dandelion* centerpiece, molded glass. Alsace, France, ca. 1921-1937 (private collection)

◄ Xavier Nogués and Ricard Crespo, Barcelona, 1930. Enameled glass (private collection)

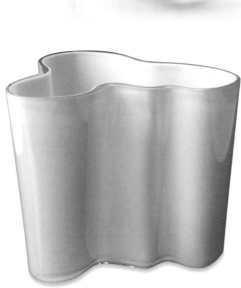

► Alvar Aalto, *Savoy* vase. Finland, 1937 design. Colorless, molded opaline glass (private collection)

▲ Moser, ca. 1914-1926. Vase of cut crystal with engraved and gilded band (private collection)

► Sally Fawkes. *Face to Face*, 2001. Cast glass worked cold, 9 x 7.5 x 5.3 inches (23 x 19 x 13.5 cm)

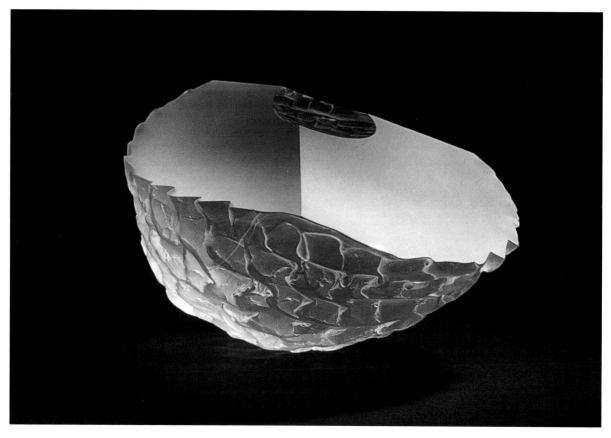

efore studying the materials, tools, and techniques for kiln work with glass, it's important to become familiar with the nature of the material itself. You'll want to learn about its physical and chemical properties, and how it's made before it is transformed. This chapter explores different kinds of glass available to artists—both flat glass and glass for fusing. Thoroughly exploring the complex nature of glass and the different ways of working it could fill an entire book rather than a chapter, so keep in mind that this is only an introductory overview.

In this chapter, you'll learn about the many characteristics of glass and how it behaves during the firing cycle. These are essential points to keep in mind before beginning any glass project that involves a kiln.

The Nature
of Glass

Glass as a Material

Glass is a synthetic material that is surprisingly malleable because of its physical and chemical characteristics. Despite its solid appearance, glass is considered to be a liquid because of its amorphous or non-crystalline structure. To understand this concept, compare it with ice. When water freezes very slowly, crystals form and change the liquid into an opaque solid that you can't see through. On the other hand, if the process is sped up (as with ice cubes), the frozen water appears glassy and transparent, since no crystals form to make the material opaque.

Physical and Chemical Nature of Glass

Every type of matter can be classified as one of three possible states: solid, liquid, or gas. However, vitreous matter such as glass requires another designation—the vitreous state. Glass can't be considered a solid because it has an amorphous, rather than crystalline, structure. The crystalline structure of matter is characterized microscopically by the clustering of ions, atoms, and molecules according to a model that repeats periodically. The structural disorder of glass is more reminiscent of liquids, although technically, it can't be called one. So glass can be defined as a melted inorganic product that has cooled to a solid state without undergoing crystallization.

Through heat, glass is made in a fusion reactor from a mixture usually consisting of siliceous sand with dry, pulverized, or granulated metallic oxides. In the fusion process (when heat changes the substance from solid to liquid) a viscous material is formed, and the mass becomes transparent and homogenous at temperatures over 1832°F (1000°C). When you take the glass out of the kiln, it becomes more rigid and can be worked and manipulated into different shapes. During this process, called annealing, it's always necessary to control the cooling temperature to avoid devitrification (crystallization) of the material.

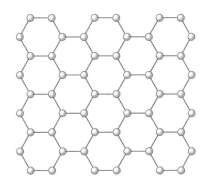

▲ Model of how the atoms of an organized material are distributed (crystal)

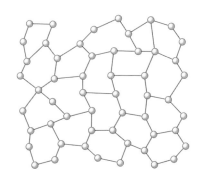

▼ Model of how the atoms of glass are distributed

▼ Diagram of how glass is made commercially

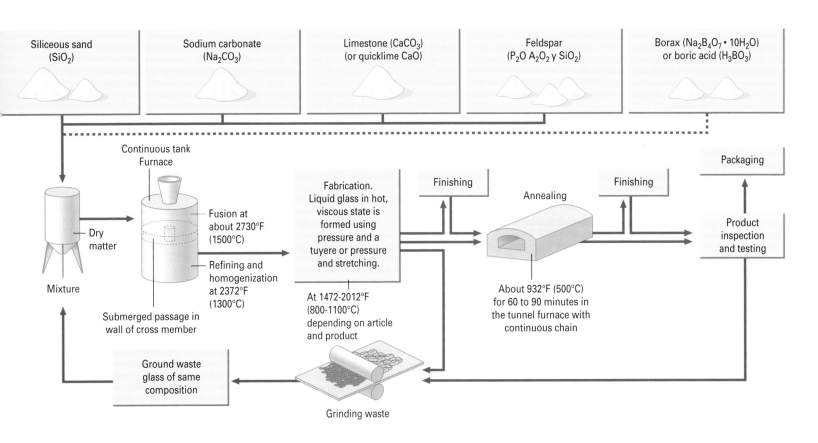

Siliceous sand (SiO$_2$)

Sodium carbonate (Na$_2$CO$_3$)

Limestone (CaCO$_3$) (or quicklime CaO)

Feldspar (P$_2$O A$_2$O$_2$ y SiO$_2$)

Borax (Na$_2$B$_4$O$_7$ • 10H$_2$O) or boric acid (H$_3$BO$_3$)

Continuous tank Furnace

Packaging

Finishing

Finishing

Annealing

Fabrication. Liquid glass in hot, viscous state is formed using pressure and a tuyere or pressure and stretching.

Dry matter

Fusion at about 2730°F (1500°C)

Refining and homogenization at 2372°F (1300°C)

Mixture

Submerged passage in wall of cross member

At 1472-2012°F (800-1100°C) depending on article and product

About 932°F (500°C) for 60 to 90 minutes in the tunnel furnace with continuous chain

Product inspection and testing

Ground waste glass of same composition

Grinding waste

Components

Silica

The basic component of glass is silica (in the form of silicon dioxide or SiO_2), which comprises some 60 to 80 percent of most glass by weight. When silica melts, it changes to a thick, viscous liquid. If you cool this liquid in a controlled fashion to the solidification point, the atoms don't have the freedom of movement to recover the ordered structure they had previously. Instead, they remain, as if frozen, in a semi-disordered structure similar to that of liquids; however, in contrast to liquids, the atoms of glass cannot move, they vibrate only around fixed positions.

As a result of its partially disorganized structure, glass has no crystalline structure, and it has no definite fusion point; rather, melting takes place gradually along an interval of temperatures, and glass softens progressively.

It is this physical property that makes glass transparent, like most liquids. In contrast, quartz crystal has an orderly atomic structure with successive layers of atoms that disperse light. In glass, the lack of such a structure creates a transparent material that allows the passage of light.

If silica is heated to around 3100°F (1704°C) it becomes a viscous liquid that is difficult to mold before it solidifies. Ever since the discovery of glass, the difficulty and effort involved in reaching this temperature made it necessary to add other compounds based on silicon dioxide. And yet, even though today we now can heat silica to this temperature easily, melting it alone in the form of sand to produce glass results in a fragile, brittle material that is useless for making any shape or object. For these reasons, it's necessary to add other compounds to silica to lower the melting point and lend the glass the hardness needed to work it into shapes.

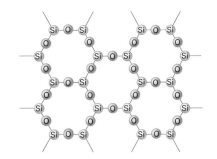

▲ SiO_2 molecules in their crystalline form (quartz crystal)
▼ SiO_2 molecules arranged in an unorganized lattice characteristic of glass

▲ Quartz crystal

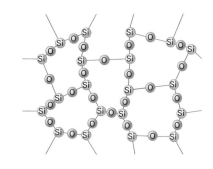

Fluxes

The raw materials used to make glass are divided into four basic groups, according to the roles they play in the process: vitrifiers, fluxes, stabilizers, and secondary materials.

The main element used as a vitrifier is the silica in the sand. This material constitutes about three-quarters of glass; other materials are added to lower the melting point, harden, color, or clarify the resulting glass.

Fluxes are substances added to the material to stabilize it and facilitate melting at a lower temperature. Throughout history, there have been two basic types of glass, depending on the type of flux used, whether sodium or potassium (extracted from plants and minerals). These produce what is known as either sodium or potassium glass.

Stabilizers

Stabilizers, in the form of calcic substances, are commonly added to the basic mixture to lend some rigidity to the vitreous material. Without them, the glass would be soluble, even in water. Some ancient authors spoke of adding pulverized seashells to the sand to increase the hardness of glass, but recent analytical studies of archeological glass show that lime was commonly used, as it is today.

▶ Various mineral components used in melting glass

Sodium-Calcium Glass

Because of the need to lower the melting point of glass and decrease its viscosity in the liquid state, most glasses are made using a mixture of silicon dioxide and other metallic oxides that act as fluxes. This produces two types of glass. The most common one is sodium-calcium glass, produced by mixing the basic elements of silicon dioxide (SiO_2), sodium carbonate ($Na2CO_3$), and calcium carbonate ($CaCO_3$).

ELEMENTS	PERCENTAGES (%)
Silicon	70 — 75
Sodium	12 — 18
Potassium	0 — 1
Calcium	5 — 14
Aluminum	0.5 — 3
Magnesium	0 — 4

Sodium-calcium glass is the easiest to melt and the cheapest. As we can see by the percentages, silicon is the basic raw ingredient (vitrifier), sodium improves the ease of melting (flux), and calcium provides chemical stability (stabilizer). This composition is used to produce the majority of clear and transparent glass available on the market.

Lead Glass or Crystal

Another type of glass is made by mixing and melting oxides of silicon, potassium, and lead to produce crystal, a glass with a high refraction index that can be cut and makes a ringing noise when it's struck. In this type of glass, calcium oxide is replaced by lead oxide as a flux. This produces a denser glass, and as a result it has a higher light refraction index. Cut-glass objects are made from crystal because it's a softer glass that retains plasticity that allows engraving and cutting.

Optical glass belongs to this family of glass; in order to produce it, it's necessary to add lanthanum oxide and thorium. Because this glass disperses light of all colors, it's the ideal material for making camera lenses. With minimum correction, the lenses provide light and focus it uniformly on the plane of the film. Otherwise, some colors would be rendered in greater intensity than others, making it difficult to capture realistic images.

▼ The physical characteristics of crystal allow it to be cut by methods similar to the ones used with gemstones.

Borosilicate Glass

Borosilicate glass is commonly used today. It has great chemical resistance, minimal thermal expansion, and, therefore, heightened resistance to thermal shock. This glass, invented in 1912, has physical and chemical characteristics that make it highly appropriate for use in laboratories and daily applications. It resists abrupt temperature changes with a minimal coefficient of expansion, and this can, for instance, translate into a material that can withstand high temperatures used to cook foods. Its components are silicon dioxide (SiO_2), boric acid (H_2BO_3), phosphoric acid (H_3PO_4), and, in certain circumstances, aluminum oxide (Al_2O_3).

▲ ▼ Laboratory and household implements made from borosilicate glass

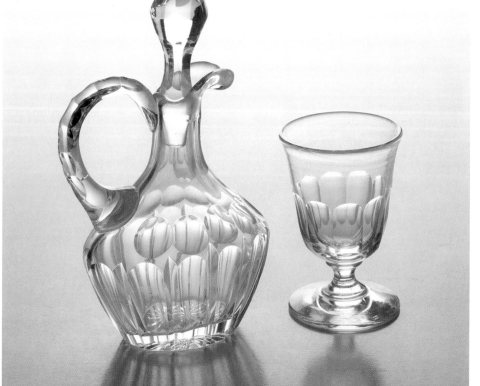

Coloring Agents

Ancient glass was often colored as the result of impurities in the fusion materials and firing system. Today, glass is colored during the fusion process by techniques such as adding small quantities of metallic oxides or even fragments of colored glass. Making colored glass is not merely a matter of adding these oxides and materials, however, because the final result also depends on the components of the glass and the effects of oxidation or reduction in the kiln, as well as the valences of the minerals used. For example, iron oxide in the form of ferrous oxide (FeO) can create a blue glass, or, in the form of ferric oxide (Fe_2O_3), a green glass. Besides the nature of the glass, other factors, such as the temperature and length of the fusion process have an effect on the color.

Since colored glass is produced by adding various metallic oxides (such as oxides of iron, cobalt, magnesium, and others), and sand commonly contains some of these oxides, you have to remove them to make colorless glass.

To understand the complexity of the process used to color glass and the variables that come into play, you need to know how various colors are created. For example, using copper oxide can result in green or blue glass, but when the copper is heated with silicon at a very high temperature, it's deposited in the form of a lattice that produces a ruby color.

This same technique can be used to create opaque glass, because the lattice that forms inside the glass diffracts light, eliminating the transparency. It's also possible to make a glass similar to alabaster; some subtle coloration is normally added to this material to create an opalescent glass. Although the internal structures formed during the creation of such effects are not completely understood, this mystery poses no obstacle to making such glass for industrial or artistic purposes.

Another kind of non-monochrome coloration is an iridescent effect similar to oil on water. This optical effect involves the breakdown of light into the seven primary colors. Iridescent glass is produced by various means; one of which involves adding salts dissolved in distilled water to the glass during the annealing process. Another is adding different metallic oxides to the glass's melting body so that the resulting glass can then be subjected to a reducing flame in the annealing kiln.

The coloration of glass during its formation is complex, involving many physical and chemical processes. Each type of glass is the result of a mixture of different materials, but other factors that determine glass color include the following: coloring agents, temperature, the range and exposure time to the temperature, the type of kiln, plus different ways of coloring the material once it comes out of the crucible.

▲ Opalescence and iridescence are two of the possible effects of coloring glass.

COLORING AGENTS

Copper oxide	Cu_2O
Ferrous oxide	FeO
Ferric oxide	$(Fe2O_3)$
Cadmium sulfide	$CdSO_4$
Sulfur	S_8
Potassium dichromate	$K_2Cr_2O_7$
Neodymium oxide	Nd_2O_3
Cerium oxide	Ce_2O_3
Erbium oxide	Er_2O_3
Cobalt oxide	CoO

▶ Some of the metallic oxides used to color glass

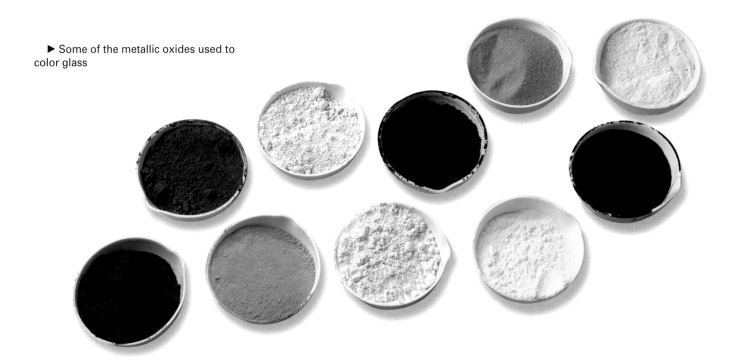

Different Kinds of Glass

You can buy glass in many different forms, and all of them are appropriate for the techniques used in the following chapters. The actual production of glass is so difficult (and the setup required is so complex) that very few artists make the glass for their works.

Flat Glass

Hand Blown

Flat hand-blown glass is of the highest quality and is used in windows as well as castings and thermoforming. Following ancient hand-made techniques employed by medieval glassmakers, this glass begins with a mass of melted glass that is spread out smoothly to form a sheet of glass. This glass can also be made through the formation of a glass sphere that transforms into a disk and is then cut into slices. Hand-blown glass is valued *because* of its imperfections: the differences in thickness, the bubbles, and the fact that its handmade nature renders every plate unique.

Blowing and Mechanical Stretching

At the beginning of the 20th century, when the process of making blown glass was mechanized, it became possible to create glass more economically in larger sizes. As with the handmade method, the industrial process involves creating a mass of molten glass that can then be spread out and smoothed.

Other possible techniques for making flat glass nowadays include continuous lamination and pouring. This technique, introduced in 1932, consists of making the glass overflow one end of a large flat-glass kiln, forcing it to slide toward laminating rollers. The glass sheet slides horizontally while the controlled cooling or annealing takes place.

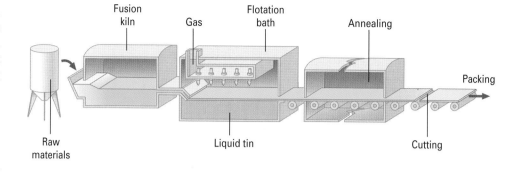

Fusion kiln · Gas · Flotation bath · Annealing · Packing · Raw materials · Liquid tin · Cutting

▲ Diagram showing how float glass is manufactured

◄ Process of creating flat blown glass using spot technique

Float Glass

This glass gets its name from its manufacturing process that involves melting the glass in a blast furnace before placing it in a chamber where it floats on a bath of melted tin. The material stretches and spreads out horizontally, passes out of the chamber, goes to an annealing furnace, and is finally cut into pieces. This process, invented in 1959, makes it possible to manufacture the economically priced glass used in windows, although it's also used to make craft glass.

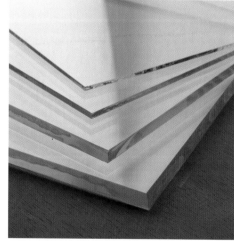

▲ Different thicknesses of float glass

◄ Process for making flat blown glass using the technique of creating a disc (left), which is subsequently cut into slices

Plaqué or Flash Glass

Plaqué or flash glass was originated during the Middle Ages in response to the need for a lighter glass. At the time, red glass was made by adding copper oxide and iron filings to the crucible. The result was a very opaque glass that wasn't very useful for stained-glass windows, since it created dark spots in the pieces. The solution was to blow two layers of glass simultaneously, one red and one colorless, resulting in a plate with red glass making up half the thickness. This technique is still used to make layered glass with special color effects or to create various shades of color on the sheet by thinning one layer with hydrofluoric acid or sandblasting.

▲ Side view of a piece of *plaqué* or flash glass

Pressed Glass

Manufacturers make pressed glass by pouring the mass into a mold and using a roller to spread the glass and create a sheet. If this roller has a design on it or a slight texture, it's transferred to one of the faces of the sheet, creating a glass with one textured face and one smooth one. (The smooth face is the one that was in contact with the mold.)

Cathedral glass is a term used to describe a type of pressed glass that can be clear or translucent. It comes in a wide array of colors. Clear cathedral glass often has a geometric or abstract pattern created by the roller. Such patterns lend interesting luminous effects when light penetrates the glass.

▶ Various sheets of textured, translucent glass

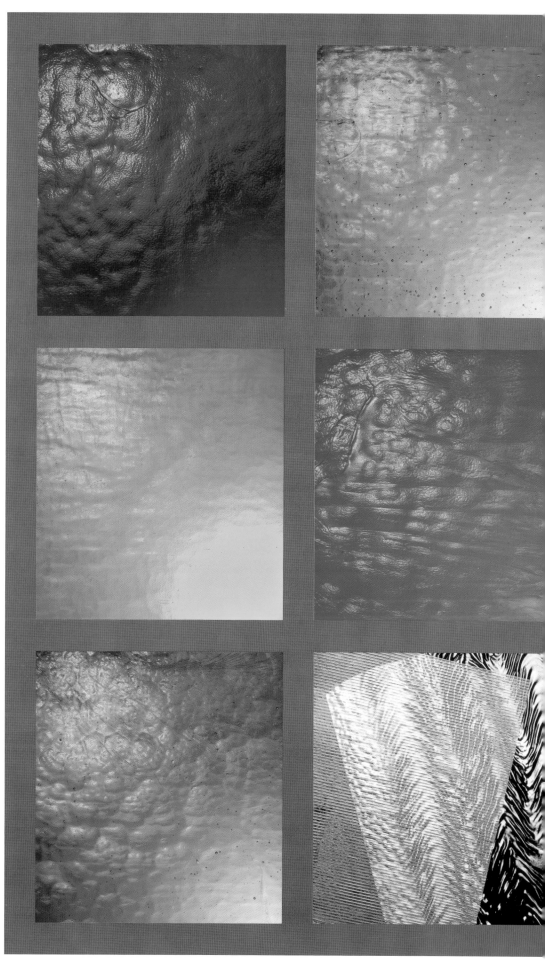

Other Forms

Slabs

The slab (or "dalle") is a type of glass brick that's made by casting glass in a mold. Usually the dimensions vary between 6 x 8 inches (15.2 x 20.3 cm) and 8 x 12 inches (20.3 x 30.5 cm). Slab glass can be used for making glazed windows or can be remelted for casting purposes.

Compatible Glass

For use in glass projects, companies produce different types of glass that are compatible (have the same chemical composition) to prevent certain technical problems. For example, if you fuse together glass of dissimilar compositions, you'll normally have difficulties, including cracked layers. If different kinds of ground glass are mixed together in a pâte de verre process, the glass won't fill the mold as desired, or it will crack after the annealing cycle. Compatible glasses will behave in the same way when used in various processes involving the kiln.

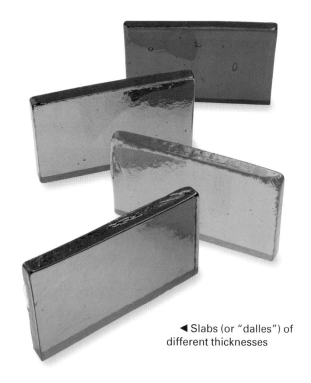

◀ Slabs (or "dalles") of different thicknesses

Glass for Fusing

To make pâte de verre pieces, you'll need glass that's appropriate for fusing in molds. If you don't create your own glass, it is easy and efficient to buy glass debris and reduce it to the desired granulation. Today, companies sell glass in different forms for making pieces in a refractory mold. That way, you can be sure of their exact composition and how they'll behave when exposed to different temperatures.

In contrast, if you buy leftovers from the crucibles or fragments from a factory, you probably won't know the exact composition. As a result, it is very hard to calculate the annealing cycles. At the same time, there is no way to judge whether the possible combinations of glass will be compatible.

In addition, these types of glass made specifically for casting contain no impurities or dirt, so you'll be spared the work of extensive cleaning as well as undesirable bubbles or colors at the end of the procedure.

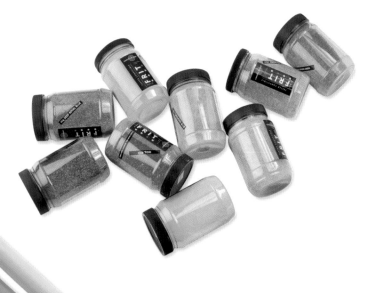

▲ Frit (pulverized glass in various granulations) appropriate for pâte de verre and for decoration on cast items

◀ Compatible rods of various sizes that are useful for fusing projects

▶ Colored flat glass

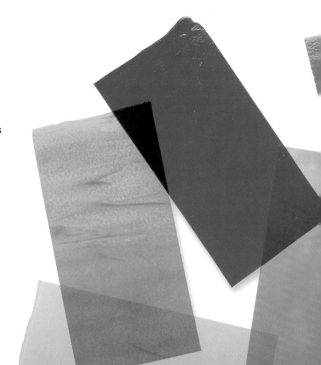

▲ You can buy flat glass that's compatible with rods and colored fragments.

▲ Glass suppliers sell colored glass rods of various thicknesses that can be used to create attractive decorative effects.

▶ Various kinds of glass that are compatible for fusing

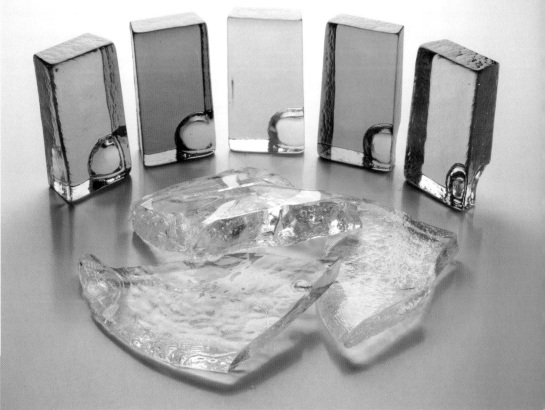

Materials
and Tools

This chapter explores materials and tools used in a glass workshop, grouped according to use for easy reference. Included is a description of each material or tool, an explanation of its possible uses, and wherever necessary, some safety advice. It's just as important to know the tools used to manipulate glass, as it is to understand the material itself.

Glass art covers a broad field with constantly expanding boundaries resulting from innovation by glass artists. New discoveries lead to original solutions that inevitably require a familiarity with up-to-date materials and tools. Because of this evolution, this chapter addresses common materials and tools that are the most universal. As you gain experience as a glass artist, you'll naturally use new techniques, which will lead you to more materials and tools.

Materials for Originals

For Making Models

Clay

Over millions of years, water decomposes feldspathic rocks, which are abundant in the earth's crust. This action results in clay, a hydrated aluminum silicate comprised of about 40 percent aluminum oxide, 40 percent silica (silicon oxide), and 14 percent water. It's a plastic material that, once molded, retains its shape. Clay shrinks or reduces during drying and firing. Used to make models for original pieces that are subsequently used to create molds, it is also used to support and close openings in objects used to make molds.

Latex

This milky-looking diffusion of synthetic resins in water is used to make molds for a series of identical objects. It dries quickly, although temperature and humidity affect its drying time considerably. Dry, warm air encourages faster drying. Latex is a better choice for molds than silicone, even though, unlike silicone, it shrinks when it dries. Avoid direct contact between latex and your eyes, and use it only in a well-ventilated area.

Silicone

Silicone, used for making solid molds, is a semi-organic polymer made up of chains of silicon atoms alternating with oxygen atoms that are joined in organic groups. Its main disadvantage is its cost, which is higher than that of latex; however, in contrast to latex, it doesn't shrink.

Elastomer-type silicones are used to make prototypes. These are made up of two components: the silicone itself and the catalyst. The catalyst is a substance that triggers a chemical reaction and remains intact once the reaction is complete.

To make a prototype, follow the manufacturer's instructions to mix together the right proportion of silicone and catalyst. Be sure to wait the amount of time indicated before removing the mold. A thixotropic additive can be added to keep the mixture from dripping during application.

Bee's Wax

This wax is a transparent liquid that transforms into a semisolid substance after it comes in contact with air. The color of bee's wax has a large range—it covers the whole spectrum of yellows, shades of tan or brown, and even black. To create prototypes for a series of identical pieces, it's heated with paraffin and rosin.

Molding Wax

This wax can be molded directly without having to add any other ingredients. Depending on the manufacturer, it can be pink to red in color. It's a mixture of paraffin, microcrystalline waxes, and other components. The best molding wax is laminated cold, which gives it elasticity so it can be molded easily once it's heated. However, once the sheet of wax is cast, it loses its elasticity.

▼ Clay (A); found items: stones, pebbles, and mollusk shells (B); latex (C); silicone (D); and catalyst (E)

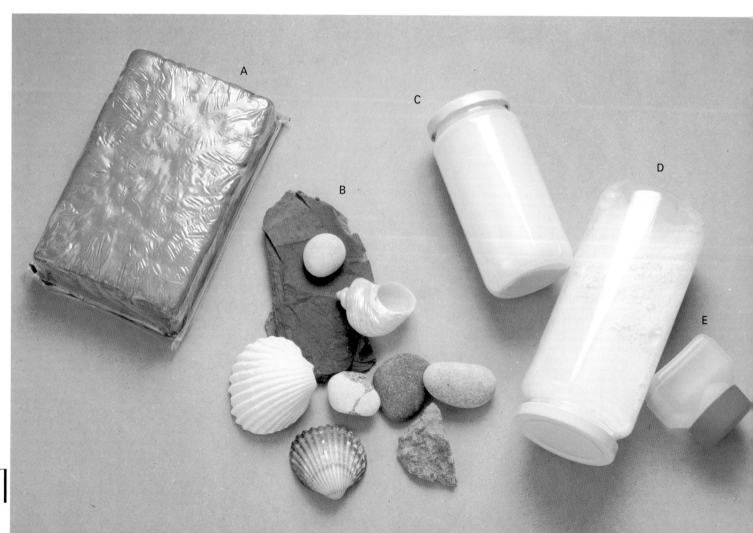

Solid Paraffin

Paraffin, a mixture of hydrocarbons, is a translucent white substance derived from petroleum. When it's used to make prototypes, it's mixed with bee's wax and rosin. The paraffin hardens the mixture as it cools.

Rosin

Natural rosin is derived from two types of conifers. Transparent and yellow or reddish in color, it is easily melted at a temperature of 212°F (100°C). When mixed with bee's wax and solid paraffin to make prototypes, it lends elasticity to the mixture.

Gypsum

Used in making the prototype for an original piece, gypsum is a dihydrocalcium sulfate ($CaSO_4 \cdot _2H_2O$). Found in nature in the form of clear crystals that flake off in sheets, it is sold in dehydrated form as a white powder that hardens when it's mixed with water. It's a widely used material because of its strength, setting time, and narrow range of expansion and contraction.

Foam Board

Expanded polystyrene (EPS) or foam board is made with an expanding agent that causes it to be made up of 98 percent air and two percent polystyrene. It's a lightweight material that's strong and easy to work, so it's well suited to making models.

Separators

Shellac

Shellac is a refined lac, a resinous substance secreted on certain trees by various scale insects. It's sold in flaked form and is soluble in alcohol. The films it produces are sensitive to water, they dry hard and elastic, and they're shiny. It's used as a separator for models done in gypsum when the appropriate mold is made. Prepare gum lacquer by mixing around 5 ounces (150 mL) of scale lacquer into 2 pints (1 L) of ethyl alcohol in a container with a tight lid. Keep the container closed and shake it until the product is totally dissolved.

Original Objects

Found Objects

In addition to original pieces made in the workshop, it's also possible to use found objects as models. Mollusk shells (land, sea, or freshwater), stones, and textured pebbles are a few of the possibilities.

Other Objects

Metal objects, regardless of their shape, can also be useful as models, although they must first be prepared by oven-curing them with commercial separator or kaolin. Items rich in calcium (bones, for example) can be interesting to use, since they burn up during baking but leave their shape in the melted glass.

▼ Bee's wax (A); mold wax (B); paraffin (C); rosin (D); gypsum (E); shellac (F); foam board (G)

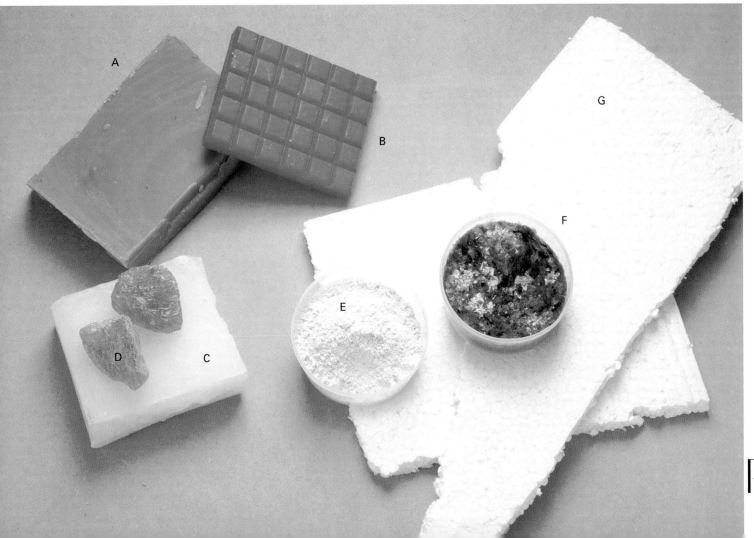

Materials for Molds

Making a Mold

Walls

Walls are used to form a framework for making molds. Generally made from chipboard covered with melamine or some other plastic material, the walls can be bracketed at one end to hold them together and support them when used to make a rectangular or square freestanding framework.

Plastic

Thick plastic is an alternative to walls in cases where a circular mold is needed. Like walls, it's used to make the framework for the mold. It's arranged on a rigid surface (such as a sheet of chipboard covered with melamine) and attached to the base with plaster.

Duct Tape

Use this tape to hold together the ends of the thick plastic used to make circular molds.

Silica

Silica, or silicon dioxide (SiO_2) is one of the most abundant compounds in nature; it's estimated that 60 percent of the earth's crust is composed of it. In nature it is found mostly in the form of quartz, either with a crystalline structure or as sand. Since silica has a very high melting point (3115°F/1713°C), adding it to the mixture used to make the mold assures heat resistance when the mold is put in the kiln. Silica comes in the form of sand or very fine dust, so it's essential to wear a respirator when handling it.

Molding Plaster

This extremely durable plaster was developed especially for making molds. It is a high-quality plaster that sets up in 30 minutes, is very stable, and expands very little, so the mold is absolutely true to the model. If it's added to silica in water, the silica sets up the mixture and makes it harder.

Calcined Plaster

Calcined plaster is sold in the form of a very light, white powder. Like gypsum, it's mixed with water to create a paste that sets up as it dries, producing a reaction that gives off heat. Calcined plaster is finer than gypsum, dries quicker, takes on a brighter white color, and is less porous. Thus, it produces better finishes. Plaster can be used to make molds when mixed in water with the silica in a two-to-one ratio (two units of silica to one of plaster).

Wire Mesh and Wire

Hexagonal wire mesh ("chicken wire") and wire are used to hold the first layer of the mold in place. Then the mesh is covered with a second layer of the mold mixture. The wire mesh keeps the mold from breaking apart entirely if it cracks from the heat, and it keeps cracks that develop from spreading. However, the mesh should never come in contact with the glass.

Ceramic Fiber

This material, manufactured from aluminum oxide and silicates (minerals that contain silica), is held together with an organic binder. This off-white fiber can be purchased in various forms. A thin version (about .020

▲ Sheet of ceramic fiber

inches/0.5 mm thick) is used on the kiln shelves as a separator for firing. The major drawback is that it shrinks a little and cannot be reused.

A thicker form of this fiber (from .039 to .312 inches/1 to 8 mm thick) is used for modeling the glass directly. It can be reused several times if you apply a layer of separator for firing. An even thicker sheet (from ⅜ to 2 inches/1 to 5 cm thick) can be used to make a permanent base inside the firing chamber, as well as to model the glass directly.

You can cut ceramic fiber with a hobby knife, scalpel, or scissors, but you can also rip it by hand to create an uneven edge. Ceramic

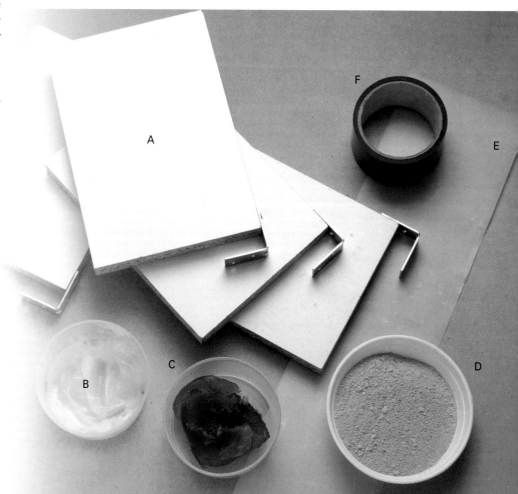

▶ Partitions (A); separators: petroleum jelly (B), soap (C), and separator for firing (D); plastic (E); duct tape (F)

fiber always has one smooth face and one textured one, either of which can be used with the glass. The organic binder in the ceramic fiber can affect the glass, giving the surface a cloudy or dull appearance. To avoid this, bake the material at 1200°F (650°C) before using it. During this curing, the ceramic fiber turns blackish as the binder starts to burn, and it gives off a characteristic odor. The fumes aren't harmful, but it's always a good idea to provide adequate ventilation in the workshop. Once the binder has been removed, the ceramic fiber returns to its white color, and it can be used with the glass. Be sure to wear a respirator and gloves when handling it.

Refractory Clay

This heat-resistant clay has a high melting point of between 2912 and 3182°F (1600 and 1750°C). This clay is quite pure, practically free of iron, and contains high levels of kaolinite (the basic material of clays) and aluminum oxide. It's used to make molds for thermoforming in the workshop.

▼ Refractory clay

Separators

Petroleum Jelly

This creamy petroleum substance is applied with a small brush and used as a separator between the original and the mold. If it's too thick, it can cover the surface texture of the object or the original and produce an undesirable finished effect. To prevent this, dilute it with mineral spirits.

Dish Soap

Soap, dissolved in water, is used as a separator on the original and is applied with a small brush.

Kiln Wash

This product is sold in powder form. Depending on the manufacturer, it's composed of silicates, aluminum hydrate, kaolin, calcium, and other agents such as binders and bentonite (clay that's produced by altering volcanic ash). Kiln wash is used to prepare molds and other surfaces so that glass doesn't stick to them at high temperatures in the kiln. It withstands temperatures up to 1472°F (800°C); for temperatures higher than that, kaolin should be used.

Prepare this separator by mixing it with water according to the manufacturer's instructions. Make it slightly thicker (mix it with less water) when using it on iron or other metallic surfaces. To lend texture to the glass, apply a thick coat to the mold with a broad palette knife, in four alternating vertical and horizontal layers. Then put the glass into the kiln at 500°F (260°C) for 10 minutes (or allow it to air dry for a longer period). If it's been heated, take it out of the kiln and allow it to cool before using it with the glass. Kiln wash is pink and retains this color when dry; however, the color disappears after it's taken from the kiln. The wash has to be eliminated completely by sanding it (with 80-grit sandpaper) off the surface of the glass where it was applied. Use safety glasses and a respirator when handling this product.

Talc (magnesium silicate) can also be used as a separator for firing, either alone or mixed with water or alcohol and vaporized on the surface.

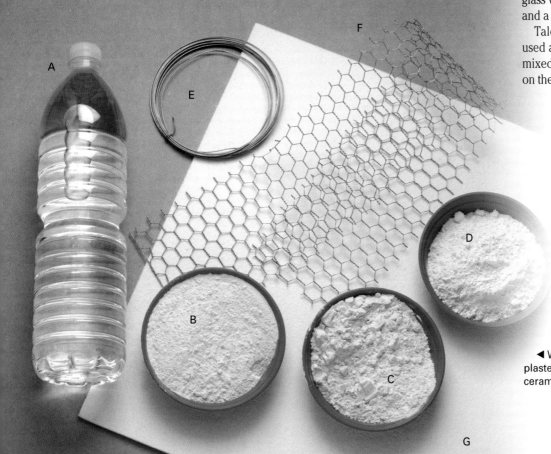

◀ Water (A); silica (B); mold plaster (C); plaster (D); wire (E); hexagonal wire mesh (F); ceramic fiber (G)

Materials for Inclusions

Metals

Copper

Copper (Cu) is a reddish brown metal that's very ductile, malleable, tough, resistant to corrosion, and one of the best heat conductors. It's probably the most commonly used metal for inclusions because it produces very interesting effects, its behavior and results are predictable, and is reasonably priced. Copper oxidizes in the presence of heat. However, sheets or layers of copper used as inclusions between two pieces of glass keep out enough air to prevent complete oxidation, producing heterogeneous color gradations.

Silver

Silver (Ag) is a precious metal that's shiny, ductile, very malleable, and an excellent heat conductor. It's found in nature in a crude state or as part of certain sulfured minerals. Silver oxidizes in the presence of heat, and there are certain characteristic results that are very noticeable if it is used as an inclusion in sheet form.

Gold

Gold (Au), a precious metal, is the most malleable and ductile of all metals. It's very heavy and resistant to most corrosive agents. Gold doesn't oxidize in the presence of heat, and it retains its characteristic yellow color.

Tin

White, shiny, and soft, tin (Sn) melts easily and resists the effects of wind and water without oxidizing. Malleable at room temperature, it becomes fragile when heated. As an inclusion, it oxidizes in the presence of heat.

Iron

A metal whose chemical symbol is Fe, iron is grayish-white in color, malleable, ductile, very strong, magnetic, and oxidizes easily in the presence of moisture. It's a very common metal in nature, since it makes up about five percent of the lithosphere. When heated, it oxidizes through reduction, producing a dark, black color.

Others

Besides the main metals that are commonly used as inclusions, it's possible to use other metallic materials, whether alone (such as aluminum and zinc) or in the form of alloys (e.g., nickel copper, an alloy of these two metals; white copper, an alloy of copper and aluminum, etc.). The possibilities are practically limitless if you're willing to experiment.

Various Forms of Metals

Mesh

Mesh is a weave of metallic wire with holes between the interlaced strands. There are many types of mesh with various-size holes, making it easy to choose the right one for any inclusion. It's possible to buy silver mesh from companies that sell jewelry supplies (or from jewelry stores that include a workshop), or you might be able to find a jeweler who can make silver mesh for you.

▼ Plant materials: leaves (A); fiberglass (B); chicken wire (C); steel wool (D); steel wire (E); wire (F); and copper wire (G)

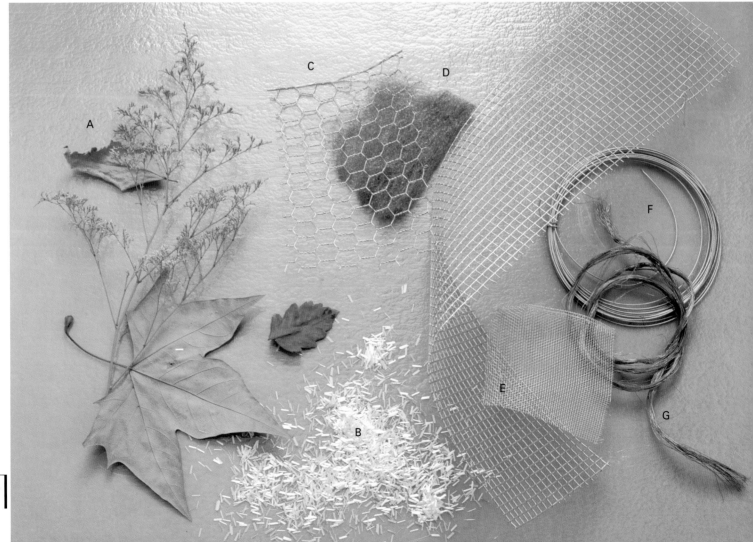

Steel Wool

Steel wool, made of iron filaments bundled together, is tough and spongy. It can be cut with scissors, and it's a good idea to wear protective gloves while using it.

Heavy Wire

This very flexible, strong steel wire is produced by cold extrusion or molding.

Thin Wire

This is a thin, flexible filament made from copper, silver, gold, or other metals or alloys.

Sheet

This is a thin, flat layer of metal made in an industrial press. A sheet is thicker than a leaf (see below).

Leaf

An extremely thin layer made from certain metals, generally precious ones. There are also leaves made from alloys that look like precious metals, plus rolls of metal for household use, such as aluminum foil. Metallic leaves are commonly sold in booklets—small folders in which the leaves are sandwiched between fine paper. Leaves of real gold are so delicate that you can see through them when you hold them up to a light.

Powder

Very tiny, separate solid particles made from some kinds of metal. Handle this powder carefully to keep it from becoming airborne. It's a good idea to wear a respirator when using it.

Organic Materials as Inclusions

Certain organic elements such as leaves, small branches, and flowers can be used as inclusions in glass work. The material burns and turns to carbon in the kiln, leaving behind its imprint.

Other Inclusions

In addition to the materials already mentioned, it's possible to use fiberglass, powdered glass, enamels, and even air as inclusions. Air can be used as part of an inclusion if you deliberately create air pockets by wearing down the glass with a sand blaster or arranging cut pieces. The glass must completely surround the worn area or air pocket so that air remains trapped inside when the glass melts.

▼ Copper sheeting (A); aluminum foil (B); silver leaf (C); copper leaf (D); leaf of false gold (E); powdered fine gold (F)

Finishes

Acid/Etching Cream

This chemical preparation with a creamy liquid texture is used to create a matte finish on glass. The actual composition of specific products varies by manufacturer, but acid creams usually include ingredients such as sulfuric acid, sodium bifluorides, hydrofluoric acid, and ammonia mixed with other components. A matte surface is produced when the acids in the cream react chemically with the glass surface and eat away at it slightly, creating a thin, translucent off-white layer. Apply etching creams with a wooden or plastic tool, or a brush. You can reuse them if you put them back in the container.

Always follow the manufacturer's instructions, and use them in a well-ventilated area. Wear gloves, safety goggles, and a face mask. Dispose of them properly, following the manufacturer's instructions.

▼ Etching creams

Masking Materials

PVA Glue

Polyvinyl acetate (PVA) is a transparent, diaphanous resin that's soluble in certain organic solvents. These glues are strong and age well. They form a very flexible layer that resists light and is stable in the presence of various products. In glass work, this glue can be used to mask off areas to create a design. It can also be brushed on the glass to make freehand shapes.

Sheets of Self-Sticking Plastic Sheeting

This plastic sheeting, made specifically for sandblasting, has a strong adhesive on one side that is protected by paper. Once the paper is removed, it sticks to any surface. It is usually transparent, but it also comes in different colors.

To mask off a design on glass, simply cut out the desired shape and stick it to the glass. You can also stick a whole piece of it on the glass, draw on a design with a marker, and cut away the excess with a hobby knife, leaving only the shape of your design.

Plastic Adhesive Tape

Plastic adhesive or packing tape can also be used to create masked areas on glass. Simply stick it directly onto the glass, arranged in the desired pattern. This tape is not flexible, so use it mainly for masking areas of simple or geometric shapes.

Masking Tape

This tape can also be used for masking like plastic adhesive tape, but it can be torn by hand.

▼ Abrasive diamond boards: orange (600) for medium polish (A), white (800) for fine polish (B), blue (1800) for superfine polish (C), and gray (3500) for the finest polish (D). Various granulations of abrasive (E) and cerium oxide (F)

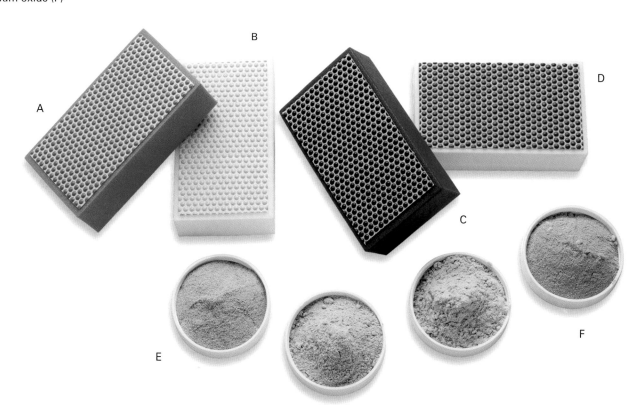

▲ Sheet of self-adhesive plastic (A), plastic adhesive tape (B), smooth masking tape (C), and white glue (D)

Grinding and Polishing

Diamond Blocks

The hardest mineral in existence, diamond is pure, crystallized carbon. It has a rating of 10 on the Mohs scale, which was developed by a German mineralogist for indicating the relative hardness of minerals from one (softest) to 10 (hardest). Diamond blocks are used to file away material and polish the surface of the glass. One surface of the block is covered with diamond dust. The blocks come in various colors indicating the grit and concentration of the dust, and they correspond to a number that goes from 50 (for major abrasion jobs) to 3500 (ultra-fine, for very fine polishing). The correspondence of colors and numbers varies according to the manufacturer. These blocks are used wet, just like other abrasives. To create flexible blocks that conform perfectly to the surface of the glass, they can be cut in half lengthwise.

Carborundum

Carborundum is silicon carbide (SiC), and it ranks nine on the Mohs scale, so it isn't as hard as diamond. Like diamond, it's used for grinding and polishing. Carborundum crystals have a surface with many ridges that make it a particularly effective abrasive. It's used wet in the form of a brick or a block, a stick, or powder. The coarsest grit has the lowest number (24), and the highest number (1200) has the finest.

Pumice

Finely pulverized pumice stone is a material of volcanic origin that's comprised of about 70 percent silica, 15 percent aluminum or aluminum oxide, and traces of potassium or sodium oxide. Pumice grits range from those for heavy-duty polishing to ultra-fine. It's used wet, particularly for fine polishing.

Moto-tool

This electric tool, used for cutting holes and polishing glass surfaces quickly, has a

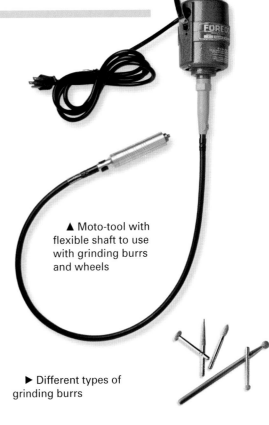

▲ Moto-tool with flexible shaft to use with grinding burrs and wheels

▶ Different types of grinding burrs

powerful motor and a chuck at the end of a shaft that comes with various grinding attachments and burrs. They're used for making orifices and polishing glass surfaces quickly.

Corundum

Aluminum oxide (Al_2O_3), also known as alumina, has a hardness of nine on the Mohs scale. Its surface has fewer ridges than diamond and carborundum, so it's particularly well-suited for refining areas already sanded down with other materials. It's used wet in powder form and is sold in a range of grits.

Cerium Oxide

Cerium oxide (CeO_2) is sold as a reddish powder. It has a hardness of six on the Mohs scale and is used to produce a very smooth final polish after sanding with pumice.

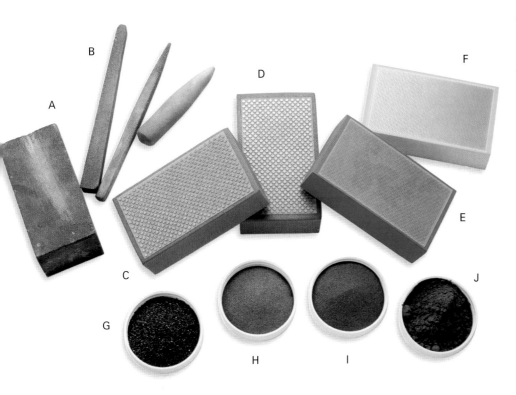

◀ Carborundum block (A), carborundum sticks (B). Abrasive diamond blocks: dark green (50-grit) for coarse abrasion (C), black (120-grit) for moderate abrasion (D), red (220-grit) medium abrasion (E), and yellow (400-grit) for fine abrasion (F). Carborundum powder: 30-grit (G), 220-grit (H), corundum (I), and 400-grit (J)

Auxiliary Materials

For Tests

Silver Stain

This material consists of silver salts (silver chloride, silver iodide, and other compounds) mixed in certain proportions with finely ground clay. The clay serves as a vehicle and reduces the compound's concentration.

Silver stain is mixed with water and used to check and differentiate the faces of float glass, since one side has a thin layer of tin on it from the manufacturing process and the other doesn't. The stain is applied to two samples of glass from the same sheet before putting the glass into the kiln. Silver salts react differently with the thin layer of tin on one face, resulting in a dark colored area that contrasts with the lighter side that has no metallic residue. Once this is done, the clay remains on the surface of the glass and can be recovered and used again.

For Cleaning

Ethyl Alcohol/Ethanol

An alcohol with the formula CH_3CH_2OH that is a clear, fragrant, volatile liquid solvent that evaporates quickly. Ethyl alcohol's vapors are not considered toxic; however, it is highly flammable and should be used only in well-ventilated areas. You can use it to clean glass and make the shellac separator. Ethyl alcohol is sold in denatured form, i.e., with certain toxic substances added to modify its taste, making it inconsumable for humans. When the alcohol evaporates, these substances remain on the glass in the form of residues.

Methyl Alcohol/Methanol

An alcohol, with the formula CH_3OH, that is also called fuel or wood alcohol. This strong-smelling alcohol is very volatile and flammable and is also extremely toxic if ingested or inhaled. Use a respirator, protective gloves, and safety glasses when using it, and always work in a well-ventilated area away from heat sources and flames. It's very good for cleaning off the lines made with a marker. However, it's sold with added color indicators, which may leave a residue on the glass when the alcohol evaporates.

Vinegar

Vinegar is the sour liquid that wine changes into through fermentation. Its main component is acetic acid (CH_3COOH). Unlike the alcohols, vinegar contains no impurities, so it's usually considered more appropriate for cleaning glass.

Liquid Dish Detergent

Dish detergent can also be used to clean glass objects. Rinse the glass well in running water after washing it.

Paper Towels

Household paper towels are used to wipe glass while cleaning with either alcohol or vinegar and to dry glass once it's clean.

For Marking and Copying

Markers and Pencils

Keep a good supply of markers and pencils in the workshop. You can use permanent markers when you need to make indelible marks on glass, to indicate an area to be polished, the faces of that area, or another feature. Use fine-tipped markers and pencils to draw designs on paper before tracing them with carbon paper on the ceramic fiber.

▲ Silver stain

▲ Methyl alcohol

▼ Liquid dish detergent and vinegar

▲ Paper towels

Carbon Paper

Also referred to as transfer paper, carbon paper is used to transfer designs by tracing them from the design onto the ceramic fiber.

For Gluing

Gel Glue

This glue, made of polyvinyl acetate (PVA), has the consistency of a gel, so it's easy to use a very precise amount. It doesn't drip, and once applied, it doesn't slip. It's non-toxic and soluble in water. Gel glue is used to hold pieces together during the fusing process and leaves no residue once the glass is heated in the kiln.

Methylcellulose Glue

Methylcellulose glue (sodium carboxymethyl-cellulose) is an inert, non-toxic adhesive made from cellulose fiber. Some manufacturers add silica to it. It's mixed with ground glass to prevent the glass from slipping, holding it in place in the mold. Prepare this glue by mixing it with hot running water, following the manufacturer's directions, and then add the ground glass. The glue produces ashes in the kiln, so the temperature of the oven has to be kept up (1150°F/620°C) until the residue disappears completely.

For Smoothing

Sandpaper

Sandpaper is sold in different grits, as indicated by the number on the back of the paper. It's used for removing commercial separator left on the substrate once it's been in the kiln, and for smoothing edges.

▲ Permanent markers (A), fine-tip marker (B), and pencil (C)

◀ Different types of sandpaper

▼ Carbon paper

▶ Gel glue (A) and powdered methylcellulose glue (B)

Cutting Tools

For Cutting Directly

Tile Cutters

These are used mainly for cutting tiles, but they can also be used for cutting and slicing very thick pieces of glass. The cut is made by a small, hard metal disk attached to a shaft with a handle that slides between two fixed guides.

Cutting Compass

This tool, used to make curved cuts and circles, consists of a squared axis with a suction cup at one end and a movable cutter on the other. The suction cup has a clamp to hold the end of the tool in place. Measurements are engraved on the top surface of the metal axis, and slides along it, adjusting to the desired length.

◄ Breaking pliers

▲ Tile cutter

▼ Cutting compass and square

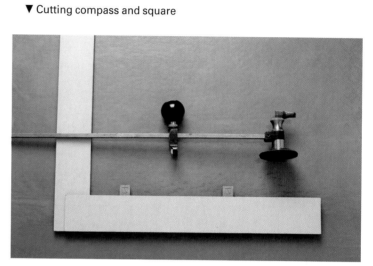

▼ Oil cutter (A), glass cutter (B), cutting pliers (C), and pliers (D)

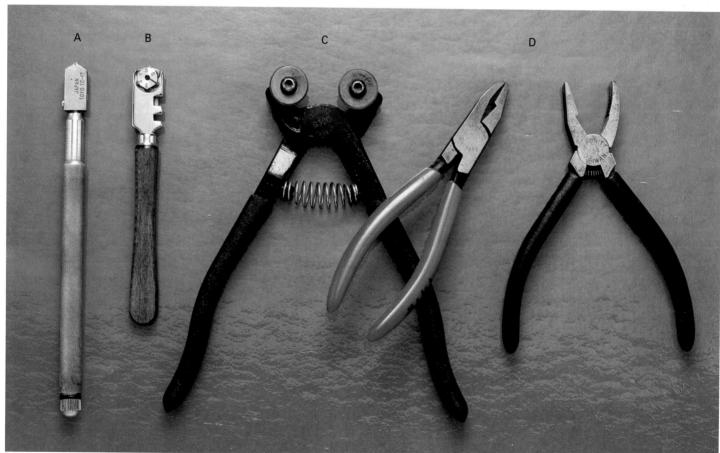

A B C D

Glass Cutter

This tool usually has a wooden handle. The cutter is a small metal wheel (made from carborundum or other materials) that cuts as it turns.

Oil Cutter

The handle of this cutter has an oil reservoir inside it that can be filled by removing a plug at the top of the hollow handle. When used, the oil is dispensed to lubricate the cutter. Some oil cutters have a transparent handle, making it easier to check and control the oil level.

Cutting Pliers

Used to cut threads, rods, and small pieces of glass, this tool is made of hardened steel and has two ends joined at a pivot pin that close like a clamp. Each end has a small wheel-

shaped cutter attached to it. As the blade's cutting edges dull, it's necessary to turn the wheels slightly for the tool to cut perfectly.

For Guiding the Cut

Square

A square, commonly made of steel, is made of two legs joined at a right angle. It allows you to cut sides that are perfectly straight and perpendicular to each other. Make sure your square is large enough to fit your cutting needs.

For Opening the Cut

Breaking Pliers

These pliers with jaws coated in plastic help you make clean, easy breaks or openings in the glass along cut lines. Some models have jaws that can be adjusted to different shapes and sizes. Aluminum models are extremely light.

Pliers

Common pliers are used as an auxiliary tool for opening up cut lines, cutting very small pieces, and breaking glass.

Work Surface

Cutting Table

Your work surface is as important as the cutting tools that you use. Select a cutting table large enough for working comfortably, even with large pieces. It should be stable and high enough that you can stand comfortably, without having to bend over too much. The top of it needs to be solid but cushioned. A sheet of plywood or particleboard covered with felt is ideal for this, since the felt provides a soft surface for handling the glass and helps prevent breaking.

Finishing off Cuts

Edge Polisher

An electric edge polisher or grinder is used to smooth sharp edges on cut glass pieces. An abrasive carborundum wheel located in the middle of one side spins while a small sponge distributes water at the back. The top surface in front of the wheel is protected by a grate or mesh. The glass is placed flat on the mesh, with the edge to be smoothed against the grinding wheel.

▼ Cutting table

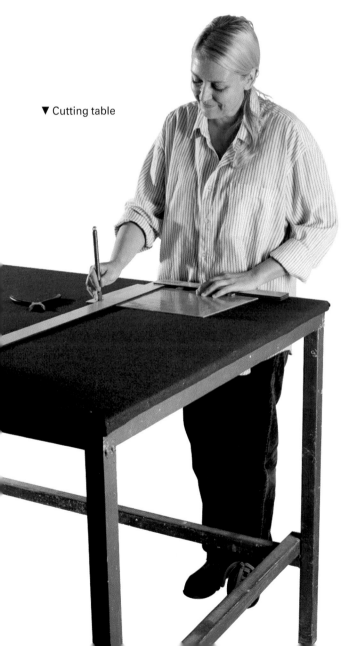

▼ Edge polisher/grinder

GIGANT I

Tools for Originals and Molds

For Making Originals and Working with Molds

Rolling Pin
Rolling pins are used to roll out the clay and for other tasks such as forming sheets and strips.

Wire or Cutting Thread
This tool is used to cut clay. It's made with a fine metallic thread or wire (or a piece of nylon line) with small wood handles at each end that make it easier to cut without hurting yourself.

Paring Tools
These tools are used to hollow out solid pieces and smooth surfaces on originals. Once the mold is made, they are also used to remove excess clay that served as a support or closed up the original. Paring tools usually have wood or plastic handles with thin metal loops on each end that can be bent in various shapes, depending on the tool. Use round-pointed paring tools for scooping out, use those with a straight end to smooth surfaces, and use cutting trimmers to get rid of excess clay and remove material from molds.

Spatulas
Generally made of wood, and sometimes of plastic or steel, spatulas are used for modeling as well as joining, retouching, smoothing, and texturing the clay. Each end of the spatula is shaped differently, making the tool twice as useful.

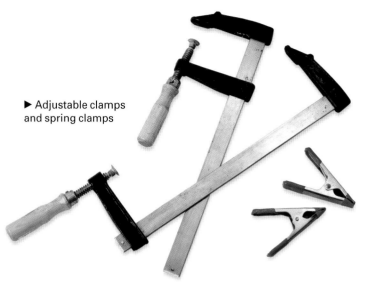

▶ Adjustable clamps and spring clamps

Needle Tool
This tool has a fine, sharp point attached to a handle. When making originals, use it to mark, score, or stitch the clay. You can also use it to bore through materials and manipulate very small pieces.

Ribs
These ceramic tools are used to smooth and level surfaces of prototypes or models.

Painter's Spatulas
A painter's spatula has a broad, flexible metal blade that is straight on one edge with a plastic handle on the other. Although used primarily for smoothing the surface of prototypes, it's also useful for cutting clay strips.

Scrapers
Also called cabinet scrapers, these are high quality, semi-hard, tempered steel blades used to smooth surfaces. They're usually rectangular, although they're also available in different shapes to fit various surfaces.

For Holding and Attaching

Clamps
These steel or plastic tools, made for clamping and applying pressure, consist of two projecting parts, one fixed and one that slides and adjusts with a screw. They help hold and attach pieces and walls of molds while the plaster sets up.

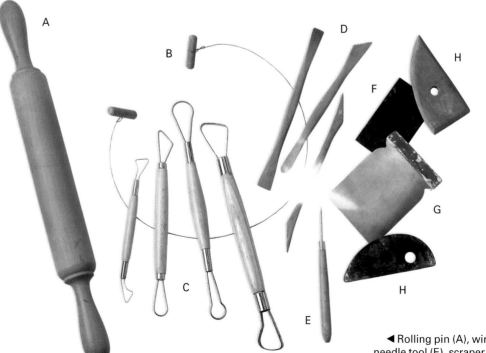

◀ Rolling pin (A), wire or cutting thread (B), paring tools (C), spatulas (D), needle tool (E), scraper (F), painter's spatula (G), and ribs (H)

Spring Clamps

These tools have a spring mechanism for tight clamping. Use them to firmly hold and attach parts, pieces, and walls during the construction process.

For Heating

Electric Hot Plate

This electric heating appliance is used for heating wax and mixing formulas requiring a heat source.

Torch

This gas-powered tool with a nozzle for opening and closing the fuel supply is used to direct a flame to any spot where a very high temperature is needed. You can use a torch to heat metal molds quickly before applying a commercial separator to them.

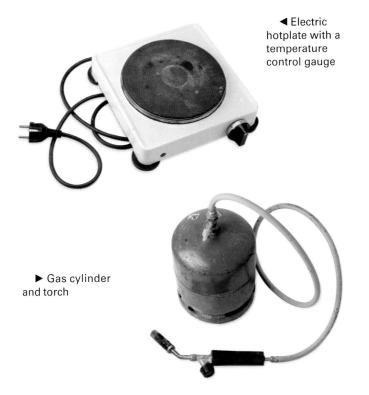

◀ Electric hotplate with a temperature control gauge

▶ Gas cylinder and torch

For Leveling

Levels

These tools have one or more tubes filled with liquid containing an air bubble that is centered in the tube when the level is perfectly horizontal. It's very useful to have several types of levels in the workshop; circular ones are ideal for getting small pieces perfectly level.

FLUORESCENCE
Ultraviolet Lamp
This fluorescent tube produces ultraviolet waves. UV radiation excites the fluorescence of materials, causing the emission of the received energy in the form of radiation of different wavelengths. Even though UV radiation is invisible, it's possible to observe the fluorescence of certain materials with the naked eye. UV lamps are used to determine which face of a piece of float glass contains tin that it was exposed to during the manufacturing process. This face will show fluorescence under the lamp. Always wear special goggles for UV radiation and gloves when using the lamp.

COMPATIBILITY ISSUES
Polarized Light Lamp
This lamp, equipped with a polarizing lens mounted in a cardboard or plastic frame, and a polarized diffusing lens, is similar to the ones used for photographic slides. It is used to observe and identify the internal stresses in materials, making it possible to observe the compatibility between different types of glass. The compatibility of any type of glass is determined by comparing it to the transparent base glass. If all of the different colors display similar stress to this glass, they should be compatible with one another.
To find this out, make a sample that contains the various types of glass to be used in a piece. Then set the sample on the lamp's polarizing diffusion lens, and place the other lens over the sample. Turn the upper polarizing lens slowly with a rotating motion until the greatest amount of visible light vanishes. If the sample is incompatible with the base glass, some very distinct dark, curvy shapes will appear, whereas compatible samples look homogenous. This test will also reveal possible color changes that might happen when you fuse the glass.

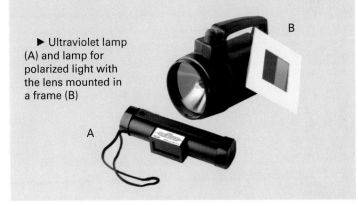

▶ Ultraviolet lamp (A) and lamp for polarized light with the lens mounted in a frame (B)

◀ Levels

Prefabricated Molds

Metal Molds

Wok

This mold for thermoforming gets its name from the cooking utensil. It has a nearly hemispherical shape and a flat base.

You can buy this wok made for thermoforming, or adapt a household wok by removing the handle. Then, use a drill with a bit for fine metals to make a series of four equidistant holes in the shape of a cross just above the flat base. Drill one more hole in the center of the base. These small holes allow any air remaining between the glass and the mold to escape, assuring that the glass will conform perfectly to the shape when it's in the kiln.

Ring

A ring is a mold that is used in a free fall. Metal molds are generally made of iron or stainless steel. The latter are of higher quality and don't rust with use, but they're more expensive. If you use an iron mold, make sure it is completely rust-free.

Ceramic Molds

These molds, used in thermoforming projects, are made of stable refractory ceramic materials that stand up to heat in the kiln. They're sold in a great variety of shapes and sizes.

Common forms include the ring or ellipse for free fall, and oval, circular, and curved molds for thermoforming.

They have a fine, smooth, homogenous surface that takes the kiln wash uniformly. Under normal conditions, they don't crack, and if they're handled correctly, they don't break, which means they can be used in the workshop for a long time. Once you've used a ceramic mold, remove the kiln wash, and be sure the mold is perfectly clean before storing it.

► Various shapes of prefabricated ceramic molds

◄▼ Different types of ceramic molds

◄ A household wok (A) and one that's been adapted for thermoforming (B)

A

B

Kilns (or Ovens)

The kiln is the most important piece of workshop equipment. Kilns used for working with glass are the same as those used for ceramics, but they are seldom used at temperatures above 1800°F (982°C).

A kiln has a metal structure enclosing a fire chamber made of ceramic fibers that provide great thermal stability and insulation. This chamber is in turn enclosed in metal and insulated. Inside the heat chamber, elements arranged inside translucent quartz tubes serve as supports. These increase the heat radiation and are easily replaceable.

The kiln's elements must be arranged to assure even heat distribution. Electrical current passing through the elements produces heat that is transmitted to the chamber's interior and ceramic lining by conduction and radiation.

"Trunk-type" electric kilns have a top that lifts up completely, and other kilns open in the front. Electric kilns require proper maintenance; for example, the elements need to be changed occasionally, and, as in all work involving glass, using a kiln requires extra attention on your part.

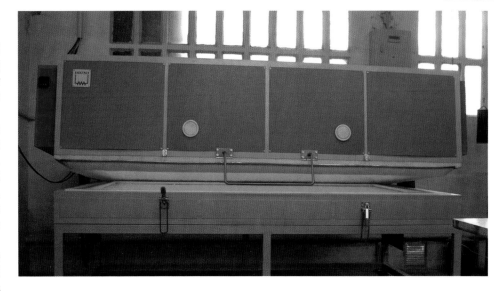

Gas kilns, sometimes but not often used for glass work, require a greater infrastructure than plug-in electric ones with respect to output, elimination of gases, and fuel cylinder storage. In addition, they require special precautions to avoid gas leaks and explosions.

▲ "Trunk-type" electric kiln

▼ Front-opening electric kiln with heating elements on the back wall, sidewalls, base, and door

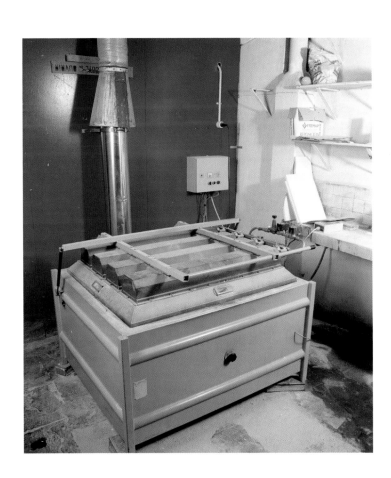

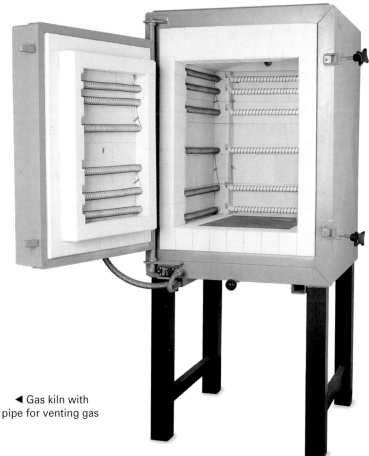

◄ Gas kiln with pipe for venting gas

▲ Digital temperature programmer

Supports and Shelves

These items are used to arrange and support pieces inside the kiln. Made of refractory materials with a high heat-resistance, supports can be hollow cylinders or dense bricks. The bricks are made of refractory material, and they take longer to heat up than ones made of more porous material; however, they can also support more weight.

Shelves are used to hold the glass. They should be prepared with kiln wash if they'll be in contact with glass. Cordierite shelves withstand temperatures up to 2160°F (1182°C).

Sandblasting Equipment

Sandblasting was invented in 1870 by B. Tilghman, who took his inspiration from the effects caused by sand on the windowpanes of houses on the North American plains.

Used for finishing and decorating glass, sandblasting equipment propels very fine powder and compressed air, creating an abrasive effect that can be used to dull or even pierce glass.

A sandblaster typically consists of a closed, hermetically sealed cabinet equipped with an air gun that propels the abrasive, a vacuum system to remove particles, and a mechanism to collect the excess abrasive at the bottom. The cabinet is lighted. The vacuum system is similar to a household one: the air is filtered, the particles are left behind in a container, and clean air is released. The top of the cabinet has a large window so you can see inside. Just beneath this window is an opening for your hands. The door to the cabinet is located on one side, and takes up the entire side so it can be opened up wide enough for large objects.

▶ Pyrometric cones before firing (A) and bent after reaching the target temperature (B)

Digital Temperature Programmer

This piece of equipment measures and programs the kiln's temperature cycle, making it possible to perform the firing curve in a totally automatic fashion by increasing, decreasing, and maintaining the temperature.

Pyrometric Cones

Cones, used mainly for the process of firing ceramics, are pyramid-shaped ceramic pieces designed to sag at specific temperatures. They're used less to verify the temperature inside the kiln than to locate areas in the heat chamber where the temperature varies from the overall temperature of the chamber. Each cone is numbered on one of its faces according to the temperature at which it folds. In Europe, Seger cones are used; in America, Orton cones. Tables that correlate cone numbers with sagging at certain temperatures are available for both types of cones.

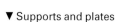

▼ Supports and plates

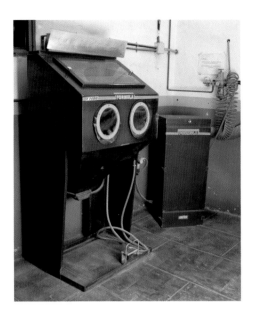

▲ Sandblasting setup

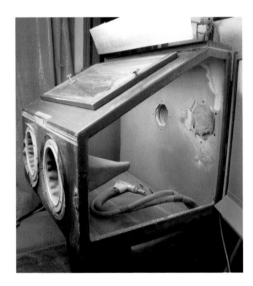

▲ Interior of the sandblasting cabinet, where the air gun is visible

▼ Aluminum oxide abrasives: 70-grit (A) and 120-grit (B)

A

B

► A sandblasting machine and its component parts

In one type of sandblaster, the gun that sprays the abrasive is connected with a hose to a compressor. The injection system used to spray the abrasive uses suction or pressure. Generally speaking, the suction system involves a flow of compressed air delivered by a hose from a compressor. As the air passes through the air gun, it propels the abrasive particles at high speed. This system is economical but requires a powerful compressor.

Another sandblasting system, one that uses pressure, involves directing part of the compressed air right into the reservoir that contains the abrasive. That way, the air is used more efficiently, and it's possible to control the flow of abrasive by means of a mixing valve. This system is more costly, but it is very efficient and makes it possible to work more quickly. In a humid climate, a filter is needed to remove moisture from the compressed air.

Some sandblasters have a pedal located between the legs of the cabinet to start the air flow. This makes it possible to control the machine with your foot, leaving your hands free for work.

Before sandblasting begins, close the side door, and when the job is done, wait at least a minute before opening the cabinet to be sure all the dust has been sucked out. The abrasive deposited in the lower part of the cabinet can be reused.

▲ Use special gloves to protect your hands while using a sandblaster.

Abrasive

The most commonly used abrasive is aluminum oxide (also referred to as alumina or corundum), which is sold in different grits. The finer grits are most commonly used; for example, number 70, with particles measuring from .005 to .010 inches (0.12 to 0.25 mm), and number 120, with particles of .002 to .005 inches (0.06 to 0.12 mm).

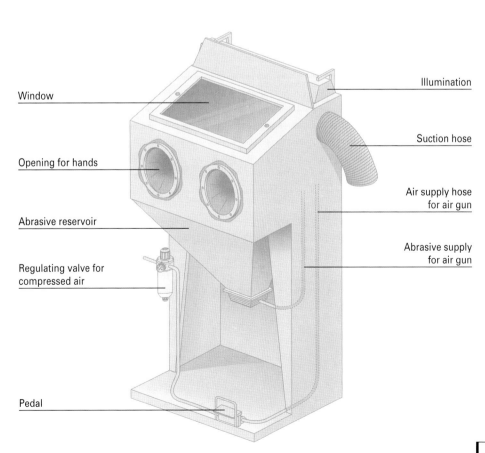

Window

Opening for hands

Abrasive reservoir

Regulating valve for compressed air

Pedal

Illumination

Suction hose

Air supply hose for air gun

Abrasive supply for air gun

Auxiliary Tools

For Cutting

Mat Knife

Use this knife to make precise cuts. As the blade becomes dull, it can be discarded and replaced with a sharp blade.

Scalpel or Hobby Knife

A scalpel or a hobby knife is ideal for making very precise, clean, and deep cuts. It's comprised of a steel blade mounted in a handle of the same material. Some knives have a handle and blade made up of a single piece, while others have replaceable blades.

For Applying and Pressing

Artist's Brushes

The bristles of these brushes work well for applying products such as separators.

Paintbrushes

These common brushes from a home-supply store can be used to apply products on broad surfaces, particularly commercial separator on molds and plates.

Spray Bottle

Mix water and clay in this bottle when making models or putting pâte de verre into the mold.

Mortar and Pestle

Use a mortar and pestle to grind up glass to a very fine consistency. You can also use the pestle to press pâte de verre into all sections of the mold.

▲ Artist's brushes and common household brushes

For Sifting

Sieves

Sieves are also known as screens or sifters, and they are made up of a frame, usually wood, with a wire mesh bottom. They're used to separate glass particles or pieces of different sizes. It's a good idea to have sieves with different mesh sizes in the workshop.

You can make your own sieve by nailing four strips of wood together to form a frame or stretcher before nailing a piece of wire mesh tightly in place along the frame's edges.

Strainer

A metal household strainer is very useful for sifting tiny fragments and separating the small grains of glass dust.

▲ Scalpel and mat knife

◄ Porcelain mortar and pestle

▼ Spray bottle

◄ Sieves with various meshes and a household strainer

For Weighing and Measuring

Scale

A mechanical or digital scale is used to weigh the glass before placing it in the mold. A mechanical scale will suffice for most of your needs, but a digital one is more accurate.

Measuring Cups

Use a measuring cup to determine the capacity of a mold by pouring measured amounts of water into the mold until it's full. If there's water left in the cup, subtract that leftover amount from the total to give you the mold's internal volume.

Measuring Tools

Tools such as a tape measure, triangle, and metal ruler can be used to make precise measurements and draw straight lines.

For Mixing

Containers

You'll need several containers in your workshop: large-capacity buckets for preparing the mixes for the molds, wide buckets for cleaning the glass, and small containers for preparing and using small quantities of materials such as kiln wash.

For Striking and Removing from the Mold

Hammer

A hammer with a steel head and a wooden handle is used for striking and nailing, and generally for all jobs that can't be done with the force of your hands alone. It works well for breaking up chunks and slabs of glass.

Chisel

This tool with a double-beveled straight steel blade is usually used when working with stone or metal. In the glass workshop, it's useful as an auxiliary tool for removing pieces from molds.

Putty Knife or Scraper

This can also be used as an auxiliary tool for taking pieces out of the mold or for smoothing the surface of the clay in originals.

▲ Chisel (A), scraper or putty knife (B), and hammer (C)

For Cleaning

Scrub Brush

A brush with strong, thick plastic bristles is good to have on hand for sweeping up the small fragments and splinters of glass remaining on the cutting table.

Tablecloth Sweeper

To pick up smaller particles of glass, use this brush that picks up debris as it turns and deposits it inside a receptacle.

▲ Measuring cup and mechanical scale

▲ Tape measure (A), triangle (B), and metal ruler (C)

▶ Containers: large-capacity buckets for mixing the ingredients needed to make molds

▲ Scrub brush and table

Workshop Safety and Organization

Safety

Safety is an important aspect of working with glass, and it must be respected at all times. At all phases of production, protecting yourself should be your first priority, especially when it comes to using, storing, and disposing of hazardous materials.

The workshop must be equipped with fire extinguishers, according to your fire marshal's regulations. Make sure they're clearly marked and placed where they're easy to find and use in an emergency. Remember to check them periodically. Keep a first-aid kit in an accessible place, and post emergency numbers in plain view next to the phone.

Keep technical and safety sheets that apply to any hazardous materials in the workshop so they can be consulted if you're in doubt about something or there's an emergency. Make sure that any others in the workshop are familiar with the danger symbols marking hazardous materials and what they mean, as well as precautions to be followed when using them.

Protection

Personal protection is, of course, the main feature of safety in the glass workshop. Because you'll be using hazardous products, you'll need to wear a respirator to avoid inhaling particles and toxic vapors. There are different types of masks, both disposable and with replaceable filters. Always use approved masks that are within the effectiveness date indicated by the manufacturer on the box or wrapping. Never manipulate a filter to lengthen its usage time. When harmful powdered or gaseous products are handled, the proper mask and safety gloves and goggles must be worn. It's also a good idea to wear work clothes to change out of at the end of the workday. Also, when you work with a kiln or handle hot pieces, you must wear special fire-retardant gloves. Wear glasses with appropriate filtered lenses whenever you need to look inside of the kiln.

Suction cups that attach directly to the surface of large plates of glass make handling easier and safer.

Product Storage

Keep hazardous products in a separate place in the workshop—preferably, in a locked cabinet or closet. Naturally, you must store flammable products far from any heat source. Store powdered materials as close as possible to the spot where they'll be used, so you won't need to carry them far.

▲ Splinters of glass remaining on the cutting table are swept up with a stiff plastic bristle brush and collected in a container.

▲ The workshop must have a well-stocked first-aid kit, located in a visible, easy-to-reach location.

▲ Dust mask

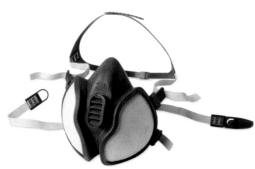

▲ Respirator with disposable filters

▼ Safety equipment: suction cup for handling and carrying large plates of glass (A); kiln gloves (B); latex gloves (C); glasses with appropriate filtered lenses (D); and safety goggles (E)

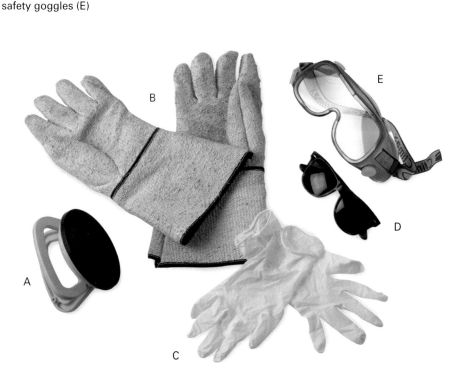

Organizing the Workshop

It's preferable for a glass workshop to be located on the ground floor with easy access to the street. The space must be well ventilated with good air circulation and be large enough that you can work comfortably and have space to store products and materials.

A workshop should have natural light as well as adequate artificial light. It's important that all workstations are well lit, with extra lighting available for precision work. Your worktables must be large enough to accommodate large pieces and tall enough to allow you to work while standing. The tops used for cutting should be covered in felt or another cushiony fabric.

The workshop needs a separate electrical box for the kiln, equipped with automatic circuit breakers that are activated in case of overload. All areas of the workshop need adequate wall outlets. The oven has to be located near the work surfaces, and yet it also needs to be isolated from any combustible materials.

Glass plates can be stored in wide, deep shelves, but they shouldn't stick out very far. Shelves built for such a purpose are very useful, since they make it easier to arrange, locate, and handle the glass.

Hazardous materials, as already explained, should be stored separately, far removed from the work areas. Clean your tools after each use, and store them in a visible and accessible location. It's also a good idea to have a separate area for storing completed pieces.

▶ A workshop with wide, deep shelves for storing glass

▼ Work surfaces must be large, and there must be enough space in the workshop to allow everyone to move around safely.

This chapter introduces concepts that you should understand in order to work successfully with glass. The first section gives you basic information that anyone interested in working with glass should know. In a scientific but practical fashion, you'll explore the concept of compatibility, the characteristics and behavior of glass, and the basic theories of firing. Once you fully understand these concepts that affect your results, you can adapt this knowledge to your daily work. This information is basic for comprehending the different techniques described in this book, so read it carefully.

In the second part of the chapter, you'll learn about general considerations such as cleanliness, cutting glass, and making prototypes and molds.

Preliminary
Considerations

Compatibility

Compatibility is the first concept that you need to understand when you begin working with glass. It's essential for carrying out the work, but it can be confusing at first. If you take the time to understand it from the start, you'll be paid back by the success of your work.

The concept of compatibility is based on the behavior of two or more types of glass when they're placed in contact with each other and heated. Glasses are compatible if there are no internal tensions that can cause the parts to separate, or the item to crack and fracture after the firing cycle. Thus, compatibility can be thought of as the property of two kinds of glass when they're combined. Some types are compatible and others aren't.

Traditionally, compatibility was defined by its coefficient of expansion. This idea is too simplistic, however, since viscosity is another factor.

Coefficient of Expansion

The coefficient of expansion is the number that expresses the percentage of expansion in glass in relationship to temperature. It's determined by the dimensional change that the glass undergoes for each increase in temperature. The greater the coefficient of expansion, the more the glass expands.

This coefficient is determined by means of laboratory tests or mathematical calculations. Tests allow the measurement of expansion at temperatures between 32 and 572°F (0 and 300°C). Unfortunately, no measuring can be done above the highest temperature, which is always exceeded by a wide margin in any technique used. In contrast, the coefficient arrived at by mathematical calculation is based on factors that go into the formula for the glass; but it doesn't take into account such parameters as variations in the materials, the fusing, and the percentage of oxide in the colorings.

Viscosity

Viscosity is a characteristic peculiar to fluids, especially liquids. It is the resistance the fluid offers to the relative movement of its particles (molecules). This property is directly related to temperature and varies with it. In general, the viscosity in liquids increases as their temperature decreases. So, if you begin with cool glass and increase the temperature, its viscosity decreases; that is, the molecules move and displace more. At room temperature, the molecules practically lose movement, and, because of this, they never find the right orientation for making a crystalline solid. They maintain an amorphous structure of a super-cooled liquid.

▲ In this photo, you can clearly see the tensions produced by the incompatibility between two kinds of glass. Numerous cracks can lead to breaking.

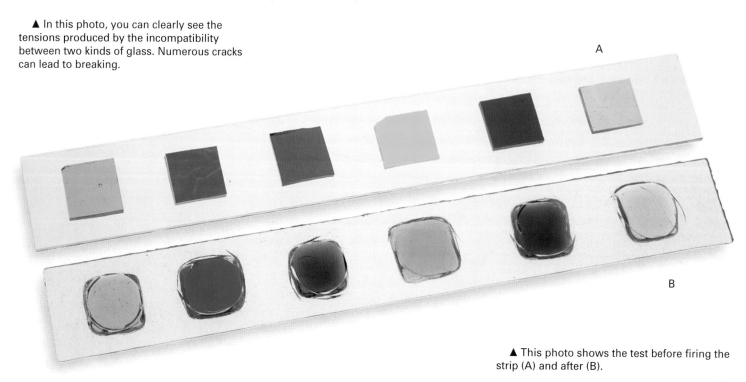

A

B

▲ This photo shows the test before firing the strip (A) and after (B).

Glass Compatibility

As you've already learned, two types of glass are *considered* to be compatible if they have the same coefficient of expansion, i.e, if they expand and contract simultaneously with one another. However, this statement is incomplete. Compatibility, understood as the ability of two or more types of glass to join together, depends on the two parameters explained earlier.

The coefficient of expansion is the main factor that affects compatibility during the first part of the firing program, from room temperature up to the tensile stress point. Viscosity affects compatibility from the tensile stress point up to the tempering point. Thus, differences in viscosity affect compatibility, since one type of glass can be less viscous than the other, and tensions will be produced between them during the tempering phase.

▲ Detail of an object containing inclusions. Note the crack in the left side of the green glass. This cracking was caused by the incompatibility between the fragment of green glass used to make the inclusion and the transparent glass. In this case, the incompatibility affects and compromises the integrity of the piece.

▲ Here you can see a very pronounced incompatibility between the two types of glass. The photograph shows the fracture lines caused by the internal stresses between the float glass (transparent) and the green glass.

In fact, in general terms, compatibility is the union of these parameters by means of a combination of compensation for error. In order for types of glass with different viscosities to be compatible, their coefficients of expansion must be different. Two different types of glass will be compatible if the stresses produced by the changes in viscosity are offset by the tensions generated by the changes in expansion. In other words, if the tension that exists between the two types of glass because of their different viscosities and the compression produced by the expansion have the same value, the two stresses cancel each other out. This explains why different kinds of glass with very dissimilar parameters are compatible.

The firing cycle is just as important as the compatibility of the types of glass. For firing, you must take into account the quantity of glass and the different phases of heating and cooling. Different sheets of glass can also have varying characteristics that affect compatibility.

◀ Samples are checked using a polarized light lamp. In this case, you see a large halo around the blue piece that reveals considerable internal stresses; thus, the samples are incompatible.

Compatibility Test

So, it's now easy to understand why the only reliable way to check the compatibility of any combination involving different types of glass is by doing a test in the workshop. This test serves to verify the compatibility or incompatibility of glass combinations, since you'll be subjecting them to conditions similar to the ones used to produce the piece. This system makes it possible to conduct several tests at the same time, and it also serves to check for possible chromatic changes in the glass as a result of firing. Its only disadvantage is that it can only be used with colored glass on transparent glass.

To conduct a compatibility test, cut out a strip of float glass (referred to as window glass) or some other type of glass about 1 inch wide (2.5 cm) and 6 to 8 inches long (15.2 to 20.3 cm). On this strip, arrange squares of different kinds of glass to test them, separated by about ¾ inch (1.9 cm). Next, place them in the kiln and raise the temperature to 1525-1550°F (830 to 843°C), followed by a maintenance cooling for 15 minutes at 975 to 985°F (525 to 530°C). Once the firing is complete, and the glass has cooled down to room temperature, it's possible to use a polarized light lamp to see internal stresses in the different glasses.

Characteristics and Behavior of Glass

The behavior of glass is defined by its particular physical characteristics, which are defined in turn by its molecular arrangement. Its structure as an amorphous solid determines its behavior in the face of heating and cooling. Understanding glass behavior makes it possible to comprehend the complexity of any firing program.

Fusion Point

A substance in a liquid state is characterized by the mobility of its molecules, which move around in a disorganized pattern, allowing the liquid to flow and adapt to a container's shape. As this liquid cools down, the forces of attraction between the molecules decrease until, at a certain temperature, they are immobilized in fixed, definite positions. These repeat regularly throughout the entire mass, making up crystallized networks. In other words, the substance reaches a solid state characterized by its rigidity. The temperature at which this transformation from liquid to solid state occurs is called the fusion point, which differs for every pure substance.

With most substances (other than glass), the mobility of the molecules at the fusion temperature is high enough (with low viscosity) to permit a molecular grouping that produces a crystalline structure. This passage from solid to liquid state (or the inverse) occurs suddenly during fusion.

However, when glass is heated, it softens and becomes fluid in a progressive fashion, without changing suddenly. The molecules move around freely, allowing the glass to flow. As the melted glass cools, the molecular mobility gradually decreases, and the molecules become fixed in a disorganized pattern (amorphous structure).

Viscosity curves

Viscosity log (poises) vs. Temperature (°C)*

- Stress point
- Annealing point
- Softening point
- Working point

Lead glass · Sodium-calcium glass · Borosilicate glass
Hard lime glass · 96% silica glass · Melted silica glass

▲ Viscosity curves of various kinds of glass

* See conversion chart on page 158 for Fahrenheit.

Viscosity as a Function of Temperature

As you just learned, one of the identifying parameters of a substance is its fusion point. Since this is indefinite in glass, we must determine its viscosity (describe its behavior with respect to temperature). As the viscosity of a liquid becomes greater, its resistance to flow increases as well.

In glass, the passage from a solid to liquid state occurs subtly, and the viscosity varies continuously, producing a very gentle relation curve between viscosity and temperature. The higher the temperature, the less the viscosity of the glass; that is, the more fluid it is. In other words, an increase in temperature produces more movement in the molecules, reducing the resistance the fluid offers with respect to its particles.

Since glass has no fusion point, it maintains its homogeneity when it cools down and hardens. If it cools slowly enough, crystals from the still-liquid mass begin to separate. This is the point of devitrification, which will be explained in depth later.

▼ As glass is heated, it becomes liquid and can be poured into a mold for casting.

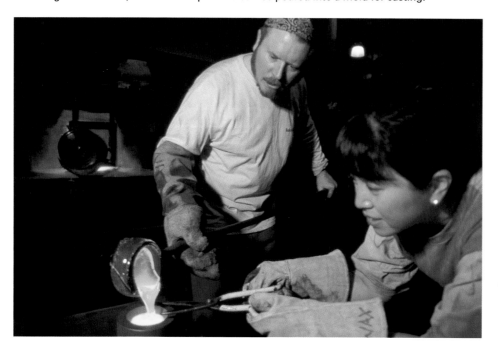

◀ The surface of this object shows devitrification. Note the dull appearance of the glass caused by the formation of crystals on the surface.

▼ Glass is broken or "cut" by means of fracturing. Once a line is marked off, the break can be made by applying force with breaking pliers, as shown here.

Isotropy

When glass cools down, the molecular movement decreases. Even though the molecules have a tendency to line up, they remain fixed in an organized pattern when the material becomes rigid. The result is a solid with molecular distribution similar to a liquid. The physical properties of glass are independent of the direction of the molecules.

Glass is isotropic (with a quality proper to liquids); i.e., the action that occurs at one point of its mass is transmitted in all directions.

Mechanical Resistance

Glass is a solid with mechanical properties that make it similar to crystalline solids. It is neither ductile nor malleable and isn't permanently distorted by force. Once the limit of its strength is reached, it fractures. Glass always breaks as the result of traction rather than by compression.

Glass can break as the result of a thermal spike—temperature shock in response to sudden cooling or heating. The break is not the result of a sudden change in temperature, but rather the mechanical traction force caused by the thermal spike. In other words, the break is due to the unequal contractions and expansions that this change produces in the glass. The property of resistance to thermal spikes is referred to as thermal resistance; it depends on various factors such as resistance to traction, the coefficient of expansion, and the thickness of the glass.

▶ This glass broke as a result of the mechanical traction force caused by a thermal spike. The unequal nature of the contraction and expansion produced many breaks that affected the integrity of the glass.

Firing Glass

Glass has certain physical characteristics that make an interesting but challenging material with which to work. To work with it, you must deal with the inherent complexities of compatibility between the types of glass and the firing cycle.

Similar to the issue of compatibility, the firing cycle involves a series of features and steps that are detailed, even though they aren't difficult to understand if you know the peculiarities of the material. For any firing program, you must look at the theoretical basis for certain procedures. Without doing this, you'll have insoluble problems, for without the theoretical support, it's impossible to determine the causes and find appropriate solutions. This can thwart any new project. An understanding of the theoretical components of the firing cycle and temperature curve facilitates research and opens up the path to innovation.

The Firing Program

The firing program, no matter the technique you're using, always involves a series of previously established phases that are in turn defined by the special behavior of glass. The success of your work depends entirely on this program, making it essential to be totally familiar with it and understand each phase.

All firing programs are composed, generally speaking, of a sequence of heating phases followed by cooling phases. All of these phases proceed by increasing or decreasing the temperature during an established time period. Thus, a firing program is the result of the right combination of two parameters: temperature and time. If one of these isn't right, not only that phase but also the entire cycle will fail.

Next, we'll thoroughly explain each of the phases of an ideal firing program along with the theoretical bases that make it possible to understand such a complex process. Then, in the chapters that follow, we'll explain practical firing graphs for the techniques and exercises in this book.

Initial Heating

The first phase of the firing program consists of heating the glass from room temperature to a level slightly above the stress point (see below). The temperature curve must be increased gently but distinctly over time to avoid thermal shock caused by a sharp increase in temperature during a short time period (thermal spike). A gradual temperature increase serves to dry the molds, if you're using a technique that involves a drying step. During this phase, the glass is still solid, and it gradually becomes more fluid once the stress point is exceeded.

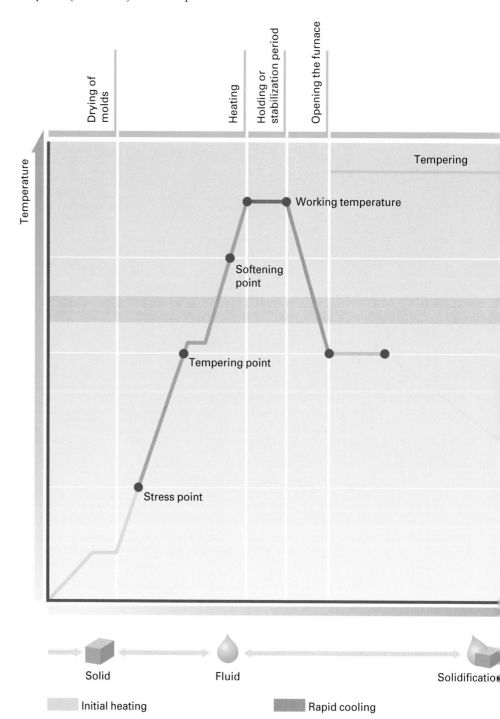

► Graphic representation of a theoretical, ideal firing program. Note the temperature curve, the firing phases, the temperatures, and the devitrification range.

• **Stress point.** Up to this point, the glass is still rigid and solid with no stresses. The stress point is defined by the maximum and minimum temperatures that completely eliminate stress during heating and cooling. Its viscosity is at its highest for the entire cycle, around 1014.16 poises (a value that varies according to the type of glass).

Rapid Heating

The phase that follows the initial heating is carried out from a level that's higher than the stress point and up to the required working temperature. The working temperature depends on the technique you're using and the requirements of the object; for example, it's higher when you're making an object in a mold than it is when you're doing a full fusing. This phase has to be carried out quickly, increasing the temperature significantly over a short period of time, so that the curve of the parameters is as steep as possible. Around the middle of the curve, you can briefly monitor the temperature to assist in properly forming the second part of the curve, which has to be as steep as possible. Stabilization assures the rapid temperature increase in the kiln to avoid undesirable devitrification. In fact, passing through the devitrification range must be done as quickly as possible. In this phase, the glass becomes increasingly fluid. Once the desired working temperature is reached, the glass is briefly stabilized.

• **Softening point.** The softening point is the temperature at which the glass quickly and visibly distorts under its own weight and sticks to other surfaces. The viscosity of the material at this point has decreased significantly (107.65 poises, depending on the glass), increasing the fluidity.

• **Working temperature.** This temperature (the working point) makes it possible to shape the glass. The viscosity of the glass is at its lowest point in the cycle, around 104 poises (a value that varies as a function of the glass).

Rapid Cooling

Once the heating is complete, the cooling phases begin. The first is quick cooling. In this phase, glass is cooled so that the working temperature is lowered toward the annealing point. Carried out quickly by opening the kiln until the annealing point is reached, this phase produces a graph of parameters that is as vertical as possible. As in the previous phase, the glass passes through the devitrification range, so the temperature reduction must be as rapid as possible.

• **Annealing point.** This point, also known as the tempering point, is the temperature at which the internal stresses in the glass are eliminated by stabilizing the material at that temperature over a certain period of time (maintenance cooling). The viscosity of the glass is 1013.14 poises (which varies according to the glass).

Once the annealing point is reached, tempering begins—the step that includes the last phases of the firing program, from maintenance cooling to the point at which the glass reaches room temperature. Annealing designates the two phases that include the cooling from the annealing point to the stress point.

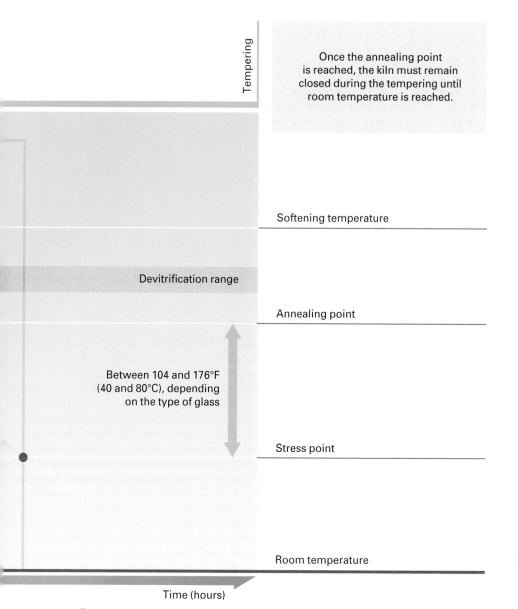

Tempering

Once the annealing point is reached, the kiln must remain closed during the tempering until room temperature is reached.

Softening temperature

Devitrification range

Annealing point

Between 104 and 176°F (40 and 80°C), depending on the type of glass

Stress point

Room temperature

Time (hours)

Solid

Controlled cooling

Cooling to room temperature

Maintenance Cooling

During this phase, the temperature of the glass (annealing temperature) is kept stable for a period of time to eliminate internal stresses. The temperature of the glass and the kiln stabilizes. The amount of time needed depends directly on the size of the glass.

When pieces are made with several types of glass, more time is needed because of the difference between the various annealing points. The greater the difference, the longer the time needed for the maintenance cooling.

Controlled Cooling

During this phase, the temperature of the kiln has to be reduced to allow the glass to cool from the annealing temperature or point to the stress point. As this happens, the glass gradually becomes less fluid (the viscosity increases), yet it doesn't have the consistency of a solid. The curve of the parameters must decrease gently and tend toward the horizontal. In addition, internal stresses are eliminated by slightly decreasing the temperature over a long time. If temperature reduction and timing are not handled correctly, internal stresses will appear in the glass once the firing cycle is over. These can cause the piece to crack, fracture, or be completely ruined.

TEMPERATURE		APPEARANCE	BEHAVIOR	FIRING PROGRAMS
Room temperature 1004°F (540°C)		Room temperature 1 glass (⅛ inch/3 mm): remains rigid, edges sharp, no visible change 2 glasses: (¼ inch/6 mm): no visible change 3 glasses (⅜ inch/9mm): no visible change	The glass may begin expansion and contraction movements. There is risk of thermal shock at temperatures under 810°F (450°C).	Some glass has stress and annealing points in this temperature range.
540°F (540°C) 1256°F (680°C)		At the highest temperature: 1 glass: the edges begin to soften and become round 2 glasses: they won't combine unless this phase is prolonged for the necessary time 3 glasses: similar to the previous case	The glass begins to soften, the viscosity gradually decreases, but the original shape is maintained.	This temperature range is the best for firing pieces with paint or enamels. Some types of glass may bend if they are kept at the highest temperature for the required time, or if they have weight on them.
1256°F (680°C) 1346°F (730°C)		1 glass: the edges round, the surface takes on a shiny appearance 2 glasses: similar appearance, the glasses begin to combine 3 glasses: similar to the previous case	The glass gradually passes from solid to liquid. During this phase it passes through the devitrification point or liquidus. If the glass stays too long in this temperature range, devitrification may occur.	The glasses combine and the surfaces stick to one another. During this time, what's known as fire polishing occurs, in which the surface wrinkles disappear. At the highest temperature the glass sags: Free fall Thermoforming Pate de verre
1346°F (730°C) 1400°F (760°C)		1 glass: contraction begins, the ends bend upward 2 glasses: the pieces combine, the upper edges become rounded, but the base remains stable 3 glasses: similar to the previous case	The surface tension of the glass exceeds gravity. If devitrification occurs and this phase is maintained long enough, devitrification may affect the entire piece.	The glasses combine and their edges become rounded: Partial fusion At the highest temperature: Inclusions

Cooling to Room Temperature

In the final phase of the cycle, the temperature goes down from the stress point to room temperature. During this period, the piece must not be subjected to thermal shock. The curve must be gentle, and not as long in duration as in the previous phase.

It's important to know that the curve of the firing cycle, i.e., the temperature and the time, always depends on the glass used. The stress, annealing, and tempering points will vary considerably with the composition and manufacturer of the glass. Ask the manufacturer for a tech sheet containing those values.

Further factors on which the curve directly depends are the glass's quantity and thickness, the technique used, and the desired final result. Also, it's important to keep in mind the characteristics of the kiln, including its heating power and programming possibilities, as well as the kind and the location of the heating elements. All of these factors affect the heat distribution.

Finally, keep in mind that successive firing cycles produce a loss of fluxes and changes in viscosity. Thus the firing program and temperature will differ: In general, the heating time has to be increased up to the stress point, then the increase that follows will be very rapid as well as cooling down to the annealing point. Finally, the tempering point will be higher.

TEMPERATURE		APPEARANCE	BEHAVIOR	FIRING PROGRAMS
1400°F (760°C) 1508°F (820°C)		1 glass: the center of the piece becomes increasingly thin, while the perimeter becomes thicker and takes on a pointed profile 2 glasses: at the highest temperature, the pieces are completely joined 3 glasses: the glass surpasses its original form, unless it is inside a container	At the highest temperature, the surface tension of the glass begins to be less than the force of gravity. Any air trapped between the glasses or between the glass and the base starts to expand.	Total fusing Thermoforming Free fall
1508°C (820°C) 1598°F (870°C)		1 glass: the thin central part may rise up from the surface of the base 2 glasses: the surface becomes smooth and liquid, and bubbles trapped inside may rise to the surface 3 glasses: unless inside a container, the glass flows until it reaches a thickness of approx. ¼ inch (6 mm)	Viscosity gradually decreases The glass may take shape due to the force of gravity.	Total fusing Inclusions Glass casting: at the highest temperature, the glass is fluid enough to fill in small details in the mold. Glass paste
1598°F (870°C) 1706°F (930°C)		1 glass: possible formation of bubbles, which form craters 2 and 3 glasses: the glass flows like molasses. It must be in a container. If it is not level, the glass may overflow. The bubbles in the lower layers will cause the lower glass to rise to the surface.	Viscosity continually decreases, increasing fluidity of the glass	The glass is fluid enough to be bent using metal rods. Glass casting
Temperature over 1706°F (930°C)		1 glass: craters formed are completely open 2 and 3 glasses: the activity described in the previous phase continues	Viscosity continues to decrease	Casting by means of lost wax process

Devitrification

Devitrification results in the formation of crystals in glass, i.e., the molecules line up in crystal form. This happens when temperatures are kept high for a sufficiently long time. As a result of this process, transparent glass becomes cloudy and translucent, and opaque glass loses its shine. Devitrification can happen on the surface, creating a crystalline film that can be removed with abrasives, or it can affect the entire piece. In some cases, it can be very severe and cause partial separation or total destruction of a piece.

As we know, glass has particular properties that preserve its homogeneous nature during heating and cooling. But if heating and cooling occur slowly or in stages over a long enough period of time, a temperature is reached at which the crystals begin to separate from the fluid mass of glass. This temperature is called the devitrification or *liquidus* point. Since the firing cycle is a combination of temperature and time, devitrification can be avoided if the cooling proceeds more rapidly than the glass crystallizes.

The crystallization process is very slow because of the high viscosity of glass at this temperature. It becomes even slower and more difficult at lower temperatures. In fact, at room temperature, the crystallization or devitrification time is infinite.

▲ Two examples of total fusion. The photo shows the superficially devitrified glass in the colored areas. This phenomenon is most common in opaque glass.

▼ The complete devitrification of the float glass is evident in this sampling of inclusions. This problem affects the transparency of the object, and the result is a cloudy appearance.

▲ Example of surface devitrification

The devitrification temperature is different for every type of glass, and it indicates the temperature above which it is impossible for the glass to crystallize. Below that temperature, devitrification can occur over adequate time (if the curve is not too steep or vertical), and crystals with a composition that depends on the glass will separate. These crystals, which have a different structure than the mass, create stresses that can create cracking and breakage.

Aside from these parameters, external factors influence devitrification. Surface dirt on the glass is the main factor that contributes to it, although any dirt or residue inside the kiln during firing will give off vapors and can encourage this phenomenon.

Color Changes

As a result of firing, some types of glass change color or shade (known as striking). This phenomenon happens during firing or during the second annealing. The exposure of the glass to a certain temperature can change its color or opacity, which is characteristic of pink and red glass that turns to darker colors in the same spectrum after a second annealing. Sometimes this change is desirable, but striking can also result in unwanted effects, such as reds and oranges that turn to a dark brown when they're annealed.

▲ This photograph shows a very dramatic color change: a piece of pinkish-purple transparent glass turns dark red when annealed a second time.

◄ In other instances, color changes can produce undesired effects. The photograph shows the change from a piece of transparent red glass (like the sample shown), to a dark, opaque brown after annealing.

PROBLEM	CAUSE	EFFECTS	SOLUTIONS
Spider-web break	The glass contacted the plate at a spot where there was no firing separator.	Spider-web break that radiates outward from a specific point in the glass	Irreversible
	Reaction of certain red-colored glass components (selenium, cadmium, or both): when re-annealed they cause crystallization		
Thermal shock	Significant temperature increase in a short time. If the fired piece is composed of several layers, this usually occurs in the bottom piece of glass, usually between 572 and 752°F (300-400°C).	Fracture known as "pie-shaped": the glass breaks into several large, more or less triangular fragments originating at a central point	Reversible: cooling the furnace to the right temperature for a certain time allows the fragments to recombine Improper tempering
Improper tempering	The tempering point was not reached, and there was no proper maintenance cooling, or the controlled cooling was done too quickly, for example.	Straight-line fractures	Irreversible
		"S"-shaped fractures	
		Piece broken into three fragments with curved breaks	

Cleaning

Cleaning the glass, no matter how simple and obvious it may seem, is an initial step to take before beginning any procedure. Done before any technical procedure, it helps to counteract undesirable results.

Dirt on the glass, whether dust particles or greasy residue from your hands, contributes to surface devitrification. It's also necessary to eliminate particles and dust from ground glass used for pate de verre. Finally, certain materials used during firing commonly require a final cleaning.

Next, we'll show you some cleaning methods for different forms of glass. In all cases, the glass has to be dried thoroughly after cleaning.

Cleaning Flat Glass

Flat glass, regardless of its dimensions, must be cleaned on both sides, leaving no traces of particles, grease, or markings from felt-tip pens. You can use common household products for this purpose.

Alcohol or Vinegar

Clean the surface of glass with paper towels and alcohol or vinegar. Methyl alcohol is very effective in removing marks from felt-tip pens; however, it can leave a slight residue on the surface that can cause devitrification. Vinegar, on the other hand, leaves no residue and is harmless to humans and the environment.

Detergent

Liquid dish detergent also works well for cleaning glass. After using it, rinse the glass and let it dry. It's very practical for small fragments because they can be immersed in a basin of water and detergent, left for a few minutes, and then rinsed.

▲ Clean the glass on both sides by rubbing the surface with a paper towel moistened with vinegar or alcohol.

Cleaning Glass Before Melting It

Glass fragments used for melting are commonly dusty. To eliminate dust, wash them thoroughly, either under the faucet or by immersing them in water until the dust is gone.

▼ Clean glass by submerging it in water and detergent before rinsing it.

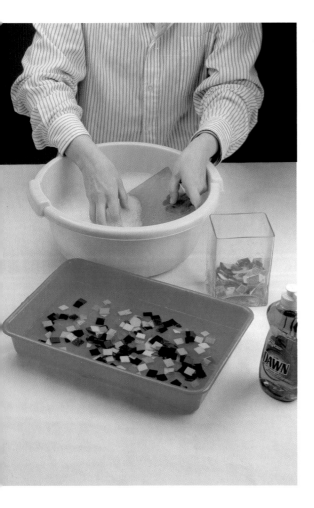

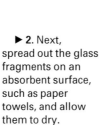

▶ **1.** You can cut yourself when handling shards of glass. To make the glass easier to handle during cleaning, use a plastic basket with holes on the sides and bottom. Next, submerge the tray in water to remove all dust. Sometimes, it's necessary to change the water several times to remove all the particles so that the water remains clean.

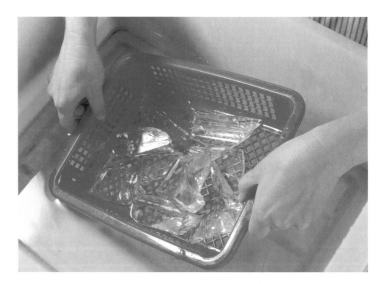

▶ **2.** Next, spread out the glass fragments on an absorbent surface, such as paper towels, and allow them to dry.

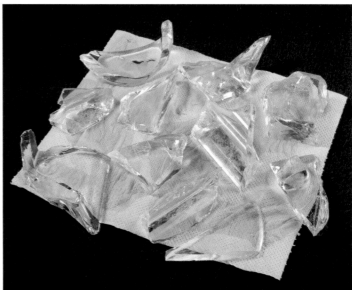

Cleaning Ground Glass

Because of the way ground glass or frit is made, it has to be cleaned in a very specific way. If you make your own ground glass using a steel mortar, use a magnet to remove iron particles that may be on the glass. Whether using ground glass purchased from a manufacturer or your own glass, it's essential to remove solid particles (dust) among the tiny granules.

◄ **1.** Use a magnet to separate out iron particles deposited from the mortar during grinding. Place the ground glass on a flat surface and go over it with a magnet, moving across the glass in all directions to make sure it comes in contact with all the granules. Gradually, small iron particles and splinters stick to the magnet, and sometimes it has to be cleaned off several times. The cleaning is finished when no more particles or dust cling to the magnet.

▼ **2.** Cleaning the dust from glass granules is done using decantation and water. First of all, place the glass in a container, add running water, and set it aside. As the photograph shows, the glass stays on the bottom of the container and the dust is suspended in the water.

▲ **4.** Repeat this process by adding and pouring off water until it looks perfectly clean and transparent.

► **3.** Next, remove the dirty water very carefully by pouring it off, taking special care with the glass.

Cleaning Fired Glass on Ceramic Fiber

Glass fired with ceramic fiber in any form needs to be cleaned after firing to avoid dispersing harmful particles. Immerse the piece in water so the particles aren't released into the air. Then remove the residue by rubbing the glass with a tool of some sort before placing it on absorbent, disposable paper towel.

▲ **1.** Once the piece is finished (in this instance a partial fusion with inclusions), submerge it in a container filled with water. Water encourages the fiber particles to stick to the glass, prevents dispersion, and facilitates the subsequent cleaning.

▲ **2.** To clean it, rub the surface of the glass with a sharp-edged broad implement (a cleaver in this instance) or a brush, to loosen the fibers. Then place it on a paper towel. Once the cleaning is finished, throw way the paper towel.

Cutting

Cutting is a basic skill that anyone who works with glass must master. Aside from other preparatory tasks such as project design and molds, cutting the material is the first step in your work. Before you adopt any of the techniques explained in this book, you must learn to do it properly. If you have some experience, you probably already know these steps well.

Glass has some mechanical features that make it similar to crystalline solids. Glass is actually cut by means of breaking or fracturing when it reaches the limit of its resistance. The cut is made by scoring the glass with a cutter, resulting in a line of weakness, which in turn creates a clean break when pressure is applied.

▼ To place a piece of glass on the cutting table, first rest it on the table's edge at an angle. Then lower the piece gradually toward the surface while sliding it forward.

Straight Cuts

Straight-line cuts shouldn't present problems if you're a beginner, since the use of a square and a cutter requires no special skill. You simply have to keep in mind that any cutting has to be planned out carefully; otherwise you'll probably waste glass.

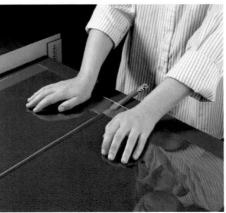

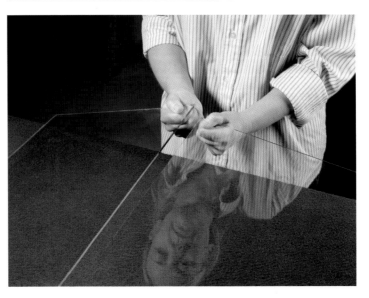

▼ 1. To cut the glass, measure it to the desired dimensions and position a metal square on it that's long enough for the entire cut. Add an extra inch (2.5 cm) to the dimension.

◄ 2. Once the square is positioned perfectly with the shorter leg aligned along the lower edge of the glass, set the longer leg on the desired measurement. Press the square down firmly on the glass with one hand while the other holds the cutter. Hold the cutter perpendicular to the surface, and move it along the glass with moderate force, using the square as a guide. Always begin the cut at the far end and draw the cutter toward you.

◄ 3. After scoring a line, the glass is fractured. This step can be done in several ways. One involves placing a small, hard, flat surface (such as the wood handle of a cutter) under the start of the marked line to lift up the glass a bit. Press both pieces gently so the glass breaks along the line.

◄ 4. You can also break the glass by hand. Hold it slightly above the cutting table, and press up on either side of the scoring line to break it.

Circular Cuts

Circular cuts are made with a cutting compass, a tool that's about as easy to use as a common compass. Sometimes you'll need to use lubricating oil to help scribe the scoring line on the glass. To cut circular shapes, trim the sheet to within an inch (2.5 cm) of the shape before beginning.

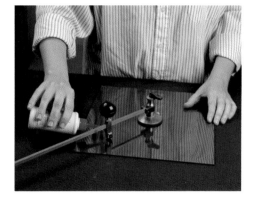

▲ 1. Place the cutting compass in the selected spot, with the suction cup in the exact location, locked into place. Next, set the cutting point at the desired length on the arm. Before beginning to mark the glass, apply a drop of lubricating oil to the cutting point.

◄ 2. Next, support the suction cup with one hand. Use the other hand to support the leg of the cutting point and move it around the complete circle. There's no need to apply excessive pressure to the cutting point. Next, turn the glass over so that the cut line is in contact with the top of the table.

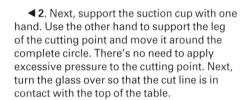

► 3. Break the glass by pressing with the thumb of one hand supported by the other, as shown. Turn the glass over again to its original position.

▲ 4. To remove the glass from the edges, mark slightly curved lines in the narrowest areas between the circle and the edges. These curved lines keep the breaking lines from interfering with the inside of the circular piece. Tap the underside (you can use the metal head of a cutter) to create the fracture.

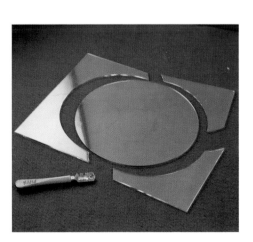

◄ 5. The sidepieces and circular piece once the cutting process is complete.

Cutting Inside Curves

Cutting curved shapes toward the inside of the glass takes more work, since such shapes require the creation of multiple weakness lines.

► This illustration shows how to cut a circular form that curves toward the inside of the glass. First of all, a cutter is used to mark off the shape of the desired cut. Next, a series of straight lines is made, as shown. The glass is broken by lightly tapping below the straight lines, and the fragments are removed until the desired shape is created. If it isn't possible to fracture the glass in this way, use breaking pliers.

Finishing the Cuts

Use an edge polisher to smooth the cut edges of the glass to remove sharp edges. Place the glass flat on the perforated base of the polisher, and the edge to be smoothed in contact with the grinding wheel, which spins at a high rate. You can also use sandpaper and water to smooth the edges.

▼ An edge polisher's grinding wheel is used to smooth the edges of cuts. The glass is supported by hand at the end opposite the grinding wheel.

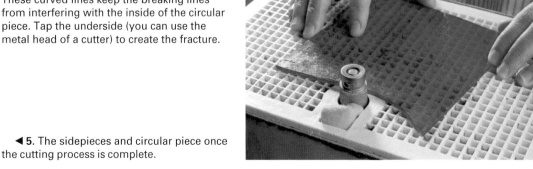

Prototypes and Molds

Even though you'll probably use prefabricated molds while learning to work with glass, you'll eventually want to create your own forms. Making prototypes and molds is another basic step that anyone who works with glass should know how to do, whether they're intended for one-of-a-kind pieces or mass production.

A prototype is an actual object or model that you'll replicate. A model can be unique, such as one done in wax that melts once the mold is made, or they can be made for mass production, as we'll explain later.

A mold imparts form to the glass through a firing process. The material is usually placed inside the mold, but sometimes the outside is used. Any object that can withstand the firing temperatures can be used as a mold, and that opens up many possibilities for experimentation. However, most of the time molds are based on the created shape or prototype. The formal possibilities, materials, and techniques used in making molds are extremely broad, so we'll cover the most practical aspects in this section, giving you the primary information you'll need.

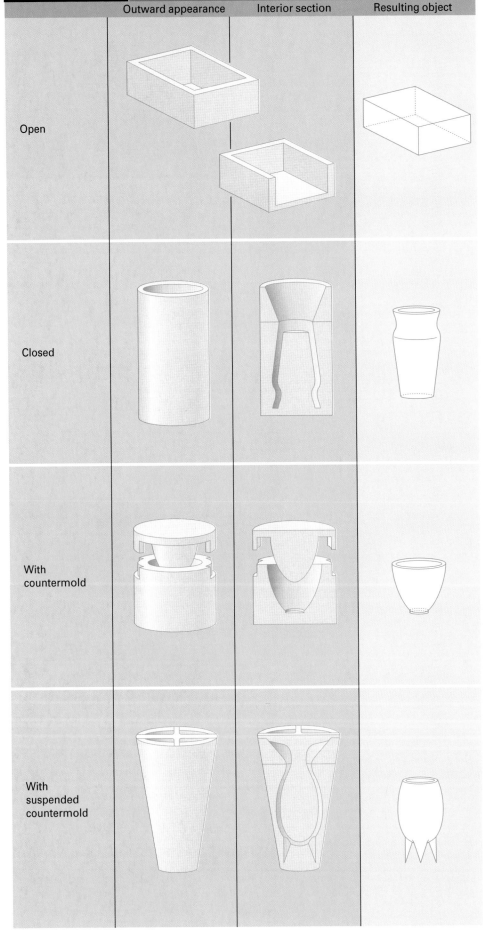

	Outward appearance	Interior section	Resulting object
Open			
Closed			
With countermold			
With suspended countermold			

Making a Prototype for Serial Production

In this section, we'll show you how to make a prototype based on an actual object. Here, we've used a mollusk shell from which we'll make a latex prototype for a series of pieces. In order to make this prototype, you must first make a primary mold directly from the object. This mold will subsequently be used for making the prototype.

▶ **1.** A mollusk shell is the basis for a prototype that will be used to make a series of pieces.

▼ **2.** Because the shell has an opening, you'll use clay to close the open area and build up a base that elevates the shell. For that purpose, place clay on the work surface and position the shell on it. Center it perfectly, keeping it straight and level. Smooth the clay's surface with a putty knife and a scraper.

▶ **3.** The clay, which is inserted in the shell's opening, is then rounded and angled out to widen at the base. Once the mold is made, this wider angle will make it easier to remove the original.

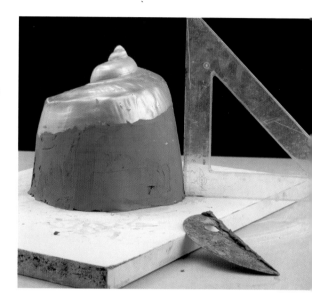

▼ **4.** Next, apply a coat of separator to the shell. (In this case, we used a thin layer of petroleum jelly dissolved in mineral spirits, and applied it with a brush. This guarantees that the mold of the prototype will reproduce the texture of the shell.)

▼ **5.** Use a sheet of thick plastic and wide packing tape to make an outer shell or container for making a mold. This container should leave room around the object without being excessively large, since there's no need to waste plaster. Next, prepare the plaster. Seal the lower edge of the container onto the base with a small amount of the mixture. First, apply it by hand, and then smooth it out with the spatula and allow it to set up.

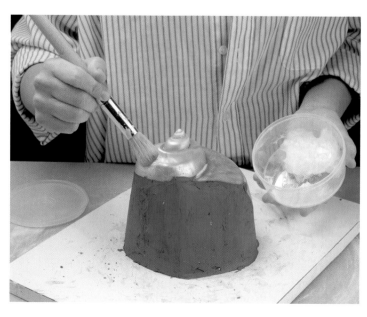

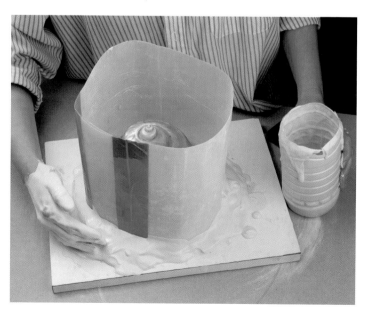

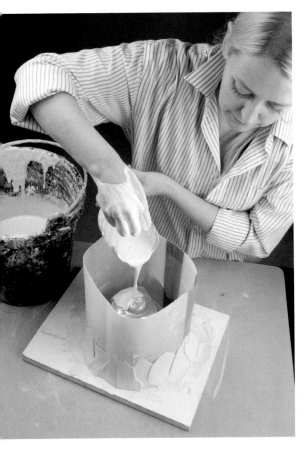

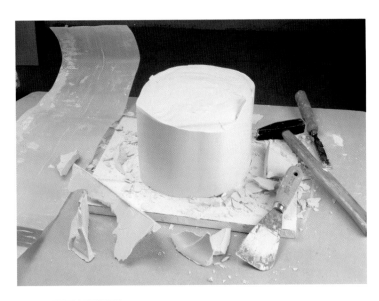

◄ **6.** Next, use a small container, such as a measuring cup, to pour the plaster over the shell. Spread it out evenly. Cover the top of it completely, making sure the mold is thick enough at the top. Agitate the mixture gently to make any bubbles rise to the top.

▲ **7.** Next use a chisel and hammer to remove the plaster base that held the plastic in place. Remove the plastic by peeling it away from the plaster (we used a putty knife).

► **8.** Turn the mold over and place it bottom-side up on the work surface. Use a wire loop tool to remove the clay that was used to close the bottom of the shell.

▼ **9.** The shape of the shell was reproduced perfectly in the plaster mold. (The leftover clay can be used for making other prototypes, but it must be kept slightly moist in a tightly closed plastic bag or allowed to dry out for recycling.)

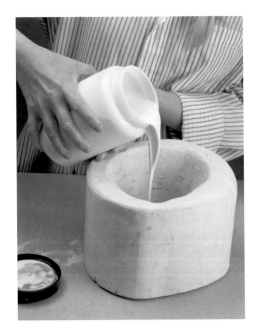

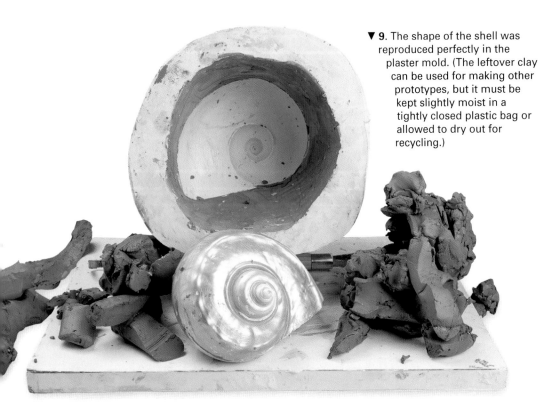

▲ **10.** In this step, you'll begin to work on the prototype itself that will make it possible to produce a serialized piece. In this instance, we're using latex for the prototype. To do this, place the mold perfectly level on the work surface. Then pour the latex directly from the jar into the mold until the shape to be reproduced is entirely covered.

◄ 11. Leave the latex in the mold until a film appears on the surface indicating that it has set up on the inner surface of the mold. Next, return the leftover latex to the container, and allow the interior of the mold to dry completely.

► 12. Remove the latex piece from the mold with the utmost care. You'll see that the prototype has perfectly reproduced the shape, textures, and characteristics of the shell.

SOME MATERIALS AND MIXES FOR MAKING ORIGINALS, PROTOTYPES, AND MOLDS		
Making originals and prototypes		
Clay		These are used to make originals to be used for molds for serializing in wax or making a silicone or latex prototype for one-of-a-kind pieces.
Molding wax (red)		
Expanded Polystyrene		These materials and some others can also be used for making originals.
Wood		
Metals		
Wax mixes for prototypes	2.2 lbs. (1000 g) bee's wax 12 oz. (300 g) paraffin 2.5 oz. (70 g) rosin	Used in series production. Once the mixture is melted it is poured into the mold and cooled with water to keep it from contracting.
	2.6 lbs. (1200 g) bee's wax 15 oz. (435 g) paraffin 7 oz. (200 g) rosin	
	If the mixture is prepared in a double boiler, first the pitch is added, then the paraffin, and finally the bee's wax.	
	If the mixture is prepared using direct heat, first the paraffin is heated, then the rosin, and finally the wax.	
Silicone		These are used to make prototypes for series production.
Latex		
Making molds		
Molds for thermoforming		Mix of 1:1 by volume of molding plaster and silica, i.e., one measure of molding plaster and the same volume of silica
Molds for cast glass		Mix of 1:1 by volume of molding plaster and silica
		Mix of 1:2 by volume of molding plaster and silica, i.e., one measure of plaster and two of silica
Molds for glass paste		Mix of 1:2 by volume of molding plaster and silica

In making molds it is possible to use material from other molds. Once the old mold is ground up, it is used as grog, one of the components of the new mold being made. In this case, the mixture would be 1:1:1 by volume, i.e., one measure of grog, one of molding plaster, and one of silica.

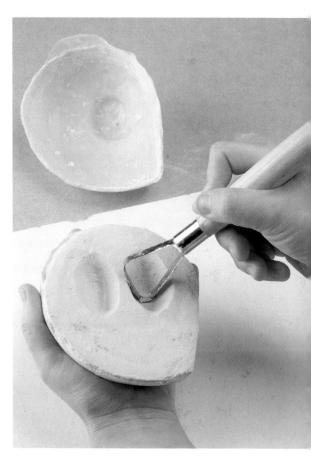

▲ 13. Since latex is an extremely flexible material, it is necessary to make a "base" to keep the prototype from distorting when the mold is made for the kiln. Therefore, place the latex piece back into its plaster mold, and pour newly made plaster inside it up to the top of the latex piece, but without spilling over. Once the plaster has set up, remove the base and latex prototype. Use a loop tool to dig out two holes to make it easier to handle the plaster piece later.

Making a Lost Mold

Molds must be able to withstand the entire firing program without crazing, cracking, or breaking. Their performance depends on both the materials and the mixture used, plus how they're made. One basic consideration is the thickness of the walls; they should be thick enough to support the glass inside the mold's cavity. They should also be as uniform as possible, so that heat is properly conveyed to the mass of glass. The thickness, dimensions, and parts of the mold depend directly on the item to be made.

In general, molds for large pieces are prepared in two layers, the first one having a thickness of just under an inch (2.5 cm). Once that's made, reinforce it by wrapping it tightly with chicken wire. The second layer of the mold, which is thinner than the first, is applied over this.

Next we'll show how to make a lost mold, which is called that because it has to be completely broken apart to remove the contents. We'll also explain one of the mixtures that can be used for this type of mold.

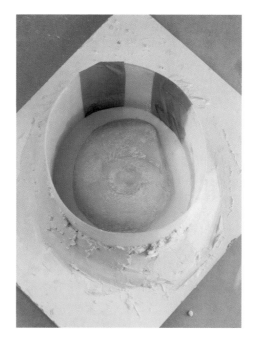

◀ **1.** First of all, place the latex prototype with a plaster base underneath it on the work surface. Following the procedure described in the previous section, construct a plastic framework and attach it to the work surface with plaster, centering the prototype perfectly inside it.

▶ **2.** Next, prepare the mixture for making the mold. Put water into a large bucket. The quantity of water is determined by the mold's size, so it has to be adequate for the purpose. Before you begin, put on a dust mask to protect yourself from the powdered silica, which is toxic. Add one measure of molding plaster per measure of powdered silica, sprinkling it in gradually by hand.

▼ **3.** Keep adding material until a little mound sticks up in the center. This indicates that the water is saturated with the mix, and that the proportions are correct. Allow the mixture to sit for two minutes before stirring.

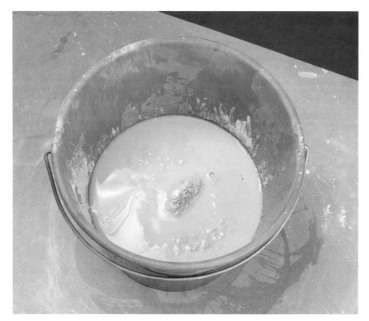

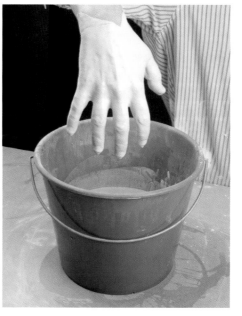

◀ **4.** Stir the mixture by hand to produce a homogenous liquid with a slightly creamy texture. The preparation is ready to use when it forms a thin, continuous film on your hand.

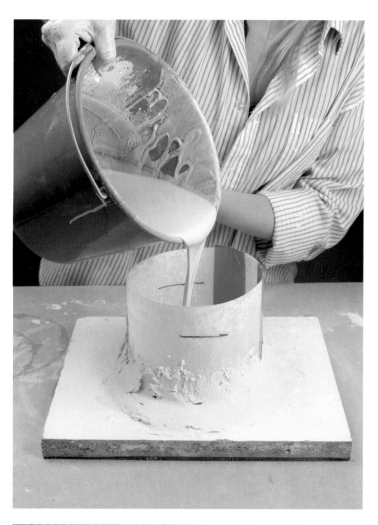

◄ 5. Next, continue as in the previous exercise; that is, pour the mixture over the prototype. Here, we've marked the plastic with a felt-tipped pen to indicate the proper level for the mixture. This assures you that the mold will have the correct dimensions, and the walls won't be too thin or thick. Stir the mixture gently with a couple of small strokes to force bubbles to the surface.

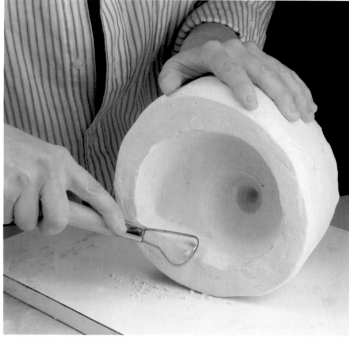

▲ 6. Once the mixture has set up and the plastic is removed, use a loop tool to widen the top of the mold. Doing this will help in pouring the glass into the mold and encourage proper fusion during the firing program.

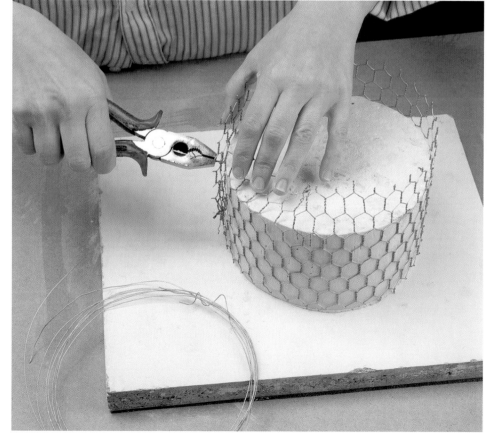

◄ 7. If you're dealing with a larger mold of moderate complexity, reinforce the outer walls with chicken wire to provide thermal stability and prevent breakage. Cut a section of wire that is wider than the mold so it can be folded over to partially cover the base and top. Wrap it around the mold, and secure it by joining the ends with wire. Finally, the outer wall of the mold is made (the second layer) using the remaining mixture.

This chapter explains the basic techniques used to make glass objects in a kiln—fusing, slumping, pâte de verre, and kiln casting. Each technique has specific procedures and a firing program that fits its needs. For each, you'll learn about theoretical as well as practical considerations, such as curves of the firing cycle, various techniques, and some finishing methods. The explanations are clearly written and illustrated to serve as a guide for any related project. We've placed special emphasis on the firing cycles, since they're the basis for all practice and provide a foundation for other projects. You'll also find explanations for potential problems and their solutions.

Technical
Procedures

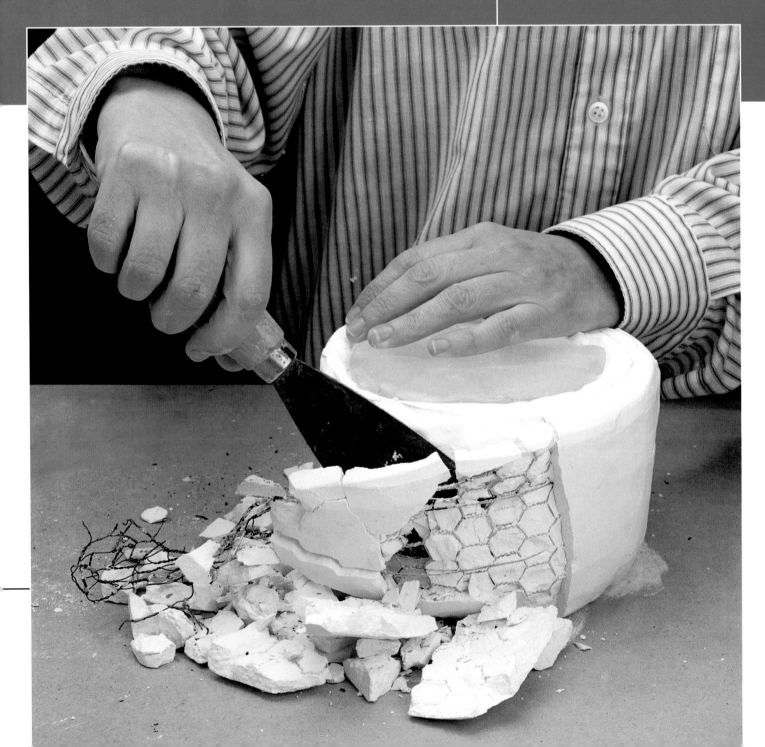

*F*using is the process of joining two or more kinds of glass through melting. It is a general term used to describe several techniques for creating flat objects by superimposing layers of glass. Tack fusing, full fusing, and adding inclusions are all fusing techniques. The main difference between tack fusing and full fusing is the operational temperature, which lends different results. Adding inclusions is the technique of laminating other materials between two pieces of glass.

Tack Fusing

Tack fusing is carried out at a lower temperature than other fusing techniques. Between 1316°F (713°C) and 1400°F (760°C), the glass is partially fused; i.e., various layers are combined and their edges and angles are rounded. Tack fusing differs from full fusing because the pieces don't amalgamate, and, consequently, retain their general shape. The glass pieces also stay in their original placement and retain the same thickness.

Next, we'll explain the ideal firing program for a kiln with heating elements in the top. After that, we'll show you how to make a piece using this technique.

Firing

As indicated above, firing for tack fusing is done at a working temperature of between 1316°F (713°C) and 1400°F (760°C).

The chart below shows the firing cycle for a piece with a 20-inch diameter (50.8 cm). It also explains some particulars of annealing ruby-colored glasses—a term that describes a variety of manufactured red glass, mostly made from mixes of cadmium and selenium, some of which may also contain a variable concentration of lead.

During the annealing of this glass, the controlled cooling time, i.e., the decrease in

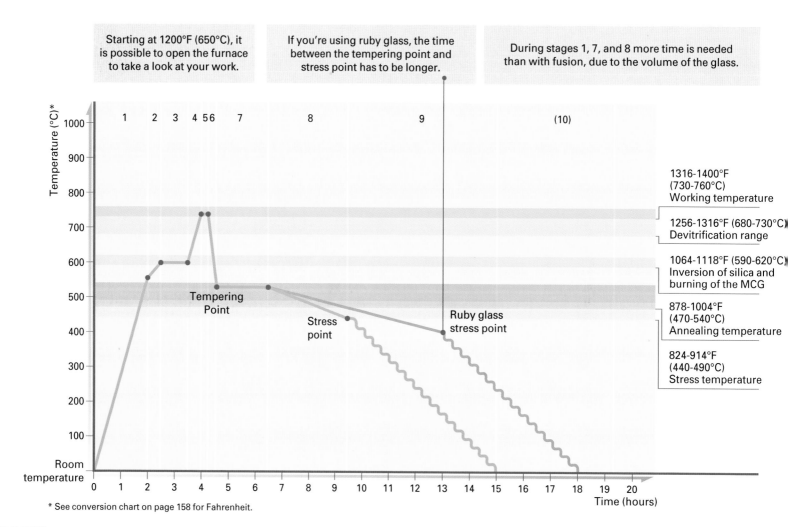

Starting at 1200°F (650°C), it is possible to open the furnace to take a look at your work.

If you're using ruby glass, the time between the tempering point and stress point has to be longer.

During stages 1, 7, and 8 more time is needed than with fusion, due to the volume of the glass.

* See conversion chart on page 158 for Fahrenheit.

temperature between the tempering point and stress point, has to be more gradual and thus takes longer than with other glasses.

Another important concept shown in the chart on the previous page with explanatory steps below is the phenomenon called quartz inversion. At 1094°F (590°C), the molecular structure of silica changes (and thus, the angles of the molecular bonds), moving from the alpha to beta phase. This phenomenon, which can happen in both directions, affects silica as a construction material for molds.

In the numbered explanation below, the third step, that of holding to stabilize the temperature inside the kiln, is unnecessary in the case of kilns equipped with perfect insulation.

Steps for tack fusing (1346 to 1400°F/730 to 760°C) for 1.5 layers of .117-inch (3 mm) glass with a 20-inch (50.8 cm) diameter, and an explanation of the vertical areas of the chart as indicated by the numbers at the top:

1. Initial heating until tempering point of the glass is exceeded

2. Slow increase

3. Holding phase to stabilize the temperature inside the kiln. At 1148°F (620°C) carbonization occurs, along with the resulting disappearance of the methyl-cellulose glue (MCG). In this phase, the quartz inversion used in the molds takes place.

4. Rapid heating: raising the temperature quickly to avoid devitrification. During this phase, it's important to check the kiln from time to time.

5. Working temperature, brief holding phase

6. Rapid temperature decrease to avoid devitrification: the kiln is opened and closed rapidly as many times as needed to reach 1010°F (543°C). If this procedure isn't followed, the heating elements could be damaged. It's appropriate to point out that certain types of kilns allow lowering the temperature efficiently without having to open them.

7. Maintenance cooling at annealing temperature

8. Controlled cooling: slow decline in temperature to the stress point

9. Cooling of kiln to room temperature

10. Cooling of kiln to room temperature, if using ruby glass

▶ Two similar pieces made using different techniques: tack fusing (A) and full fusing (B).

Heating Times and Maintenance Cooling with Respect to Size and Layers of Glass

The firing cycle for making a piece by tack fusing varies, obviously, according to the dimensions of the glass and the superimposed layers. In tack fusing, superimposing two layers is thought of as making up one and one-half layers (1.5, as indicated in the chart on this page). In certain areas of the piece, there will be two layers, but in other places there will only be the base glass. Thus, the various thicknesses make it necessary to increase the heating and annealing times. As a result of all of these variables, stacking three glasses is considered to result in 2.5 layers, while stacking four produces 3.5 layers.

Heating

The indicated temperatures for fusing go as high as 1004°F (540°C) for kilns with the heating elements located in the top and for projects in which window (float) glass isn't used.

For kilns equipped with heat sources on the sides, or on the top and sides, double the indicated heating time for pieces with a diameter up to 15¾ inches (40 cm). When working with even larger pieces, you'll need to triple the heating time.

If you use float glass, decrease the heating temperature by 25 percent (or what amounts to the same thing), or multiply the indicated time by 0.75.

Maintenance Cooling

The times shown below are valid for any kiln (regardless of whether the heat source is on the top or the sides) and for projects in which float glass isn't used.

To determine the controlled cooling times (between the annealing point and the stress point), multiply these values by 1.5.

When working with pieces with a diameter of 12 inches (30.5 cm) or more, double the maintenance cooling and controlled cooling times.

If you use float glass, reduce the times by 25 percent, or multiply the values by 0.75.

TACK FUSING				
Heating		Number of Layers		
		1.5	2.5	3.5
Diameter of piece/glass	10 cm	25 min.	35	45
	20 cm	45	65	75
	30 cm	80	110	130
	40 cm	130	150	180
	50 cm	150	180	210
	60 cm	180	210	240
Maintenance cooling				
Diameter of piece/glass	10 cm	20	30	40
	20 cm	35	60	80
	30 cm	60	80	100
	40 cm	80	100	150
	50 cm	100	120	150
	60 cm	150	180	220 min.

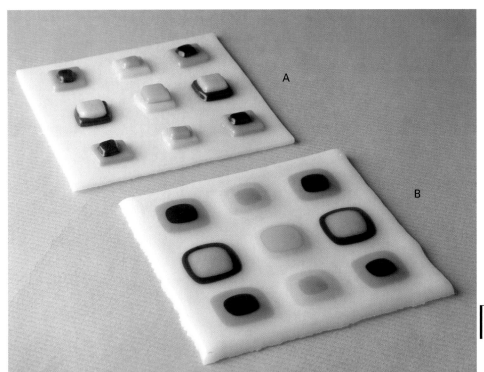

Making a Piece

In this section, you'll learn how to tack-fuse to make two different colored pieces with this same technique. Each can be made through the same series of steps, but the pieces will be fired at different temperatures to show how this affects the final result. The piece shown is made with compatibilized glass and has a diameter of about 8½ inches (21.6 cm). It is made with two pieces of glass, i.e., 1.5 layers.

To make this piece, begin by cutting a circle with a diameter of 8½ inches (21.6 cm) out of clear glass to serve as the base of the piece. Next, cut a circular piece of colored glass with a diameter of about 8 inches (20.3 cm).

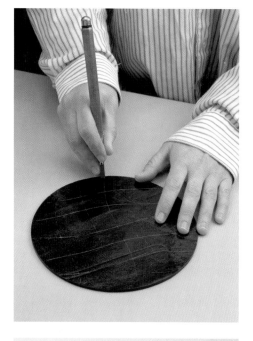

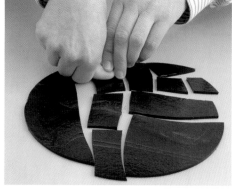

◄ **1.** Cut the pieces for placement on the transparent glass from the circle of colored glass by scoring several wavy lines. Make some vertical and others horizontal.

▼ Rene Culler, 2002. Compatible glass with enamel inclusions, tack fusing and slumping (2 x 8 x 8 inches/5 x 20 x 20 cm)

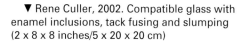

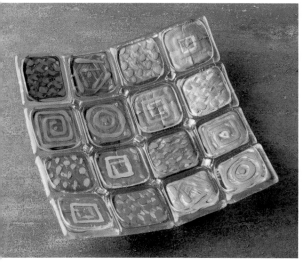

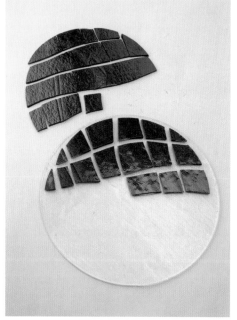

▲ **2.** Flip the piece over so that the glass surface with weakness lines is turned toward the work surface. Break the glass by pressing with your thumb along the lines and exerting pressure with the other hand. It's essential to clean the glass pieces before beginning assembly.

◄ **3.** You'll end up with a series of pieces that contrast with the transparent base and fit together like a jigsaw puzzle.

◄ **4.** Place the pieces face up on the base and slightly separated. Use PVA gel glue (polyvinyl acetate) to prevent them from moving.

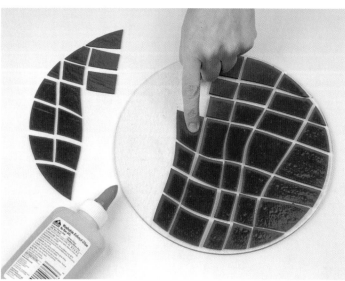

► **5.** Add colored threads for decoration. Cut them with pliers and attach them with gel glue.

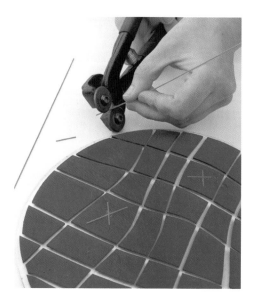

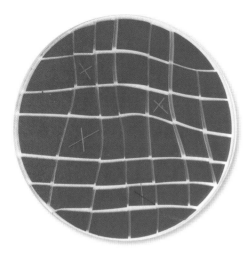

▲ **6**. This shows how the piece looks before firing.

▲ **7**. Next, prepare the plate that will serve as the base for firing. Prepare the firing separator according to the manufacturer's instructions, making sure that the mixture is liquid and homogeneous. Use a brush to cover the base plate completely.

▲ **8**. Next, apply a second layer of separator crosswise. Repeat this process until there are four layers alternating vertically and horizontally.

▶ **9**. Put the plate alone into the kiln at 500°F (260°C) for 10 minutes, then take it out to cool. Next, place the glass piece on the plate inside the kiln.

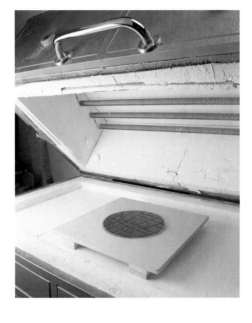

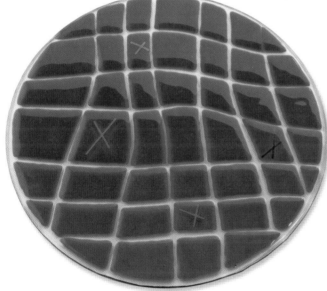

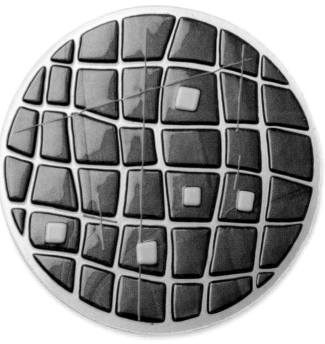

▲ **10**. The resulting blue piece was fired at a working temperature of about 1400°F (760°C). Note that the pieces of colored glass haven't retained their original volume, but have flattened out, become rounded, and expanded.

▶ **11**. In contrast, this green piece was subjected to a working temperature of 1334°F (723°C), creating a different effect. The pieces of green glass fused with the float glass while maintaining their volume, thickness, and arrangement. The angles have a rounded appearance.

Full Fusing

Full fusing is carried out at a higher temperature than tack fusing. It occurs at 1454 and 1535°F (790 and 835°C); and the glass generally melts completely, the layers become thinner, and the edges become rounded. The viscosity of the glass also gradually decreases, becoming more and more fluid, and unless it's inside a mold, it rises above the original form. If the glass stays at the right temperature long enough, it will flow to achieve a stable thickness of slightly less than ¼ inch (6 mm), as we'll explain in more detail later. The reduction in viscosity and fluidity of the glass in turn causes problems related to controlling the volume of the layers. We'll deal with this aspect in more detail later.

Next, the ideal firing program (for a kiln with a heat source in the top) for this technique is explained as well as subsequent steps for making a piece.

Firing

The firing program for full fusing uses a working temperature between 1454 and 1535°F (790 and 835°C) for a piece made up of two layers with a diameter of 20 inches (50.8 cm).

As the chart shows, the working temperature for full fusing is greater than for tack fusing. The soaking time at this temperature is also longer. With tack fusing, it is very short, or even nonexistent. The rest of the curve, with the exception of the temperature range, is largely comparable. Just as in tack fusing, if ruby glass is used, it is necessary to increase the controlled cooling time.

Full fusing chart (1454 to 1535°F/790 to 835°C) for two layers of glass measuring .117 inch (3 mm) and 20 inches (50.8 cm) in diameter, and explanation of the vertical areas of the chart with corresponding numbers:

1. Initial heating up to the annealing point of the glass

2. Slow increase

3. Holding phase to stabilize the temperature in the kiln. At 1148°F (620°C) carbonization occurs and the methylcellulose glue (MCG) disappears. In this phase, the inversion of the silica (quartz inversion) used in the molds occurs.

4. Rapid heating: a quick increase in temperature to avoid devitrification

5. Working temperature

6. Rapid temperature decrease to avoid devitrification: the kiln is repeatedly opened and closed quickly as many times as necessary to reach the temperature of 1040°F (560°C). If it isn't done in this way, heating elements can be damaged.

7. Maintenance cooling to the annealing temperature

8. Controlled cooling: slow decline in temperature to the stress point

9. Cooling the kiln down to room temperature

10. Cooling the kiln down to room temperature if using ruby glass

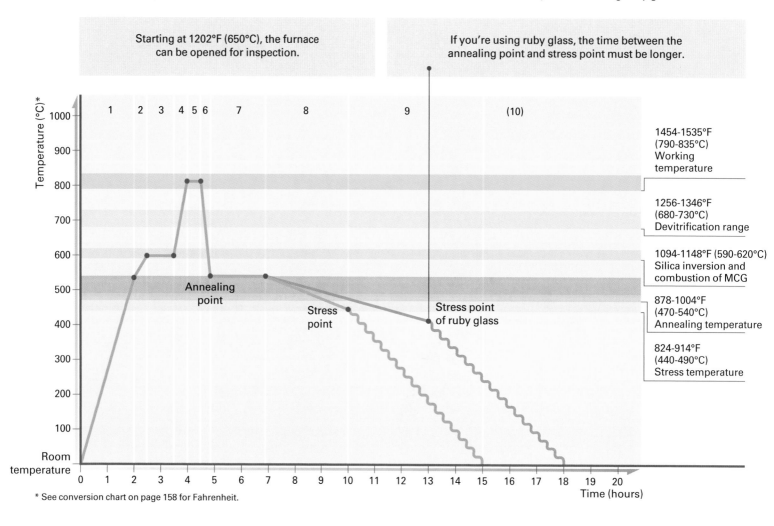

Starting at 1202°F (650°C), the furnace can be opened for inspection.

If you're using ruby glass, the time between the annealing point and stress point must be longer.

Temperature (°C)*

Annealing point

Stress point

Stress point of ruby glass

1454-1535°F (790-835°C) Working temperature

1256-1346°F (680-730°C) Devitrification range

1094-1148°F (590-620°C) Silica inversion and combustion of MCG

878-1004°F (470-540°C) Annealing temperature

824-914°F (440-490°C) Stress temperature

Time (hours)

* See conversion chart on page 158 for Fahrenheit.

Heating and Maintenance Cooling Times in Relation To the Size and Layers of Glass

Just as in tack fusing, the firing program varies according to the piece's dimensions and superimposed layers of glass. The time used in heating, maintenance cooling, and controlled cooling during firing has to be increased according to the piece's dimensions and number of layers, as summarized in the table below.

Heating

The temperatures indicated go up to 1004°F (540°C) for kilns whose heating elements are in the top and for projects in which float (window) glass isn't used.

For kilns with heat sources located on the sides or top and sides, the heating time is doubled for pieces with a diameter up to 16 inches (40.6 cm). With larger pieces, it is tripled.

If you use float glass, reduce the heating time by 25 percent (or what amounts to the same thing), or multiply the indicated time by 0.75.

Maintenance Cooling

The times in the chart work for any kiln, for pieces without a frame, and for projects that don't use float glass.

To establish the times for controlled cooling (between the annealing point and stress point), multiply these values by 1.5.

When the pieces have a diameter of 20 inches (50.8 cm) or more, double the maintenance cooling and controlled cooling times.

If you use float glass, reduce the times by 25 percent, or multiply the values by 0.75.

Problem

Solution

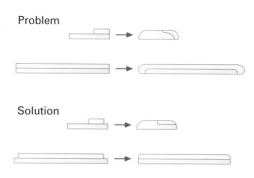

▲ Controlling the volume of the glass: the upper layer tends to increase in comparison to the lower one. The top illustrations show two possible problems that can occur. The solution is to reduce the size of the top piece, as indicated in the bottom drawings.

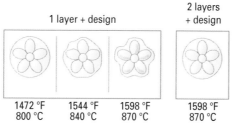

1 layer + design			2 layers + design
1472 °F 800 °C	1544 °F 840 °C	1598 °F 870 °C	1598 °F 870 °C

▲ Variations in volume and shape with respect to temperature and number of layers

Volume Control

As you've now learned, one of the most problematic aspects of full fusing is controlling the glass's volume. In this respect, the behavior of glass follows certain constants.

In the temperature range for full fusing, glass becomes increasingly fluid and its viscosity diminishes. The surface tension (the force exerted against the surface by the molecules inside) is such that it causes any volume to reach a thickness of just under ¼ inch (6mm) (as long as ideal temperature conditions are maintained long enough). For example, a piece made up of two to three layers that are each .117 inch (3 mm) will become a layer of .234 inch (6 mm) after firing.

The upper layer of glass tends to increase in surface area in relationship to the lower layer. This entails undesirable effects, since the upper layer can cover the lower one completely. The solution to this problem is to reduce the size of the top one according to this proportion: for every 12 inches (30.5 cm) of lower layer, reduce the upper one by ⅜ inch (1 cm); for every 24 inches (61 cm), reduce the top one by ¾ inch (1.9 cm), and so forth.

Another factor that affects volume changes is the number of layers. A piece made up of one layer with a superimposed design fuses at 1472°F (800°C), maintaining its surface area. If the temperature is increased to 1544°F (840°C) with the same piece, the outer shape of the base layer changes. At 1598°F (870°C), the piece undergoes a complete change in shape. However, if the piece is made up of two layers of glass with the superimposed design, the original shape of the piece won't vary at 1598°F (870°C).

FULL FUSING					
Heating (in minutes)	Number of layers				
	1	2	3	4	5
10 cm	0	20	25	35	45
20 cm	20	40	60	90	110
30 cm	35	60	90	110	130
40 cm	45	90	110	150	180
50 cm	55	110	150	180	210
60 cm	65	130	180	210	240
Maintenance cooling					
10 cm	15	20	20	30	30
20 cm	25	35	45	60	80
30 cm	35	60	60	80	100
40 cm	45	80	100	120	150
50 cm	55	100	120	150	180
60 cm	65	130	150	180	220

(Diameter of glass piece rows for both Heating and Maintenance cooling sections)

◀ Cross section of a piece made by full fusing. The photograph shows how the red, blue, and white glasses have blended with the base's black glass.

▲ Masaaki Yasumoto, 2001. Full fused and slumped glass (9 x 9 inches/22.9 x 22.9 cm)

Making a Project

This example shows how to make a piece using full fusing to combine layers of transparent as well as transparent and opaque colored glass. All possible combinations are used, and after firing, the result is a piece with interesting mixtures of tones and colors, plus gradations of transparencies and opacities.

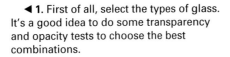

◄ **1.** First of all, select the types of glass. It's a good idea to do some transparency and opacity tests to choose the best combinations.

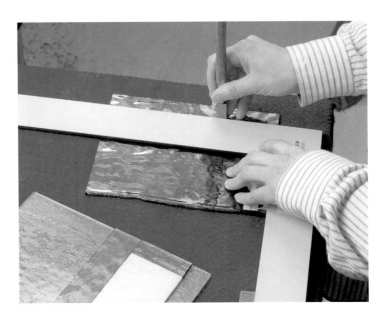

▲ **2.** Next, cut out the glass for the bottom layer, and set it aside (we're using transparent cathedral glass). The piece is 9 inches (22.9 cm) on one side. Then, use a cutter and square on top of the cutting table to score a line on top of the glass for your second layer.

▲ **3.** Certain kinds of glass might resist breaking. It's a good idea to place the glass at the edge of the cutting table and use breaking pliers.

► **4.** Fit the pieces of glass together so they're centered and perfectly aligned. Check measurements. Use small drops of PVA gel glue to keep them from moving.

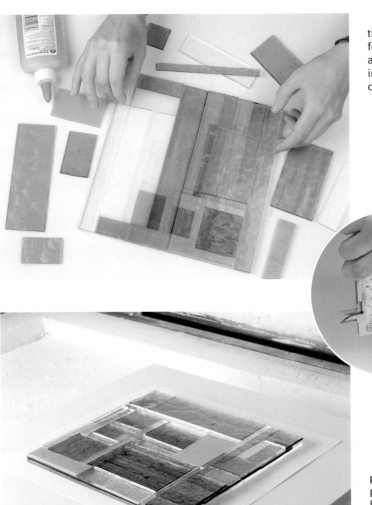

5. Finally, cut the pieces of glass for the third layer, and glue them into place in the desired pattern.

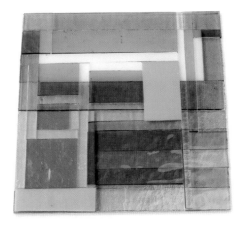

▲ **6.** The piece prior to firing

7. The total thickness of the piece before firing (slightly over ½ inch [1.3 cm])

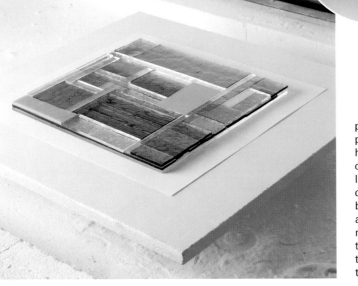

8. Place the piece in the kiln on a perfectly level plate held up by several cylindrical kiln posts. Insert a piece of ceramic paper between the plate and glass. The paper must be larger than the piece, since it tends to shrink with the heat.

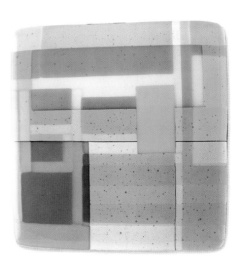

▲ **9.** Note the changes in appearance after firing.

▶ **10.** This photograph shows the size of the glass after firing it at a working temperature of 1454 to 1535°F (790 to 835°C) for 30 minutes. The piece now measures about 9 inches (22.9 cm) per side; i.e., its dimensions have increased about ⅜ inch (1 cm). The surface area has increased while the thickness has decreased.

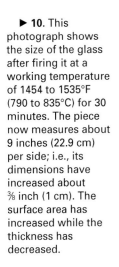

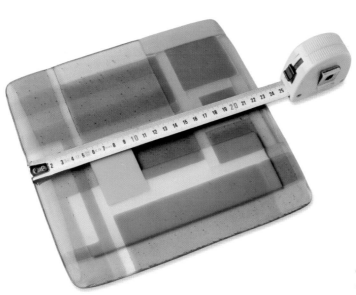

▲ **11.** The thickness of the piece has also changed. After firing, it has decreased by .117 inch (3 mm) to .351 inch (9 mm).

Inclusions

Inclusions are anything added to or enclosed between other materials. Inclusions in glass are created by placing a piece of some material between two layers of glass, usually transparent, although it is also possible to used colored glass. The fusion process laminates two types of glass and the material. Using inclusions requires a working temperature between 1400 and 1535°F (760-835°C).

Given the special characteristics of glass, it's possible to create some spectacular inclusions. There are many variables that affect the final results, such as the material used for the inclusion, the type of glass, the surface area of the glass that comes in contact with the inclusion (in the case of float glass), and the working temperature. The colors and transparencies of the glass used affect the final result, and inclusions impart formal and chromatic characteristics to the objects. In fact, inclusions are a part of the overall design of the piece.

For full fusing, when float (window) glass is used for making inclusions, the heating and maintenance cooling times in relation to the size and the layers of glass are the same as in the previous section. The only variation is not reducing the time by 25 percent, which will guarantee a good final result.

Firing

Next, we'll show the complete firing program for a piece with inclusions. A working temperature of 1400 to 1535°F (760 to 835°C) is used on the piece that has a diameter of 20 inches (50.8 cm). The piece is made with two layers, each .117 inch (3 mm) thick.

Using float (window) glass for inclusions requires increasing the time for certain phases. Thus, the initial heating beyond the annealing temperature (above 1004°F/540°C) will be longer during this process than in others in which float glass is also used. Also, the maintenance cooling must be lengthened (at the annealing point of 1004°F/540°C) and the controlled cooling phase, i.e., the temperature reduction in the kiln between the annealing point or temperature and the stress point.

Inclusions chart (1400 to 1535°F/760 to 835°C) using .117 inch (3 mm) window glass, two layers with a diameter of 20 inches (50.8 cm), and an explanation of the vertical areas of the chart:

1. Initial heating over to annealing point of the glass

2. Slow increase

3. Holding phase to stabilize the temperature inside the kiln. Carbonization occurs at 1148°F (620°C), along with the disappearance of the methyl-cellulose glue (MCG). The quartz inversion used in the molds occurs in this phase.

4. Rapid heating: quick temperature increase to avoid devitrification

5. Working temperature

6. Rapid cooling to avoid devitrification: the oven must be opened and closed quickly until the temperature of 1040°F (560°C) is reached. If this is not done, the heating elements might be damaged.

7. Maintenance cooling down to annealing temperature

8. Controlled cooling: slow temperature reduction down to stress point

9. Cooling of kiln to room temperature

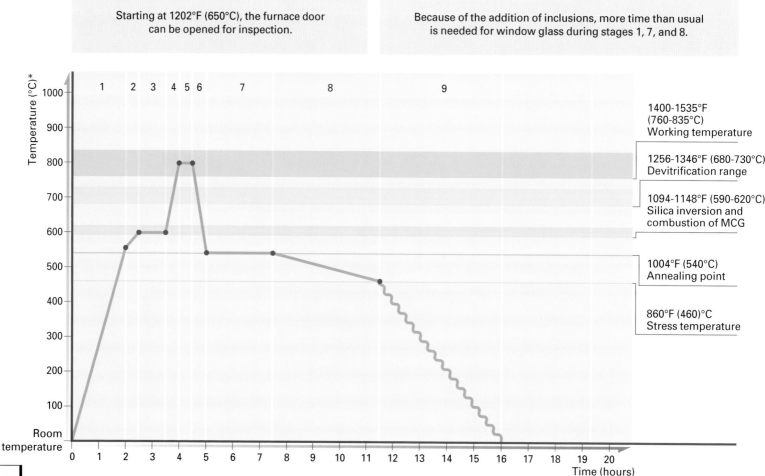

Starting at 1202°F (650°C), the furnace door can be opened for inspection.

Because of the addition of inclusions, more time than usual is needed for window glass during stages 1, 7, and 8.

1400-1535°F (760-835°C) Working temperature

1256-1346°F (680-730°C) Devitrification range

1094-1148°F (590-620°C) Silica inversion and combustion of MCG

1004°F (540°C) Annealing point

860°F (460)°C Stress temperature

* See conversion chart on page 158 for Fahrenheit.

Tests for Float Glass

The side or face of the float glass that contacts the material used for the inclusion is one variable that affects the final result of work that has inclusions. Commercial float glass (window glass) always has a side that contains no tin (designated here as A), and another face with tin (designated here as B). The presence or absence of tin in contact with inclusions made of some materials, such as silver, influences the color after firing. Thus, one of the basic aspects to keep in mind before adding any inclusion is the proper identification of the faces of this glass, especially because it's one of the most common types used in the workshop because of its low cost and wide availability.

Silver Stain

The silver stain test shows the chemical reaction between the salts in the stain with the tin. It is an easy and accessible method for deciphering the difference between the two faces of the window glass, since the compound can be used as many times as desired. Next, we'll show how to do this test.

Ultraviolet Light

This lamp is used for the same purpose as the silver stain test, to show a chemical reaction between the salts in the stain with the tin. It is based on the difference in fluorescence of the two faces of float glass. This has to be done in an area without lighting, and its major drawback is that sometimes this phenomenon is difficult to observe.

▲ This photograph shows the fluorescence of the face containing the tin (B) that contrasts with the face of the glass on the left (A) that contains no tin and fluorescence.

▶ 1. First, mix a small quantity of silver stain with a few droplets of water. Use a spatula to make the mixture into a thick paste on a hard, non-porous surface such as a piece of glass.

▼ 3. Allow the paste to dry, and put the pieces of glass into the kiln. Heat them to a temperature of 1148°F (620°C). Once they're cooled to room temperature, remove the excess silver stain with a razor blade or a hobby knife. It can be reused if kept in a separate container.

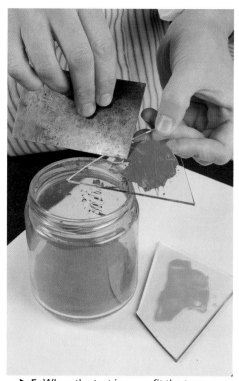

▶ 5. When the test is over, fit the two pieces back into the original sheet, and tape them in place with cellophane tape to assure the permanent marking of the two faces of the sheet.

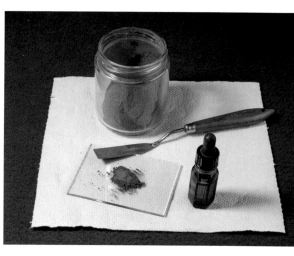

◀ 2. Cut the angle of the sheet of glass to be tested. The circular cut is made in the shape of a quarter-circle so that the resulting piece or fragment is triangular with one curved side. Next, make a transverse cut that produces two fragments. Turn one of these over and apply the mixture to the upper surface of the two pieces of glass.

▼ 4. As the photograph shows, one surface has a light spot (A), and the other a dark spot (B); the latter is the one that has the tin.

Sample Inclusions

Adding inclusions gives you an amazingly broad range of possibilities for experimentation and innovation. Many materials can be used, restricted only by their durability or behavior in the presence of high temperatures and their compatibility with glass. There are no limitations with respect to the types of glass that can be used or the temperature ranges. An inclusions sampler is used to restrict these possibilities. Here are some solutions that work. They are grouped by working temperatures, as a function of the faces of float glass, and as examples of the many materials that can be used. Use these samples as a reference point for making your own inclusions and checking the results.

Temperatures

The working temperature is one factor that determines the results of using an inclusion. This aspect is particularly variable when working with metal leaf. The exposure to one temperature or another has an effect on the resulting color, depending on the degree of oxidation.

The Faces of Float Glass

As already explained, using one face of float glass also affects the results of your work. This is especially noticeable in the inclusions with silver (leaf, thread, pieces, etc.) and copper.

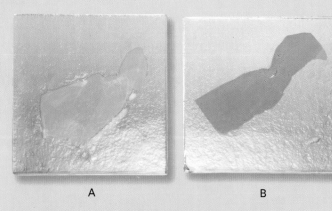

A B

▼ Sara McDonald, Bowl, 1998. Slumping, gold leaf inclusions, 22 inches (55.9 cm) in diameter

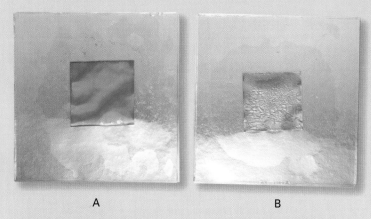

A B

▲ Inclusions of copper leaf between two panes of window glass done at a working temperature of between 1400 and 1418°F (760 and 770°C) (A) and between 1490 and 1508°F (810 and 820°C) (B). Note the color change in the second example where the copper was exposed to the higher temperature, resulting in greater oxidation.

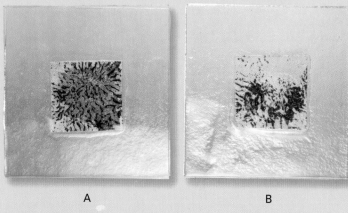

A B

▲ Aluminum foil inclusions done at a working temperature of around 1400°F (760°C) (A) and one treated at 1490 and 1508°F (810 and 820°C) (B). In the second instance, the foil has almost entirely disappeared.

◄ Silver leaf inclusions done on the face of the glass containing no tin (A) and the same silver leaf inclusion on the face of the glass that has tin on it (B)

▼ Inclusions of steel mesh between two sheets of window glass done at working temperatures of 1400 to 1418°F (760 to 770°C) (A) and 1490 to 1508°F (810 to 820°C) (B). The mesh treated at the higher temperature has oxidized, and as a result, its appearance and color have changed.

A B

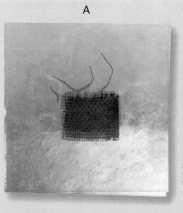
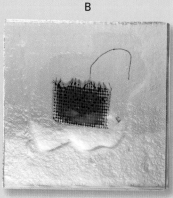

Materials

Next, we'll show you some of the materials that can be used as inclusions and the effects that can be achieved through various combinations.

▲ Inclusion of fiberglass shavings

▲ Inclusion with copper leaf and wire superimposed on aluminum leaf

▼ Inclusion with copper, silver, and aluminum leaf. Note the chromatic changes caused by the reaction of the metals with one another.

▲ Inclusions of leaves (organic materials). The working temperature didn't exceed 1400°F (760°C) to keep the material from being consumed. Note how the outside of the leaf disappears, leaving an imprint on the glass.

▲ Inclusions of tin mesh and wire

▶ The superimposition of several layers of inclusions can create interesting chromatic and transparency effects, as shown in these two examples.

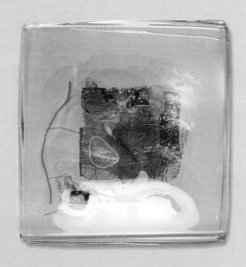

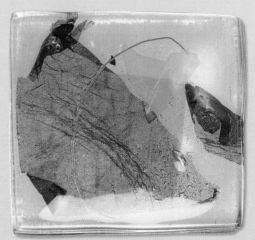

SLUMPING (THERMOFORMING)

*S*lumping is the technique of imparting shape to the glass by increasing its temperature, without heating the material to a fluid state. The nature of glass is to deform quickly and visibly under weight and adhere to surfaces once the softening point is reached. At this point, the viscosity and surface tension of the material decrease while fluidity increases, resulting in changes in the shape from the weight of the glass, or in other words, the effect of gravity.

▲ Anna Marco, 2002. Slumped dalle using a mold, 2¾ x 15 x 9½ inches (7 x 38.1 x 24.1 cm)

Slumping Techniques

Through the use of molds, slumping makes it possible to form the glass in a particular way. As we'll show in the following pages, you can use the inside or outside of molds, depending on the effect you wish to achieve. Molds can be made of various materials, and serve to make volumetric objects and pieces with relief and texture. If you use the free fall (draping) technique, the glass takes on its own shape as it hangs freely. The shape is created strictly by the deformation of the glass.

Firing Program

In generic terms, slumping is done in a temperature range between 1166 and 1535°F (630 and 835°C). This range includes the different techniques that fall under this category.

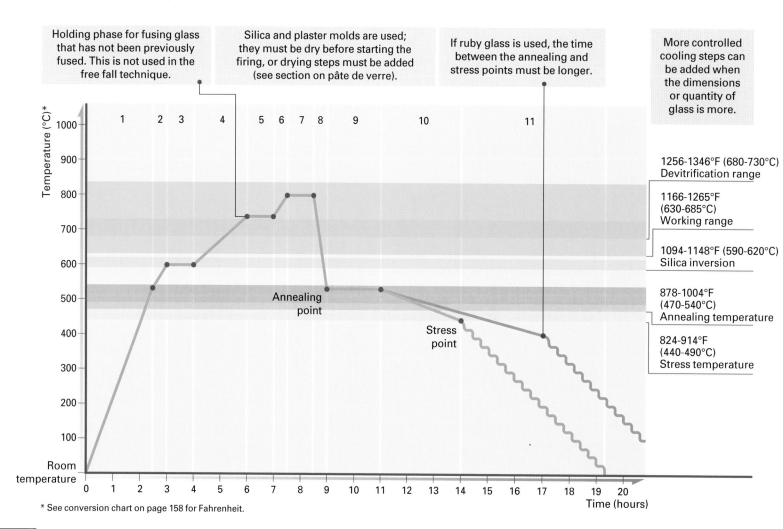

Holding phase for fusing glass that has not been previously fused. This is not used in the free fall technique.

Silica and plaster molds are used; they must be dry before starting the firing, or drying steps must be added (see section on pâte de verre).

If ruby glass is used, the time between the annealing and stress points must be longer.

More controlled cooling steps can be added when the dimensions or quantity of glass is more.

1256-1346°F (680-730°C) Devitrification range

1166-1265°F (630-685°C) Working range

1094-1148°F (590-620°C) Silica inversion

878-1004°F (470-540°C) Annealing temperature

824-914°F (440-490°C) Stress temperature

Temperature (°C)*

Annealing point

Stress point

Room temperature

Time (hours)

* See conversion chart on page 158 for Fahrenheit.

Next, we'll show you an ideal firing program for slumping glass that is ¼ inch (6 mm) thick, or two layers of .117-inch-thick (3 mm) glass with a diameter of 20 inches (50.8 cm). The kiln has a top heat source. It's appropriate to point out that this slumping program includes specific phases such as controlled increases, which allow for carefully watching over the glass's behavior during the rapid heating phase. Also, we'll show the details of the annealing phase of ruby glass.

Characteristics and Special Features

Slumping involves many factors adding up to an equation of sorts. It depends on such aspects as the type, thickness, and size of the glass; the shape of the mold and the opening as well as the shape of the ring (if present); the variations in glass viscosity (glass fluidity according to temperature); variations in surface tension; and the weight of the material (a product of the body's mass and the speed created by gravity). Generally speaking, the effects of slumping depend on a relationship between weight and variation in viscosity (thus, the fluidity), and the surface tension created by temperature variations produced during firing.

Since so many variables are involved in slumping, extreme control and attention to the process is needed while making the piece. For the process of draping, with its own peculiar characteristics, even more intense attention is required.

During the firing cycle, the glass should never reach a totally fluid state. Excessive fluidity (low viscosity) due to excessive heating can cause undesirable results, since the material can be deposited in the bottom of the mold or flow freely, in the case of flat molds.

The following chart shows various phases of slumping with general temperature ranges and characteristic glass behavior. These temperatures vary, depending on the glass and its composition, i.e., according to the manufacturer.

Slumping and free fall at 1166 to 1535°F (630 to 835°C) for glass that is .234 inch (6 mm) thick or two layers of .117 inch (3 mm), and 20 inches (50.8 cm) in diameter. The following is an explanation of the vertical areas of the chart as numbered at the top:

1. Initial heating up to annealing point
2. Rapid temperature increase
3. Holding phase to stabilize the temperature of the glass and the kiln. In this phase, quartz inversion occurs in the molds.
4. Controlled, fairly rapid increase to examine the glass's behavior
5. Holding phase to fuse glass not previously fused
6. Controlled increase to watch the behavior of the glass
7. Working temperature
8. Rapid decrease in temperature to avoid devitrification; the kiln is opened and closed repeatedly and quickly until the temperature of 1040°F (560°C) is reached. If this is not done, the heating elements can be damaged.
9. Maintenance cooling to annealing temperature
10. Controlled cooling: slow temperature reduction to the stress point
11. Cooling of kiln to room temperature

SLUMPING TEMPERATURES		
Slumping is the result of an equation involving multiple factors; among them are the thickness and the size of the glass, the effects of gravity, variations in viscosity due to temperature increase, the shape of the mold, and the opening or shape of the ring, all of which must be controlled throughout.		
Temperature		**Behavior**
Room temperature Up to 1040°F (560°C)		No visible change in the shape of the glass
1040°F (560°C) 1166°F (630°C)		The glass begins to bend. As the temperature increases, the viscosity of the material decreases, thus causing changes in its shape, accentuated by the force of gravity (weight of the glass). If a mold is used, the glass takes on the required shape.
1166°F (630°C) 1328°F (720°C)		The bend in the glass is accentuated. The glass in free fall obviously melts. The edges maintain the same thickness.
1328°F (720°C) 1535°F (835°C)		Above this temperature the glass in free fall flows freely onto the base. The edges become increasingly thin with respect to the base or the bottom of the piece. If the temperature is maintained or increased, the viscosity becomes so low that the glass may open up, since it cannot support the weight of the lower part. The glass on a flat mold (such as one made from ceramic fiber), takes on the relief and the texture of the mold.

Slumping with Molds

A s we've already explained, slumping is a technique used to shape glass in molds. Next, we'll show you the ideal firing program for it along with two systems—one using a metal mold (a wok) and another using ceramic fiber for making a hump (relief) mold. We've included a chart showing the main features of slumping and the most common molds.

Firing

Next, we'll show you the ideal firing cycle for slumping two objects. The first object is made up of two layers of float (window) glass that are .117 inch (3 mm) thick, previously fused, with a diameter of 12 inches (30.5 cm). The second is made up of a plate of .156-inch-thick (4 mm) glass. This is based on using a kiln with a top heat source. The working temperature varies between 1166 and 1535°F (630 and 835°C) and is similar to the chart on page 92. The difference is that, in this case, there are no phases of controlled increase during the rapid heating stage, and when the glass is in the mold there is no need to watch over it. We'll also explain the special qualities of the annealing phase of ruby glass.

◀ Susana Aparicio, *Table Setting in Black and White*, 2002. Fused and thermoformed glass: salad bowl and plate, saucers, fork, and spoon

Slumping at 1166 to 1505°F (630-835°C) for glass that is .234 inch (6 mm) thick or two layers of glass each of .117 inch (3 mm) thick, and 20 inches (50 cm) in diameter (second firing). The following is an explanation of the vertical areas of the chart as numbered at the top:

1. Initial heating up to a certain point between the tempering point and softening point of the glass

2. Rapid temperature increase

3. Holding to stabilize the temperature of the glass and the kiln. In this phase, the inversion phenomenon of the silica used in the molds occurs.

4. Controlled temperature increase

5. Working temperature

6. Rapid temperature decrease to avoid devitrification: the kiln is opened and closed quickly several times until a temperature of 1040°F (560°C) is reached. If this is not done, the heating elements could be damaged. If prefabricated ceramic molds are being used, it's not a good idea to open the kiln, since they could crack and break.

7. Maintenance cooling at the annealing temperature

8. Controlled cooling: slow temperature decrease down to the stress point

9. Cooling of the kiln to room temperature

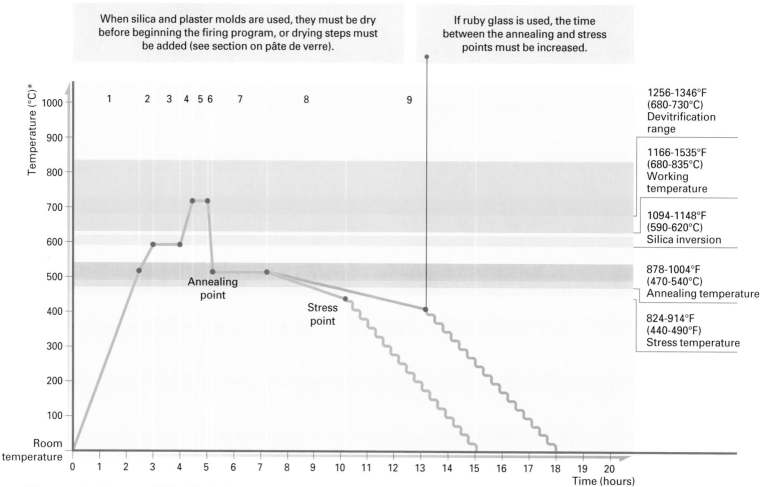

When silica and plaster molds are used, they must be dry before beginning the firing program, or drying steps must be added (see section on pâte de verre).

If ruby glass is used, the time between the annealing and stress points must be increased.

1256-1346°F (680-730°C) Devitrification range

1166-1535°F (680-835°C) Working temperature

1094-1148°F (590-620°C) Silica inversion

878-1004°F (470-540°C) Annealing temperature

824-914°F (440-490°F) Stress temperature

Temperature (°C)*

Annealing point

Stress point

Time (hours)

* See conversion chart on page 158 for Fahrenheit.

SLUMPING WITH MOLDS

Slumping inside a mold

CURVED MOLD	In a curved mold, the glass conforms uniformly to the walls. To create very closed, deep shapes, various molds can be used, several slumping steps can be used, or the time at working temperatures can be increased. All of this requires constant control and watching over the piece.	*Force of gravity (weight)* — Ventilation holes
SQUARE OR RECTANGULAR MOLD	In a rectangular mold, glass conforms to the walls in a gradual manner. At first, the center of the glass adapts, then the bottom, and finally, the sides.	
	These molds must be kept longer at the working temperature for the glass to conform to them. The glass also conforms to a shape with corners. A larger amount of material is deposited in the twists and turns. For instance, there will be twice as much in the corners as in the sides of the piece.	11½ × 9¼ inches (29.5 × 23.5 cm) 11 × 8¾ inches (28 × 22 cm)

Slumping on the outside of a mold

The glass is placed right over the mold, holding it up on two kiln posts to keep it from touching it. The contact surface between the glass and kiln posts needs to be minimal, so when the bending begins, and the glass is deposited on the mold, it slides down the supports. Next, the kiln posts are removed from the kiln and the firing cycle continues.

The glass will become wavy, and the temperature has to be increased to eliminate this undesirable effect. There may also be some minor distortion on the bottom edge of the piece, and this can be removed by polishing.

Making a Piece in a Wok

Next, we'll show you the process of using a wok to slump a piece. Again, we're dealing with a piece that is 20 inches (50.8 cm) in diameter. The piece was previously fused, contains inclusions, and is .234 inch (6 mm) thick.

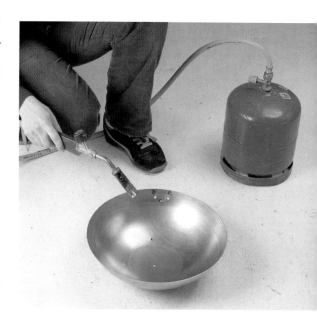

▲ **1.** First, prepare the mold (steel wok) by heating it with a gas torch.

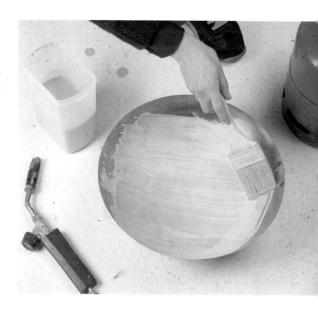

▲ **2.** Next, apply a uniform layer of kiln wash to the mold's surface, and allow it to dry.

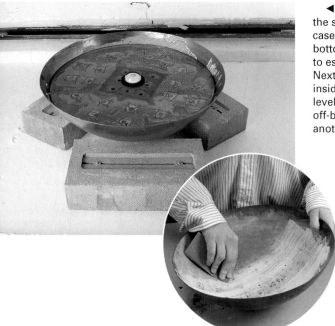

◄ 3. Center the mold perfectly and level on the supports—three refractory bricks in this case. (The mold is slightly separated from the bottom of the kiln to make it easier for the air to escape through the holes in the bottom.) Next, place the piece with the inclusions inside the wok in such a way that it's perfectly level; otherwise, the resulting piece may be off-balance, with one part higher than another.

▼ 4. Once the firing cycle is complete, and the piece has returned to room temperature, remove it from the mold. The photograph shows the curvature the glass has taken on through slumping, which was used to create a decorative bowl.

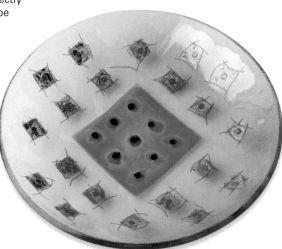

◄ 5. Once the process is complete, clean the mold by sanding the whole inner surface (in this instance, use 80-grit sandpaper). Then, remove the dust, keeping the mold clean and ready for its next use.

Making a Slumped Piece with Ceramic Fiber

Another slumping technique involves creating relief effects and texture, or objects in relief, by using ceramic fiber as a mold. This material makes it possible to make fairly complex molds quickly and easily, since it can be cut with tools or torn by hand. The best tools for making clean, precise cuts are razor blades and hobby knives; however, the ceramic fiber will wear down the sharp edges of these instruments.

Making any shape results in two templates (a positive and negative one) which makes it possible to produce interesting formal solutions. Once the shapes are cut out, they can be piled onto others to create the effect of volume, and if necessary, they can be glued with PVA gel to keep them in place. Ceramic fiber can be reused. To make it last longer, coat it with kiln wash. And, when using any form of ceramic fiber, always protect yourself with gloves and a dust mask.

Different kinds of glass react differently when they're slumped on ceramic fiber. In general, opaline glass tends to stick firmly to the fiber, but transparent and cathedral glass sticks less. The iridescent layer of one kind of glass (known as iridescent glass), when in contact with the fiber, becomes more limpid as a result of firing.

▲ 1. Once the glass is cut out, draw the design on a piece of paper. Here, we've opted for simple geometric shapes, which will produce some interesting relief designs through positive and negative combinations. As the photograph shows, three rectangles have been drawn, all inside one another with a separation of about ⅝ inch (1.6 cm).

▲ 2. Next, place the glass on top of a flat surface, perfectly square on the ceramic fiber. Use the scalpel blade to cut the fiber at a 45° angle.

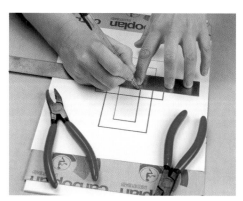

▲ 3. Use carbon paper to transfer the design onto the surface of the ceramic fiber by placing it facedown with the paper design on top of it. Hold the two papers in place with any fairly heavy objects (some pliers in this instance) to keep them from moving.

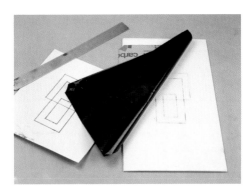

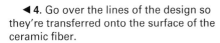

◄ 4. Go over the lines of the design so they're transferred onto the surface of the ceramic fiber.

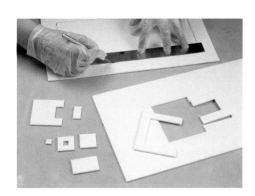

► 5. Next, use a scalpel to cut out the ceramic fiber along the lines. Cut out the border that outlines the composition from another piece of ceramic fiber.

▼ 6. Next, cut out six small squares (four for the corners, and two for the inside decoration), as well as one smaller square from the center of one of the squares. Using the scalpel like an awl, position the pieces. Then place the arrangement on another piece of ceramic fiber, and position it on a plate before firing it at 1202°F (650°C).

► 7. Once the ceramic fiber has been fired and returned to room temperature, center the glass perfectly on it, and take it through the firing cycle. Allow the piece to cool to room temperature, and take the glass out of the kiln. Remove the pieces of ceramic fiber.

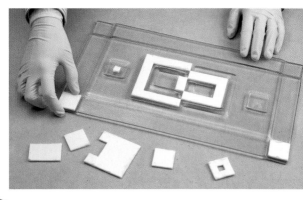

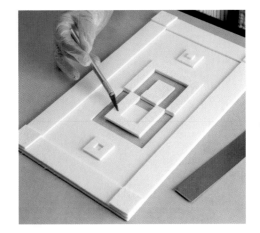

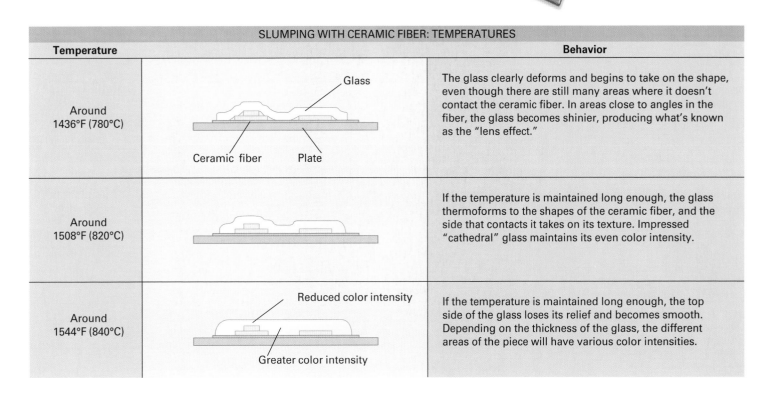

◄ 8. Once the slumping process is complete, the glass has taken on the relief of the ceramic fiber.

SLUMPING WITH CERAMIC FIBER: TEMPERATURES		
Temperature		**Behavior**
Around 1436°F (780°C)	Glass / Ceramic fiber / Plate	The glass clearly deforms and begins to take on the shape, even though there are still many areas where it doesn't contact the ceramic fiber. In areas close to angles in the fiber, the glass becomes shinier, producing what's known as the "lens effect."
Around 1508°F (820°C)		If the temperature is maintained long enough, the glass thermoforms to the shapes of the ceramic fiber, and the side that contacts it takes on its texture. Impressed "cathedral" glass maintains its even color intensity.
Around 1544°F (840°C)	Reduced color intensity / Greater color intensity	If the temperature is maintained long enough, the top side of the glass loses its relief and becomes smooth. Depending on the thickness of the glass, the different areas of the piece will have various color intensities.

Free Fall *(Draping)*

As we've already mentioned, free fall is a glass technique based on the deformation that results when glass is heated, causing it to sag under its own weight. Next, we'll show you the ideal firing program and the technical process for this technique. We've also included a chart on the main characteristics of free fall and some of the many systems that can be used.

Firing

This section will illustrate the ideal free-fall program in a second firing for a piece of glass that is ¼ inch (6 mm) thick and 20 inches (50.8 cm) in diameter. The kiln has a top heat source, and the working temperature range varies between 1202 and 1454°F (650 and 790°C). (This is a narrower range than the previous case involving a slumped piece.) The main difference is in the rapid heating phase, in which the working temperature is reached. In free fall, this phase will consist of several stages, during which a rapid temperature increase will first be produced, followed by a holding phase that stabilizes the temperature of the glass and kiln. Then a controlled temperature increase is finally followed by a series of minimal, controlled increases with appropriate soaking. This last stage is extremely important, since this is when the free fall occurs. This is the time when it's crucial to control the behavior of the glass as it distorts to keep it from getting too thin in certain areas, which could cause it to open up. This stage is very long, for the more time that's devoted to the temperature increase when the glass begins to deform, the more control you'll have over this phenomenon. The piece must be watched over continually, since the deformation can happen in a few minutes during a slight temperature increase.

The special features of the annealing phase of ruby glass are also shown in this firing program.

When the free fall begins, the glass located on a ring or any other element begins to sag, and it gradually becomes thinner on the inside where the bend originates. During the deformation stage, it becomes continually thinner right at the bottom of the curve. The shape and size of the mold, ring, or other elements, plus the distance between them and the plate or base, have an effect on the length of the process and the shape of the end product.

Heat Sources

In contrast to other techniques, the location of the heat sources in the kiln has an effect on the final result of free fall work. With kilns that have heating elements only in the top, the glass heats up evenly in the first stage, and once the deformation begins, it hangs freely (for example, through the ring). During this stage, the upper part of the piece of glass (located on the ring) always stays at the working temperature, while the bottom part (which is hanging) is farther from the heat source, so it stays at a lower temperature.

The part of the piece located just beneath the curvature gradually becomes thinner, and thus, even hotter. It becomes thinner yet

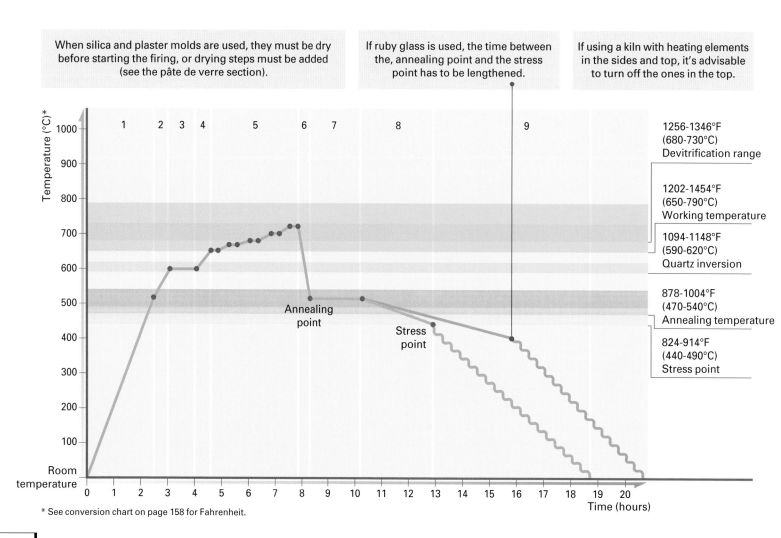

* See conversion chart on page 158 for Fahrenheit.

because of the weight of the glass in the lower part.

This phenomenon can be avoided by using kilns with independent heat sources located on the sides and bottom as well as the top. When the glass begins to deform and hang freely, the heating elements in the top can be turned off, leaving the ones on the sides turned on, and if necessary, turning on the bottom heating elements. This creates a homogeneous temperature in the entire body of glass.

Some front-opening kilns have heating elements on only three sides, which doesn't guarantee an even distribution of heat. As a result, some pieces made using free fall are asymmetrical, since the deformation doesn't occur in the desired manner in the glass that is near the door where there are no heating elements.

Still, during the free fall of the glass, it is possible to control any kiln using small increases and holding phases up to the working temperature under constant scrutiny.

Free Fall Chart (1202 to 1454°F/650 to 790°C) for the second firing of a piece of glass that is ¼ inch (6 mm) thick or two layers of .117-inch-thick (3 mm) glass with a diameter of 20 inches (50.8 cm). Below is an explanation of the vertical areas of the chart on the previous page as numbered at the top:

1. Initial heating up to a certain level between the annealing point and softening of the glass

2. Temperature increase

3. Holding phase to stabilize the temperature of the glass and the kiln. During this phase, quartz inversion in the molds occurs.

4. Temperature increase

5. Starting at 1202°F (650°C), a series of minimal, controlled increases is used, along with the appropriate holding periods, for better control and care over the free-fall process and to keep the walls of glass from becoming excessively thin.

6. Rapid temperature decrease to avoid devitrification: the kiln is repeatedly opened and closed quickly to reach 1040°F (560°C). If this is not done, the heating elements can be damaged.

7. Maintenance cooling at annealing temperature

8. Controlled cooling: slow temperature decrease down to stress point

9. Cooling of kiln to room temperature

FREE FALL

FREE FALL AND FUSING

Free fall makes it possible to make items using two or three layers of glass. Since the temperature range at which free fall is done coincides with the temperatures for tack fusing, it is possible to accomplish both processes in a single firing program. It is essential to use temperature increases and their corresponding holding periods over a longer time and in more steps.

— Ring
— Support
— Plate

DIAMETER OF RING AND FALL

The diameter of the ring used has an influence on how quickly the free fall of the glass happens. Thus, the greater the inside diameter of the ring, the less time is required for the glass to complete its fall; that is, the procedure progresses more quickly.

The illustration shows the behavior of two equal pieces of glass fired at a certain temperature for the same time, using rings of various diameters.

Some ways to make objects using the free-fall process

FREE FALL USING WIRES OR RODS

By using wires or rods, it's possible to create pieces in a great variety of shapes, from the simplest to the most complex ones that require elaborate structures.

The materials used, regardless of their form (fairly fine wires or rods), must be made from metals or alloys and be resistant to heat, according to the temperature ranges at which the procedure is carried out. They must be prepared with kiln wash. The illustration at the right shows three samples of different complexity.

— Wire
— Support
Rod —
— Support

FREE FALL USING CYLINDRICAL ELEMENTS

Another one of the many possibilities offered by this technique is to use cylindrical elements, such as kiln posts (prepared with kiln wash) to create simple or compound undulating shapes.

— Support
Plate

In addition to the systems already illustrated, there are others for making items and pieces using free fall. Elements and rods or wires can be combined, and the glass can be suspended from a system of movable chains or fixed wires after making holes to hold them and keep them curved. Movable elements can be used as well as counterweights, or both at the same time, to produce twisted shapes.

Making a Piece

Next we'll show how to make and finish a decorative item using free fall. The complete process is explained, from the preparation of the mold and placing the glass in the kiln, to cutting off the excess parts and finishing the edge of the piece with abrasives.

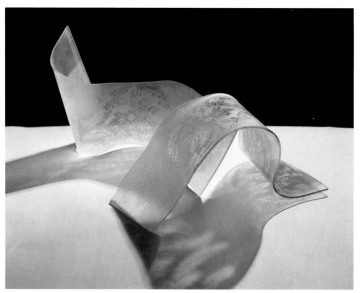

◄ Philippa Beveridge, 2002. Glass decorated with silver stain imprinting, sandblasting, and free fall (15 x 35 x 27.5 inches/38.1 x 89 x 70 cm)

▲ **1.** First, apply kiln wash to all the surfaces of the ceramic mold that will come in contact with the glass, i.e., the top and inner edge. Apply the separator with a broad brush, in four alternating vertical and horizontal coats. Put it in the kiln at 500°F (260°C) for 10 minutes, then remove it and allow it to cool before using it with the glass.

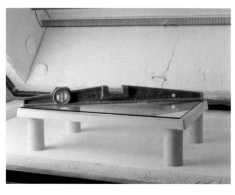

▲ **2.** Next, set the mold up inside the oven by using four cylindrical supports to lift it off the floor of the kiln, which will allow the glass to fall freely. Use a fluid level to be sure that it is perfectly level. Next, place the glass on the mold, and check to be sure it's level.

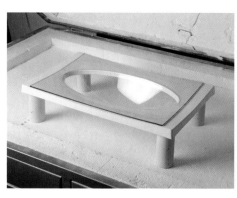

▲ **3.** This is how the piece looks while it's still in the mold once the firing program is complete. The center has sagged in free fall, producing a shape with an elliptical profile.

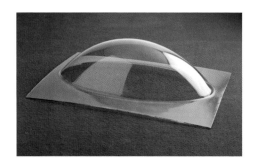

▲ **4.** Take the piece from the mold, and remove any excess glass from the top of the mold.

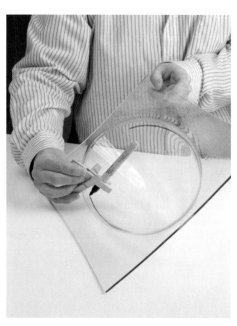

► **5.** Use a permanent marker to draw the top edge of the piece. (On a curved surface such as this, it helps to hold the marker with a pair of clothespins, as shown, to assure marking a line parallel to the upper edge of the piece.) You'll remove the extra glass above this line, and it will also serve as a guide for smoothing the edges.

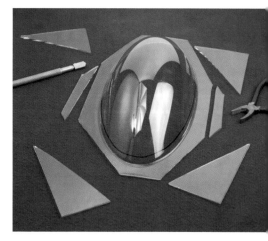

▲ **6.** After that, place the piece facedown on the cutting table, and cut the angles and sides in straight lines. Mark breaking lines with the cutter, and use pliers to begin breaking away pieces.

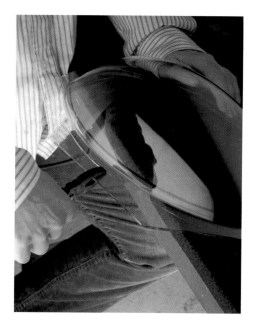

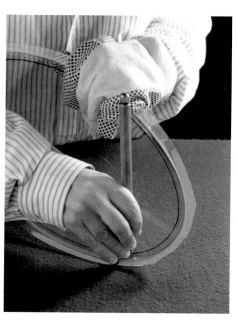

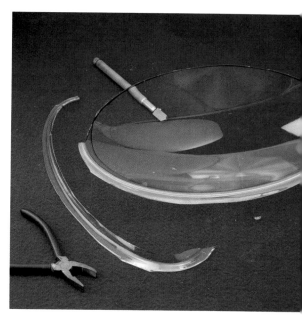

▲ **7.** Mark another line ⅜ inch (1 cm) from the edge of the fold in the glass, and use pliers to carefully remove the excess glass.

▲ **8.** Hold the piece firmly by the edge with one hand, and use the cutter to mark off half the distance of the line. It's essential to use a thick, non-slip glove to hold the glass effectively and avoid possible cuts to your hands.

▲ **9.** Use pliers to open up the cut line you made previously. Then repeat the process already described on the other side of the ellipse.

▶ **10.** The final polishing that evens out and completely polishes the edges is done with carborundum. Place a large piece of glass on the worktable to serve as a base. Then, use a putty knife to spread a mixture of 80-grit carborundum and water on the surface. Place the piece facedown, in contact with the abrasive. Put on thick, non-slip gloves. Move the piece around and rub it on the abrasive in circular motions.

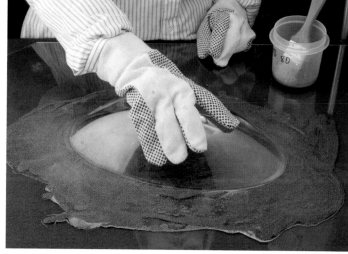

▶ **11.** Finally, you'll use a carborundum block to finish the piece with a preliminary polish. Moisten a 220-grit block with water, and rub the edge of the piece gently and uniformly to eliminate any irregularities.

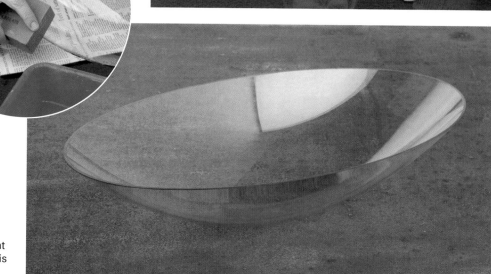

▶ **12.** Note the transparency and shine that the thermoformed glass takes on through this process when it is finished.

Finishes

mong possible finishes that can be applied to glass, one of the most common creates a special matte surface. You can create translucent, matte surfaces with sculptural areas that contrast dramatically with the transparent, shiny surface of the untreated glass. This finish can be created with acid cream or sandblasting to produce similar results.

Acid Cream Finish

Acid cream makes it possible to treat the glass surface, creating an appearance similar to industrial projects done with acid, but

without the attendant risks. However, when using the cream, protect yourself and follow any safety procedures outlined on the product.

Next, we'll explain how to decorate a piece of glass in this way (in our example, we're using the piece made by slumping with ceramic fiber on page 97). In our example, the etched areas highlight the relief created with positive and negative areas. The reserves are made with masking tape, making it possible to perfectly outline areas bordered by straight lines.

Sandblasting to Create a Finish

Sandblasting creates surface abrasion on glass by means of a solid abrasive sprayed under high pressure. This technique results in a translucent, etched surface similar to those done with acid cream. This technique also allows you to create more elaborate finishes, since it's possible to produce different degrees of the effect as well as cut the glass.

In contrast to acid cream, this technique requires special equipment, so it costs more. Using a sandblasting machine requires some learning, in addition to the investment, installation, and setup. It's advisable to do as many trial runs as you need with various types of glass, varying the time and pressure, before beginning to finish any object. Sandblasting requires a certain amount of practice before you do it in earnest.

Here are some things to consider: In cases where it's necessary to support the object on the cabinet floor, place it on a soft, plastic surface such as a mat. Move the spray gun continuously at a distance no less than 3 inches (7.6 cm) from the surface of the glass. Move the gun continuously in a circular movement to keep the abrasion from digging too deep in certain areas. You can also move the gun by alternating vertical and horizontal passes, taking special pains not to stop before moving beyond the glass to create an even surface. The abrasive has to impact the glass at a certain angle, so make sure to use the utmost care to work on objects with curved surfaces. Check the progress of the work regularly by taking the piece from the booth and looking it over, checking the abraded areas when you do.

Next, we'll explain the procedure for doing a sandblast finish, then slumping the glass, since the temperature doesn't exceed 1202°F (650°C). We'll also outline two methods of masking off the areas that won't be sandblasted.

▼ **1.** To prepare the piece for applying acid cream, mask off the areas surrounding those to be etched.

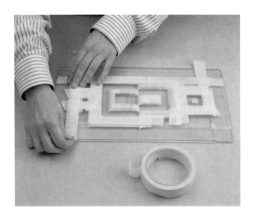

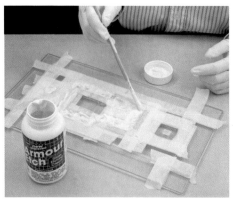

▲ **2.** Use a fine artist's brush to apply a generous layer of acid cream to the exposed sections. Allow the cream to work for five minutes, and then remove it with paper towels and throw them away. Clean the glass with plenty of water and peel away the masking tape.

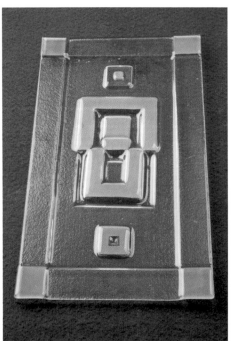

◄ **3.** Once this step is completed, the treated areas take on a characteristic matte, translucent appearance. The cream makes the surface of the glass less rough than sandblasting does.

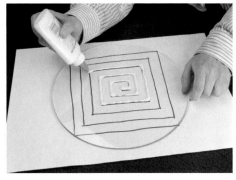

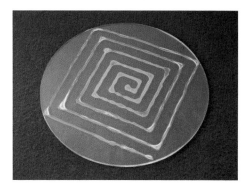

White Glue (PVA)

▲ **1.** In this example, we're working with a piece of glass cut into a circular shape. The first step is to make a template showing the design for the areas that will not be sandblasted. To do this, begin with a piece of paper with an outline of the piece of glass marked on it. Then, use a marker to draw the desired design with a fairly broad tip. (You can do this design on graph paper, if it is helpful.)

▲ **2.** Place the glass on the paper, aligned with the outline. Apply a fine line of white glue, following the marks on the template.

▲ **3.** Let the glue dry, showing the pattern of the design.

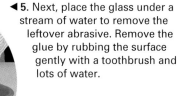

◄ **5.** Next, place the glass under a stream of water to remove the leftover abrasive. Remove the glue by rubbing the surface gently with a toothbrush and lots of water.

◄ **4.** Next, sandblast the glass. (Whenever possible, work with flat pieces of glass at this stage.) It's a good idea to wear protective clothing and long, thick gloves. *Always* wear a dust mask.

► **6.** After the design is finished, the piece is slumped, as shown. Note the contrast between the transparent, shiny lines of the reserve and the rest of the matte, translucent bowl, as well as the shadows they cast.

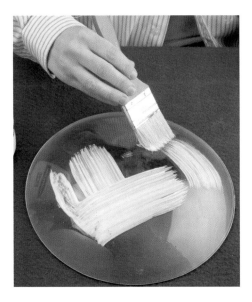

Latex

◄ **1.** Another good material for masking glass is latex. It allows you to create designs that show the strokes of a brush. Apply the latex directly to the glass with a brush of your choice (whether an artist's brush or a regular paintbrush).

► **2.** The appearance of the finished bowl after slumping is similar to the previously described one, but the design allows the brushstrokes to show, creating a different effect.

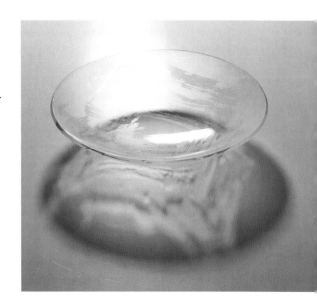

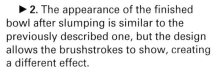

KILN CASTING AND PÂTE DE VERRE (GLASS PASTE)

*K*iln casting and pâte de verre are two techniques that share one principle: creating glass objects that take on the interior shape of a mold through the appropriate firing program. These techniques are more labor-intensive and difficult than the others that have been explained so far, and, thus, so are the phases and the progression of the firing program.

Techniques

Although kiln casting and pâte de verre are similar because they both use molds, they are two very different techniques that use different technical procedures, lending different results. Generally, kiln casting is based on creating pieces from fragmented glass or a single block inside the mold, or in a reservoir on top of it. If fragmented pieces of glass are used, they melt and fuse together more or less completely to take on the inner shape of the mold. In pâte de verre, finely ground glass paste (mixed with water or a glue solution) is put into a mold. Once the firing program is over, the glass particles join together and are still discernible to the naked eye.

Firing

The firing program for both techniques is carried out at a working temperature ranging between 1292 and 1742°F (700 to 950°C). The first stages of the firing have some special features that differ from the programs we've explained so far. In both cases, it's crucial to carry out the first phases (one through five) before beginning the rapid temperature increase phase (six) up to the working temperature. These phases dry the mold and cause the quartz inversion. These concepts will be explained in more detail later in the section on pâte de verre.

In kiln casting, there's a subsequent phase (seven) in which the working temperature is prolonged due to the granulation of the ground glass. The smaller and more finely ground the glass fragments are, the longer the holding time at the working temperature has to be for them to adapt to the mold's shape, since air bubbles are present between the tiny fragments.

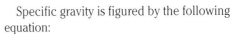

Chart for kiln casting and pâte de verre (between 1292 and 1742°F/700 and 950°C). Glass is in the range of 25 to 46 percent from leaded to float glass, and these are medium and small projects in open molds with ground glass .078 to .117 inch (2 to 3 mm) in diameter. The following is an explanation of the vertical areas of the chart on the previous page as numbered at the top:

1. Slow heating up to 392°F (200°C), increasing by a maximum of 212°F (100°C) per hour

2. Hold mode with the length of time depending on the mold's size and its dampness

3. Slow temperature increase to a point between the annealing and softening points of the glass

4. Slow temperature increase

5. Holding to stabilize the temperature inside the kiln and even out the temperature of the mold and glass. At this temperature, quartz inversion occurs, and the methylcellulose glue is burned up.

6. Rapid temperature increase

7. Working temperature

8. Rapid temperature reduction to avoid devitrification. The kiln must be repeatedly opened and quickly closed until a temperature of 1040°F (560°C) is reached. If this isn't done, the mold might split or break due to thermal shock, resulting in damaged heating elements. It's advisable to drop the temperature by about 68°F (20°C) every time you open the kiln door. Cooling should never go below 1040°F (560°C), since the kiln shelves could break.

9. Maintenance cooling at annealing temperature

10. Controlled cooling: slow temperature reduction down to the stress point

11. Slow controlled cooling and temperature reduction down to 176°F (80°C) below the stress point

12. Another temperature reduction by 176°F (80°C)

13. Cooling of kiln to room temperature

Kiln casting allows one to make pieces and items that are generally quite solid, although it's also possible to make hollow ones. The glass takes on the shape of the inside of the mold. There are various ways to do casting, but they can be summed up by two procedures: placing the solid glass inside the mold or filling the mold with fluid glass from a reservoir attached to it. The second way takes a degree of specialization that surpasses the limits of this book. So, in this section, we'll describe the process for making cast glass pieces using solid material inside an open mold, along with how to set it up and figure out how much material is needed.

Characteristics and Special Qualities

The first problem anyone encounters when learning to do kiln casting is how to calculate the amount of glass needed. (Keep in mind that glass used for casting an object should all come from the same manufacturer.)

To calculate the weight of the glass required, multiply the volume inside the mold (which the glass will occupy once it's fired) by the specific gravity of the glass:

Weight (w) = volume (v) x specific gravity (SG)

Specific gravity is figured by the following equation:

Specific gravity (SG) = weight (w) + volume (v)

The specific gravity (related to density) of a particular glass can be requested from the glass manufacturer. However, it's also possible to calculate this parameter, as shown in the following example: Cut a piece of the glass intended for casting (not too large, e.g., 1 x 2.5 inches/2.5 x 6.4 cm). Next, weigh it on a precision scale and write down the amount. Let's suppose it weighs 2.75 ounces (78 g). Next, put water into a graduated measuring device such as a laboratory test tube and fill it partway, precisely in line with a measurement. Write down this amount (let's assume it's 4.25 ounces/130 mL). Submerge the glass in the test tube, and write down the new water level (let's suppose it's 5.12 ounces/155 mL).

Do the following calculation to find out the volume of the water displaced, and thus the volume of the piece of glass:

155 mL – 130 mL = 25 mL

Then, calculate the specific gravity of the glass using the previous formula:

78 g + 25 mL = 3.1 g/mL

Thus, the specific gravity of the glass to be used is 3.1 g/mL (or g/cm3).

Once you know one of the parameters of the formula for calculating the weight of the required glass, all you need to find out is the volume inside the mold. For that, put water into a measuring device (e.g., around 800 mL), and write down the quantity. (You can also use sand instead of water, and avoid getting the mold wet.) Next, pour water into the mold until it's full. Note the amount (let's assume 450 mL), and then calculate the following:

800 mL – 450 mL = 350 mL

The result is the volume of the mold's interior. Now, apply the formula to find the required amount of glass for making the object:

350 mL x 3.1 g/mL = 1085 g

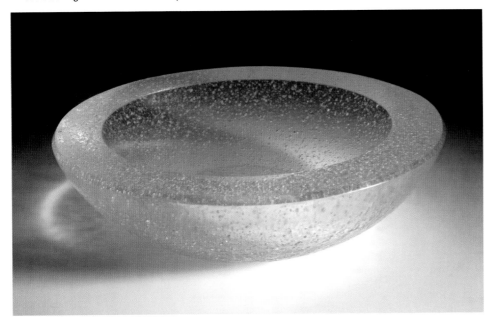

◄ Helli Aumann, 2001. Cast glass worked cold (7 x 3.5 inches/17.8 x 8.9 cm)

Firing

Firing cast glass proceeds according to a working temperature that ranges between 1535 and 1742°F (835 and 950°C). In the early stages, it shows similarities to the pâte de verre cycle, as we'll explain later.

This technique requires you to make the mold that shapes the glass. Once this is done, you'll let the mold dry at room temperature, even though it will still be necessary to put it through a drying cycle inside the kiln to insure that it's absolutely dry. In the case of the pâte de verre, a mold drying cycle in the kiln is also necessary because of the work process itself. Thus, it is essential to take the drying steps (phases one through five on the chart) that are explained in detail in the section on pâte de verre.

Next, we'll show you the chart for the firing program for making small to medium pieces of cast glass with a working temperature between 1535 and 1742°F (835 and 950°C), for a kiln with a heat source in the top.

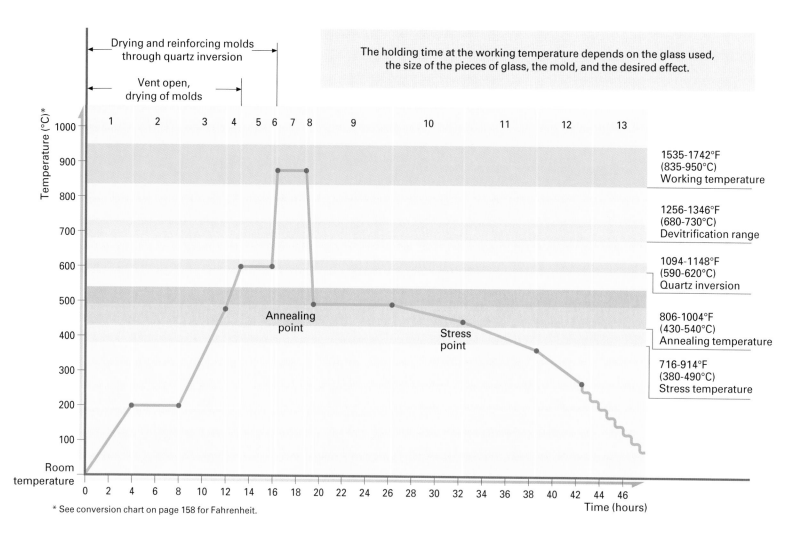

* See conversion chart on page 158 for Fahrenheit.

Chart for kiln casting (1535 to 1742°F/835 to 950°C) for small to medium items, and an explanation of the vertical areas of the chart as numbered at the top:

1. Slow heating up to 392°F (200°C), increasing by a maximum of 212°F (100°C) per hour

2. Holding phase. Its duration depends on the size of the mold and its dampness.

3. Slow temperature increase up to a point between the annealing temperature and the glass's softening point

4. Slow temperature increase

5. Holding phase to stabilize the temperature inside the kiln and even out the temperature of the mold and the glass. At this temperature, quartz inversion occurs and the methylcellulose glue is burned up.

6. Rapid temperature increase

7. Working temperature

8. Rapid temperature decrease to avoid devitrification. The kiln must be repeatedly opened and quickly closed until a temperature of 1040°F (560°C) is reached. If not, the mold may crack or break through thermal shock, and the heating elements could get damaged. It's advisable to lower the temperature inside the oven by 68°F (20°C) every time the door is opened. Cooling should never go below 1040°F (560°C), since the kiln shelves might break.

9. Maintenance cooling at annealing temperature

10. Controlled cooling: slow temperature decrease down to the stress point

11. Slow, controlled cooling, slow temperature reduction down to 176°F (80°C) below the stress point

12. Another temperature decrease by 176°F (80°C)

13. Cooling of the kiln down to room temperature. Depending on the dimensions of the piece, i.e., if it is large, intermediate steps can be added.

Granulations

Different sized glass particles, from glass dust of the finest grit to large granules, can be used to create cast objects. Even whole pieces of glass can be used. Each type of glass lends a different look to the piece. The size of the glass particles or granules is an extremely important factor, since it determines the transparency and translucence of the piece. In fact, the granulation (separation of the material according to the dimensions of the granules, particles, or fragments, and by extension, the size of the grain) determines the final appearance of the piece. This is easy to understand if you keep in mind that the ground glass granules are irregular and made up of many facets with different angles and dimensions.

The smaller the granules or particles, the greater the opacity or translucence (i.e., the less transparency) the finished piece will have. This is because if there are more within a given area, they'll join together more closely, making the glass more opaque. In a similar fashion, the larger the granules, the less opacity or translucence the glass will have, i.e., the greater the pieces' transparency. It's useful to know that the individual shape and facets of the glass make it possible to put the glass inside the molds and encourage, in part, the cohesion of the material under the right pressure.

In addition to the ground glass sold in various standard granulations, it's also possible to prepare the glass yourself. Next, we'll explain the process for preparing five different granulations of glass in the workshop.

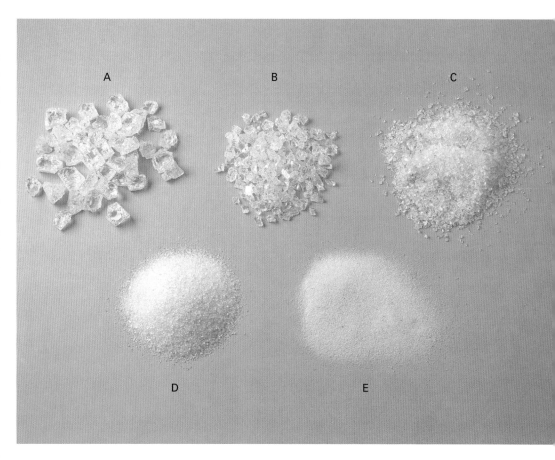

▲▼ Above, various granulations of ground glass produced in the workshop are shown. Below, you see the resulting pieces that correspond to each. Note the variation in transparency among them.

Making Ground Glass

It's very easy to make ground glass that's appropriate to your needs. In the section that follows, you'll see how to prepare five different granulations of glass. You'll be able to adapt this system to your own needs by varying the mesh of the sifters.

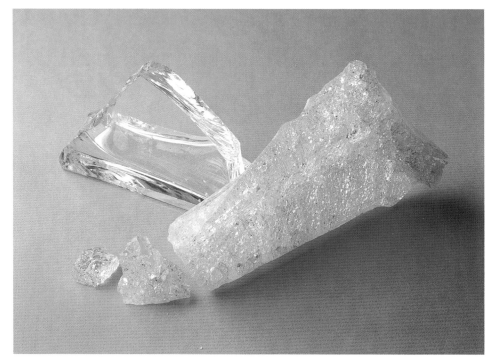

▲ 1. Heat a piece of glass (in this case, we are working with cullet for fusing), at a temperature between 932 and 1112°F (500 and 600°C), and then place it in a container with plenty of water. The result is thermal shock due to the quick temperature change that causes cracking in the body of glass. This photograph shows a fragment of glass with its original appearance behind one that has cracked from thermal shock.

▲ 2. Next, put cracked glass inside newspaper so that it's wrapped completely, and strike it with a hammer. Beat it until all the glass is ground up.

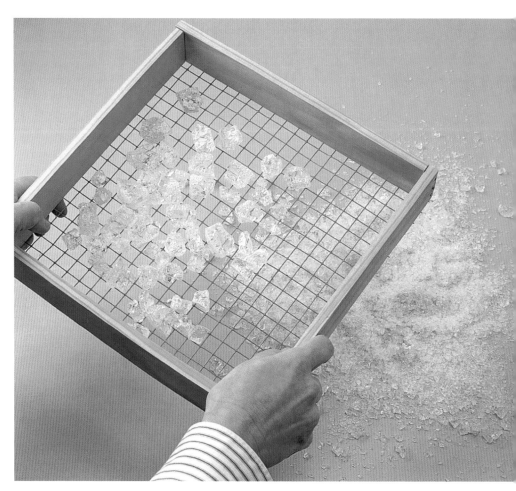

▶ 3. Sift the glass using a strainer. (The one shown is made from strips of wood and metal mesh with ⅜-inch [1 cm] openings.) The larger pieces will be strained out, and the finer granules will fall through the mesh to the work surface.

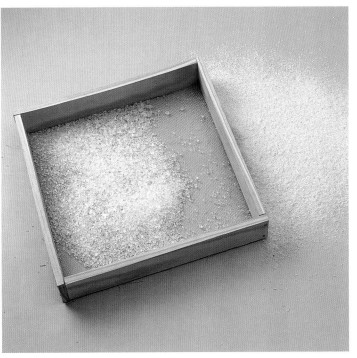

▲ 4.Take the pieces of glass left on the mesh, and repeat the process, once again grinding the glass wrapped in newspaper. This time, sift the glass through a strainer with a mesh that has openings about half the size of the previous one. Take out the pieces remaining on the mesh.

▲ 5. Use a metal mortar to grind the glass. It's easy to make one in the workshop from an iron pipe with a large diameter that has an end soldered shut. Then, sift the glass through a strainer with an even smaller mesh, around $\frac{1}{32}$ inch (1 mm).

◄ 6. Finally, separate the finest granulation. Sift the glass through a household strainer with a slightly smaller metal mesh than the previous one. Now you've produced five different granulations of the same glass.

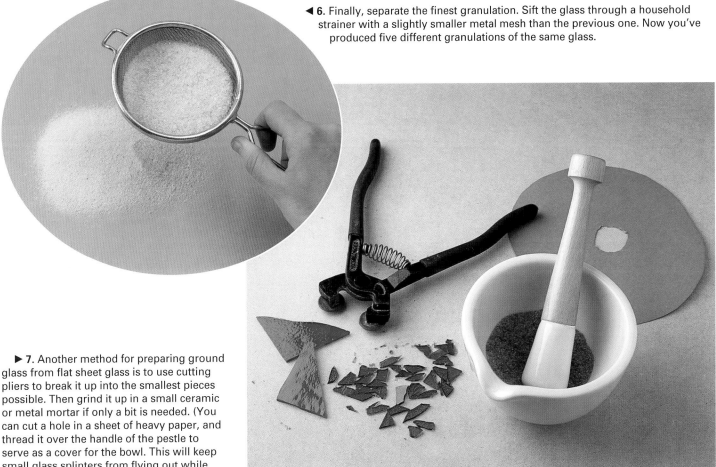

► 7. Another method for preparing ground glass from flat sheet glass is to use cutting pliers to break it up into the smallest pieces possible. Then grind it up in a small ceramic or metal mortar if only a bit is needed. (You can cut a hole in a sheet of heavy paper, and thread it over the handle of the pestle to serve as a cover for the bowl. This will keep small glass splinters from flying out while you grind the pieces.)

Making a Piece

Once you understand the main concepts of kiln casting, it's possible to make some work. Of course, the degree of complexity depends on the mold and casting method you use. Here we'll show you how to make a piece from a mold made from a mollusk shell (see pages 73 to 77). There are many methods and types of molds, but explaining them all would be impossible here. So we've chosen to show an example that's relatively easy in order to illustrate a basic process that can be used to create attractive items.

For this project, you'll need glass for casting (cullet), all fragments of which are from the same piece. The working temperature of the firing program (see page 106) is 1535 to 1652°F (835 to 900°C). You'll also see how to calculate the amount of glass you need.

◄ Diana Hobson, *Talking Stick*, 1994. Cast glass and bronze. 20.5 inches (52 cm) long

▲ **1.** The first step is to calculate the amount of glass needed to make the item. First, fill the cup with a particular amount of water, in this case 800 mL (24 oz.).

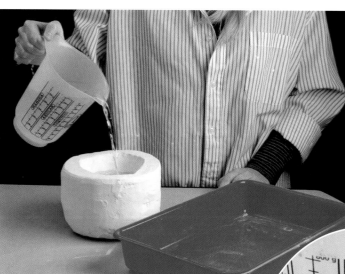

◄ **2.** Next, fill the mold with water to the level that the glass will occupy in it.

▼ **3.** Pour the water out of the mold and into a tray. Do this quickly to keep the mold from absorbing moisture.

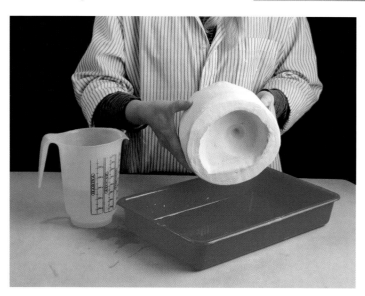

► **4.** Pour the water from the tray into the measuring cup. In this case, the water measures 450 mL (14 oz.).

$$\begin{array}{r} 800 \\ -450 \\ \hline 350 \text{ mL} \end{array}$$

◄ **5.** Thus, the mold's capacity is 450 mL (14 oz.). Multiply the specific gravity of the glass by this quantity, in this case it is 3.1 g/mL (.108 oz.). The result is 1085 grams (38 oz.), the amount of glass needed to make the object.

$$\begin{array}{r} 350 \\ \times 3.1 \\ \hline 1085 \text{ g} \end{array}$$

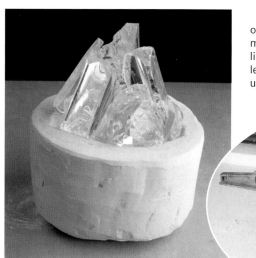

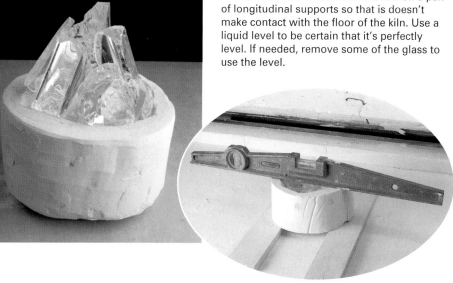

▲ 6. Next, weigh out the glass in a pan on a scale before cleaning it.

▲ 7. Put the glass in the mold. Place the roundest and most regular ones in the middle of the mold, and arrange the longest ones with their points meeting over the center of the opening.

▼ 8. Place the mold inside the kiln on a pair of longitudinal supports so that is doesn't make contact with the floor of the kiln. Use a liquid level to be certain that it's perfectly level. If needed, remove some of the glass to use the level.

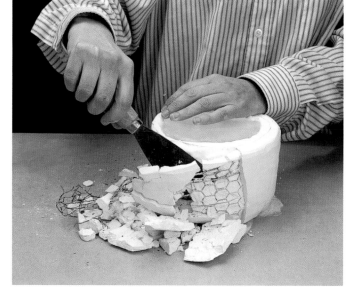

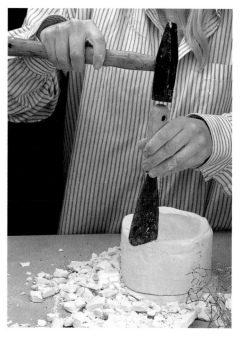

◄ 9. Once the firing is complete, remove the outer layer of the mold. Use a putty knife as a lever to pry out the chicken wire surrounding the inner layer.

► 10. To break apart the mold, hold a tool (such as a putty knife) perfectly vertical and use great care to keep it from touching the glass. Use a hammer to apply a light blow to the end of the handle.

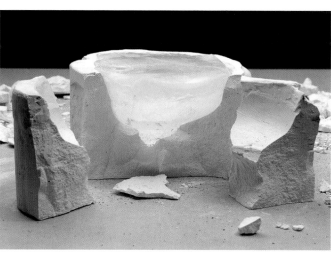

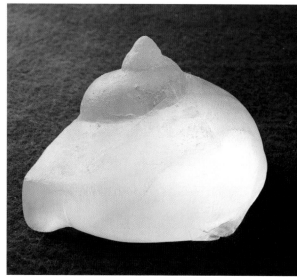

◄ 11. The mold will break apart in pieces. Repeat this step until the object is completely freed up.

► 12. This is the finished piece after it is extracted from the mold.

Common Problems

Next, we'll identify some of the most common problems that you might encounter when you make pieces using the cast glass method.

Excessive Moisture in the Mold

Too much moisture in the mold results from improper drying (see phases one through five in the firing chart on page 106). This problem can result in surface bubbles in the glass.

Mold Not Leveled Properly

A mold that isn't level inside the kiln will result in a piece that's off-center. In some cases, the glass will overflow and land on the kiln.

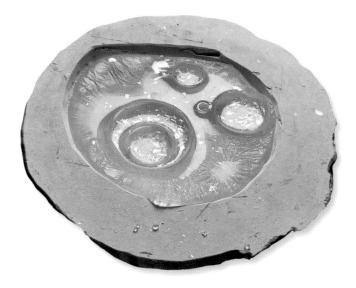

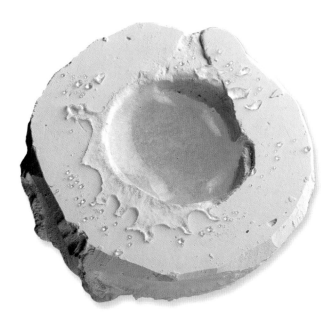

▲ This is a piece similar to the one made in the previous section, but the mold wasn't properly dried, resulting in surface bubbles. This effect can also happen in cases where the proper maintenance of the working temperature wasn't observed.

▶ Too much glass was used to make this piece. As the photograph shows, the glass has run over onto the top of the mold, creating some ugly edges. The excess glass can be removed through grinding and polishing, but this involves a lot of work that could have been avoided through accurate calculation.

▲ This photograph shows the results of a poorly leveled mold. In one area of the mold, the glass has flowed over the edge; on the other side, the glass didn't reach the top of the mold.

Just like glass pieces made by any other technique, cast glass items can be finished in several ways. In the previous section, we explained one basic way to make pieces using an open mold. One characteristic of these is that the top (in other words, one face) must be flat. Now we'll explain how to use abrasives to polish large, flat pieces of glass. This finish is always applied wet, and the work begins by smoothing off the irregularities. After this step, the piece is polished with a coarse-grit abrasive, then a finer one, and finished up with abrasives to produce a superfine polish.

Now we'll explain the complete polishing procedure for the piece illustrated on pages 110 and 111. These steps show the results of intermediate polishing. We'll introduce a few abrasives, but you'll have to choose the ones most appropriate for the piece and the effect that you want. In all cases, you'll begin the polishing with rough abrasives and finish with finer grits. This procedure can also be done with abrasive blocks, following the appropriate number system that corresponds to the grit.

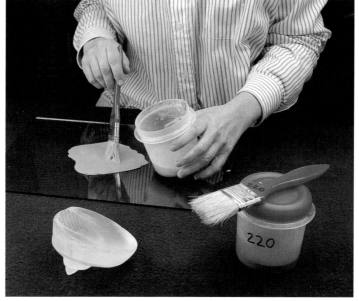

◄ 1. You'll begin by smoothing down the piece with carborundum. Place abrasive mixed with water on a sheet of glass. (Here, we've used 80-grit followed by 220.) Mark every container of mixed carborundum with its number. Also, mark the brushes used to dispense it, which must always be used with the same grit of abrasive.

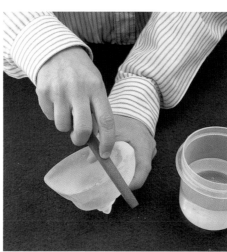

► 2. Next work on the angles of the piece, smoothing the glass with a bar of 220-grit carborundum to create the desired shape.

▲ 3. Place the flat side of the piece in contact with the abrasive and move it around in a circular pattern. Then wash it off with water and evaluate the progress. Use a broad-tipped permanent marker to indicate areas on the surface that need more polishing or still exhibit irregularities.

▲ 4. This photograph shows the difference between two polishings done with different grits. Piece A, polished with 80-grit carborundum that's quite opaque, has a textured surface; and piece B, polished with 220, is more translucent and its surface is smoother.

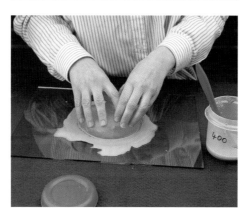

▲ 5. Next, continue the polishing with 400-grit carborundum, using the procedure already described, and wash the piece off with water. Repeat the same procedure with different grits of abrasive, and finally with cerium oxide, to produce an extremely fine finish.

► 6. The final piece after polishing. The polished, smooth surface, which is completely transparent, makes it possible to appreciate the shape of the piece and the nature of the material.

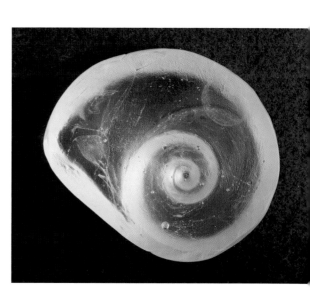

Pâte de Verre *(Glass Paste)*

The technique of pâte de verre involves using ground glass to make pieces. In general, the glass is placed inside a mold and fired with a specific program that fuses the particles together. Pieces made using this technique have certain special characteristics, such as translucence and a granular texture, and their surface has a rocklike quality.

The cast glass technique might be considered a type of melting or casting, even though it has some features that make it a technique unto itself. There are various ways of making items from ground glass and other materials, and all artisans or artists adapt them to their needs through individual methods. Thus, the technique makes it possible to use different systems that give various results. With pâte de verre (or ground glass) it is possible to make everything from volumetric pieces with very thin walls to large volumetric pieces and flat pieces.

The glass that is placed inside the mold (which will remain moist throughout the process) must logically have a certain degree of cohesion to maintain the desired arrangement during the steps leading up to the firing. This is achieved by mixing the ground glass with water or a solution of methylcellulose glue, forming a thick, semi-solid paste that lends the technique its name. Keep in mind that ground glass must be thoroughly cleaned before it's used.

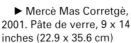
► Mercè Mas Corretgè, 2001. Pâte de verre, 9 x 14 inches (22.9 x 35.6 cm)

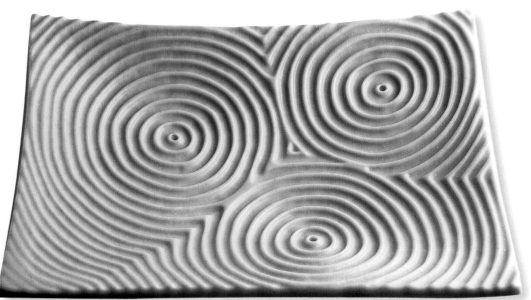

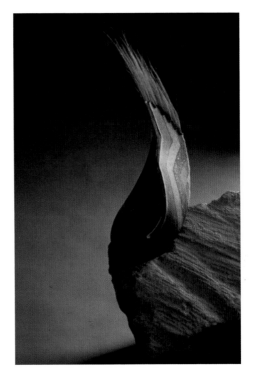

◄ Diana Hobson, *Benu Bird*, 1990. Pâte de verre with limestone, sand, and ceramic coloring agents, 12 inches (30.5 cm) high. Photo by Durell Bishop

Firing

The firing program for pâte de verre pieces involves some special features in comparison to the cycles of other techniques already explained.

In general, the working temperature ranges between 1292 and 1472°F (700 and 800°C), varying according to the glass, the granulation used, and the mold's size or dimensions. The specific characteristics of this technique are defined by the phases required for drying the mold. As we know, pâte de verre is ground glass mixed with water or water-based glue, and it requires a moist mold that has been made recently. This has an effect on the first phases of the firing, during which the mold will be dried in several stages and the methylcellulose glue burned up. If this isn't done properly, certain problems can arise, such as the appearance of surface bubbles or mold fracture. Drying (phases one through five on the chart on page 106) requires a fairly long time and is comprised of several periods. During the first drying period (phases one through three), the chimney or openings in the kiln must stay open to let steam escape. First, use a slow heat, followed by a holding stage that will always vary with the dimensions of the mold and its degree of moisture. Finally, slowly increase the temperature to a point between the stress and annealing temperature.

Next, close the openings or the chimney of the kiln. The second period begins (phases four, five, and six) with a first slow heating phase up to a temperature of around 1148°F (620°C) (between 1094 and 1148°F/ 590 and

620°C), which is the range in which the quartz inversion takes place (reinforcing the molds), and the combustion of the methylcellulose glue begins. This is followed by a holding phase during which the temperature of the mold, the glass, and the oven is stabilized. When pieces made using methylcellulose glue are fired, the piece has to be watched during this phase to be sure that the glue has completely disappeared; if it hasn't, and there is still a black film on the glass, the holding period has to be extended. Finally, the temperature is raised quickly up to the working temperature. As the adjoining chart shows, the firing program has to be longer than with the techniques explained earlier.

Chart for pâte de verre (1292 to 1472°F/700 to 800°C) for pieces with small and medium molds with ground glass in a size of .078 to .117 inches (2 to 3 mm). Below is an explanation of the vertical areas of the chart as numbered at the top:

1. Slow heating up to 392°F (200°C), increasing a maximum of 212°F (100°C) every hour

2. Holding phase. The duration of this phase depends on the size of the mold and its moisture content.

3. Slow temperature increase up to a point between the annealing and softening points

4. Slow temperature increase

5. Holding phase to stabilize the temperature inside the oven and even out the temperature of the mold and the glass. Quartz inversion occurs at this temperature, and the methylcellulose glue (MCG) is burned up.

6. Rapid temperature increase

7. Working temperature

8. Rapid temperature reduction to avoid devitrification; the kiln must be repeatedly opened and closed until the temperature goes down to 1040°F (560°C). If this isn't done, the mold could crack and break from thermal shock, and the heating elements could be damaged. It's advisable for the temperature to drop about 68°F (20°C) every time the door is opened. The cooling should never go below 1040°F (560°C), since that might cause the kiln shelves to break.

9. Maintenance cooling at annealing temperature

10. Controlled cooling: slow temperature decrease down to the stress point

11. Slow, controlled cooling, slow decrease in temperature down to 176°F (80°C) below the stress point

12. Another 176°F (80°C) temperature decrease

13. Cooling of kiln down to room temperature

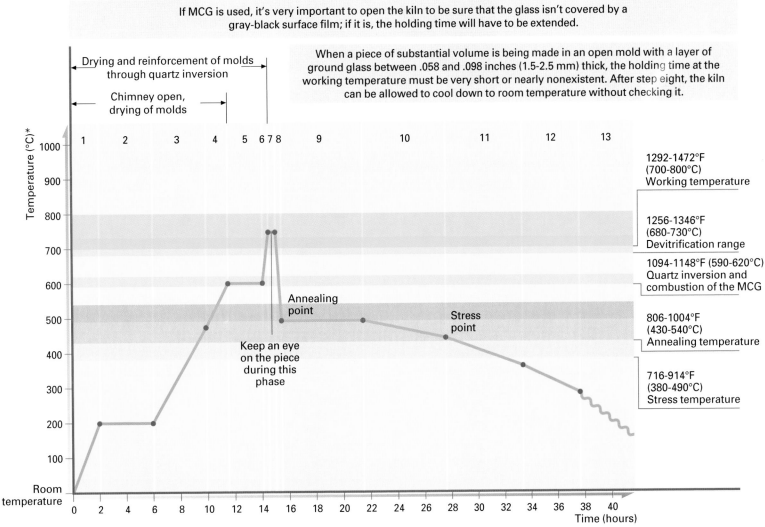

If MCG is used, it's very important to open the kiln to be sure that the glass isn't covered by a gray-black surface film; if it is, the holding time will have to be extended.

Drying and reinforcement of molds through quartz inversion

Chimney open, drying of molds

When a piece of substantial volume is being made in an open mold with a layer of ground glass between .058 and .098 inches (1.5-2.5 mm) thick, the holding time at the working temperature must be very short or nearly nonexistent. After step eight, the kiln can be allowed to cool down to room temperature without checking it.

Temperature (°C)*

1292-1472°F (700-800°C) Working temperature

1256-1346°F (680-730°C) Devitrification range

1094-1148°F (590-620°C) Quartz inversion and combustion of the MCG

806-1004°F (430-540°C) Annealing temperature

716-914°F (380-490°C) Stress temperature

Annealing point

Stress point

Keep an eye on the piece during this phase

Room temperature

Time (hours)

* See conversion chart on page 158 for Fahrenheit.

Making a Shaped Piece with Thin Walls

As we've already explained, there are lots of ways to make objects using pâte de verre, depending on the work you want to make, the size of it, and your work procedure or preferences. Making pieces from ground glass always takes lots of work, regardless of the shape, size, and method you use. The factors of time and work are two constants that have to be kept in mind when you begin any piece. In fact, placing the correctly prepared paste in the mold, arranging it, and packing it in a way that eliminates trapped air among the particles of glass involves fairly arduous work requiring lots of patience and skill.

Making volumetric, hollow pieces can involve the use of very elaborate molds, although with small pieces, it may be possible to use simpler methods. Next, we'll show the procedure for making a pair of small, decorative bowls of various colors using a firing temperature that has a working temperature between 1292 and 1472°F (700 and 800°C).

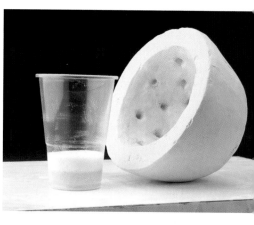

▶ **1.** First, make the mold with two parts silica and one part molding plaster (2:1 by volume). (Molds for small items with thin walls or flat pieces of pâte de verre are never reinforced with wire mesh.) Next, choose the compatible glass colors that you want to use. Here, a bit of colored glass (an orange-yellow in this instance) has been put into a container (a clear plastic cup), and it is mixed with the same volume of clear ground glass.

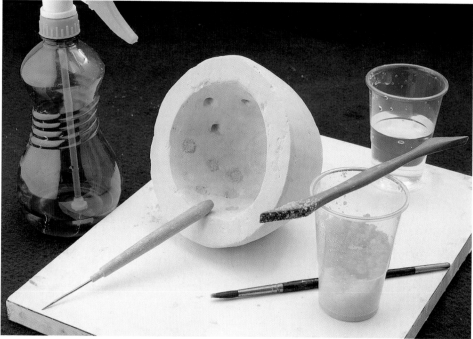

▲ **2.** Always use a moist mold in all procedures involving pâte de verre. If the mold has dried out before the work is begun, moisten it again by putting it into a container of water for a few minutes. In this example, we're filling in the holes inside the mold that will end up as projections on the bowls. When working with the glass paste, add a small quantity of water to the mixture to keep the granules together. To press the pâte de verre into the mold, you can use a spatula followed by the handle of the needle tool.

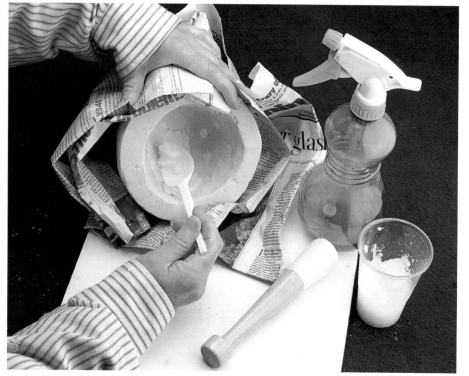

◀ **3.** Wrap the mold with newspaper to absorb any excess water that oozes through the outer wall. Whenever needed, moisten the glass with a spray bottle, since the mold will absorb the water. Next, use a plastic spoon to spread the pâte de verre inside the mold; this layer will become the walls of the bowl. In this project, the walls will be clear in one bowl and blue in the other (a paste made by mixing light blue and clear glass). Once the paste is placed, pack it in using the pestle. Turn the mold around and cover the whole interior with a layer of uniform thickness between .058 and .078 inches (1.5 and 2.5 mm).

A POTENTIAL PROBLEM

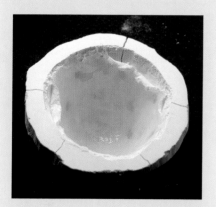

Here, the firing program for the transparent bowl wasn't right, since the proper working temperature was exceeded. This caused excessive melting, and the glass fell toward the inside of the piece. This problem can also occur when the working temperature is maintained for too long.

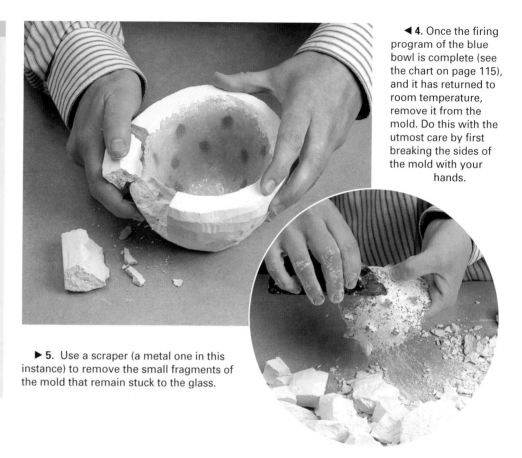

◀ **4.** Once the firing program of the blue bowl is complete (see the chart on page 115), and it has returned to room temperature, remove it from the mold. Do this with the utmost care by first breaking the sides of the mold with your hands.

▶ **5.** Use a scraper (a metal one in this instance) to remove the small fragments of the mold that remain stuck to the glass.

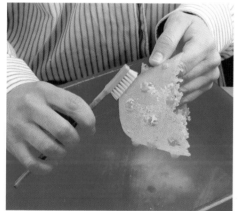

▲ **6.** Finally, wash the piece and the outer surface of the bowl. Scrub it with a toothbrush to eliminate all traces of mold material.

▶ **7.** After remaking the clear bowl, here are the final pieces with typically translucent walls. Notice that the inside of the bowls is still rather "fire polished," or smooth and shiny from the firing, while the outside has a grainy texture. This is especially visible in the blue one.

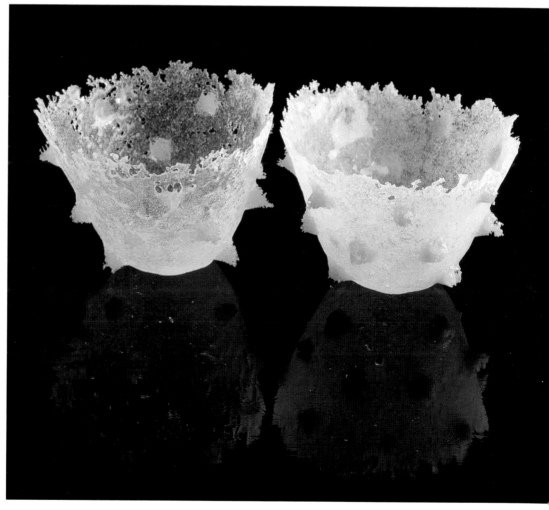

Making a Flat Piece

The procedure for making flat pieces with pâte de verre varies only slightly from the previous method. As before, the pâte de verre is placed in the mold's interior and pressed down to completely fill the space. Once that process is done, the whole surface of the piece is covered with clear ground glass.

Since it melts during the firing program, the volume of the clear glass will be reduced to one-third of the initial volume.

Next, we'll show you steps for making a decorative plate with a pomegranate motif. The firing program has a working temperature between 1292 and 1472°F (700 and 800°C). In this instance, methylcellulose glue is used with the pâte de verre. As in the previous case, the work begins with a previously prepared mold made of two parts silica and one part molding plaster (2:1 by volume). The mold is made with sides that serve to support the clear glass.

▲ **1.** First, prepare the methylcellulose glue (MCG), and mix it with ground glass according to the manufacturer's specifications. Then, if needed, touch up the mold. For instance, we wanted to make the pomegranate seeds appear in relief. To that end, we retouched the mold by scooping out the inside of the seeds with a loop tool. Then a small artist's brush was used to remove any dust.

▲ **2.** Select the appropriate granulation of glass next (in this instance, the finest and the next larger size), along with the colors of ground glass that you want to use. Mix each color with the same volume of clear glass, and then with the previously prepared methylcellulose glue. The pâte de verre (here, a raspberry red color) is packed into the seeds with a spatula.

▼ **3.** Then press it down (here, we used the handle of the needle tool) so it fills in the shapes and eliminates air between the particles. These first details to fill in are the ones that will project out from the piece the most once it's finished, followed by the shapes that will make up the rear planes, and then the background.

▲ **4.** This photo shows the colors we used: amber brown for the shell of the pomegranate, emerald green for the leaves, light amber for the background of the seeds, and blue for the background of the composition. Once the shape of the shell is filled in, the leaves, and then the bottom of the seeds are filled in, covering the latter entirely in red. Finally, the whole composition is covered with the background color. Keep in mind that the spray bottle can be used to moisten the paste whenever necessary.

▲ **5.** Cover the plate with already moistened clear ground glass. The volume needed is a third of the volume of the piece. Next, place it inside the kiln on a plate held up by three cylindrical kiln posts with a layer of sand underneath. The sand makes it easier to level the mold and encourages airflow inside the kiln.

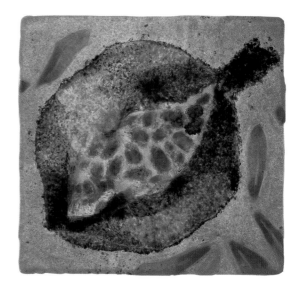

▲ When the plate is illuminated from behind, you can see the gradations of transparency.

▲ **6.** After the piece is fired, verify the combustion of the methylcellulose (see phase five of the firing program on page 115). Remove the plate by breaking the mold very carefully. Remove the remains of the mixture stuck in the cracks with water and a gentle scrubbing with a toothbrush. Use a wooden dowel to clean out the nooks and crannies.

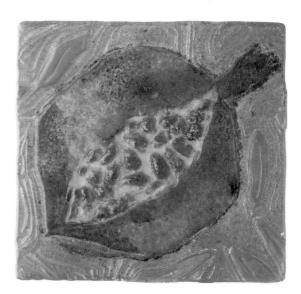

▲ In this photo, you can see the translucence and formal features of the piece at the same time.

▲ **7.** Polish the surface of the plate by rubbing it with a diamond-covered block (600-grit, in this instance) that has been previously moistened with water.

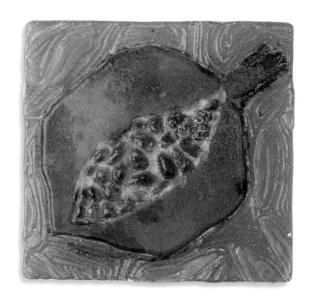

▶ Finally, in this photo (with the piece illuminated from above at an angle), you can see all the formal features of the piece, particularly the opaque appearance and texture of the surfaces, plus the relief in the plate.

In this last chapter of the book, you'll see how to make four items from glass using kiln techniques—a lighted panel, a bowl with inclusions, a vase, and a decorative centerpiece. The exercises are arranged in order of their difficulty so you can build on your knowledge. Each one shows all the steps for making an object, from making the mold or pieces, right up to the final finish. We'll also explain the firing programs for each one.

In the production of each piece, several technical procedures are performed that all require at least two firing programs. The panel is done using full fusion and slumping on a ceramic fiber mat, both performed at the same time in the first firing, and slumping on a final mold in the second firing. The bowl with inclusions was first made with the inclusions, and then finished up with the thermoforming. The vase was created from pieces made with tack fusing, joined in a mold using the same technique and made into the desired shape by draping. Finally, the decorative centerpiece was made using pâte de verre and a final thermoforming. The exercises have been carried out with a clear instructional purpose so that readers can use them as a work guide and a source of inspiration.

Step-by-Step
Exercises

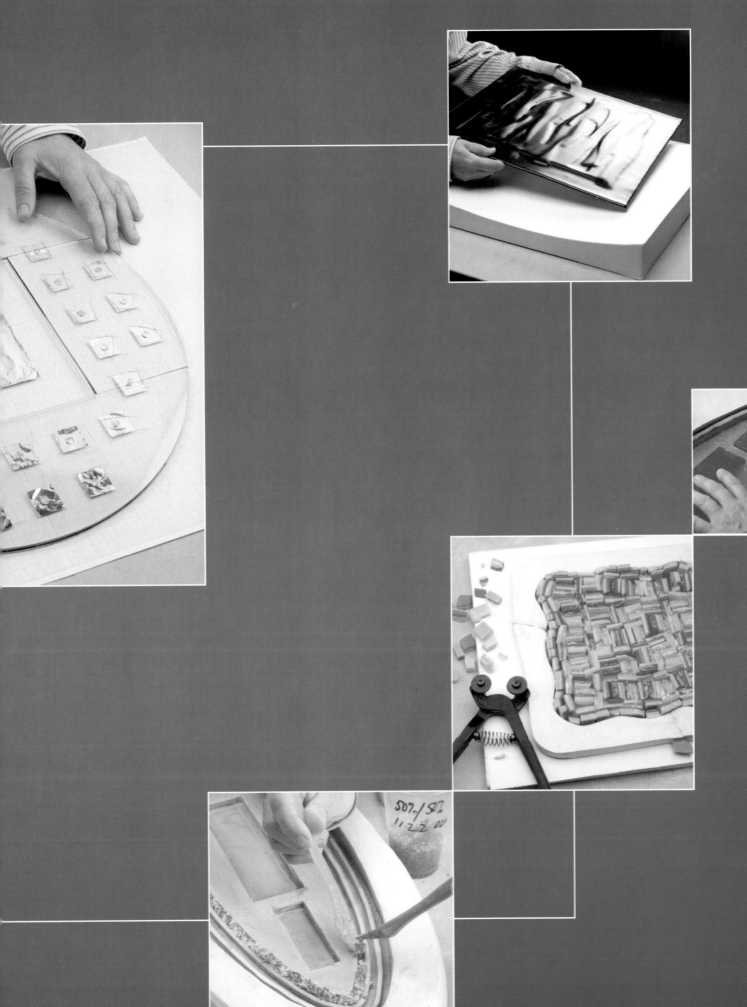

Lighted Panel

In this first project, we'll explain how to make a lighted panel that hangs on the wall. The glass is mounted on a structure that coordinates with the lighting fixture. The piece is made using several processes, incorporating two different techniques in the first firing. First, thermoforming and full fusion are done on the ceramic fiber mat, and then a second thermoforming is done on a ceramic mold to create the curvature of the panel. For this particular project, we've used common cathedral glass in lilac color that is .117 inch (3 mm) thick.

The chart shows, in detail, the two firing programs needed for making this panel; they are for a kiln with a heat source in the top. The first firing, in which the slumping on the ceramic fiber mat and the full fusing are carried out at the same time, is presented in orange. We should point out one special feature: the phase before the holding at the working temperature (number five), which includes a slight temperature increase (from 1454 to 1490°F/790 to 810°C in 20 minutes), followed by a very brief holding phase (number six) for five minutes. This slight temperature increase gives the glass more relief and more pronounced shapes. The second cycle, in which the thermoforming is accomplished, is presented in blue.

First Firing										
Step	Time		Temp. (°C)*	Step	Time		Temp. (°C)*			
1	90′	→	540°	6	5′	=	810°			
2	30′	→	590°	7	1′	→	530°			
3	30′	=	590°	8	90′	=	530°			
4	1′	→	790°	9	135′	→	450°			
5	20′	→	810°							

Second Firing										
Step	Time		Temp. (°C)*	Step	Time		Temp. (°C)*			
1	120′	→	540°	6	1′	→	530°			
2	30′	→	590°	7	120′	=	530°			
3	30′	=	590°	8	180′	→	460°			
4	30′	→	630°							
5	5′	=	630°							

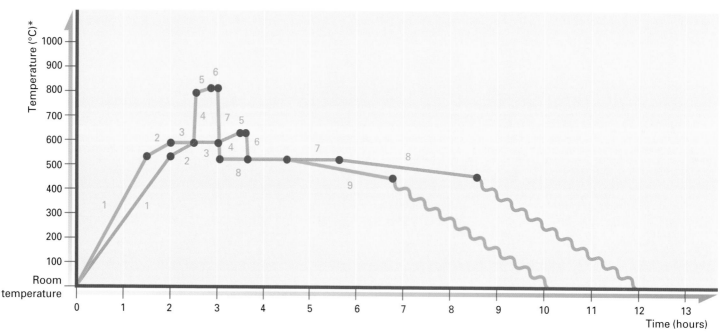

* See conversion chart on page 158 for Fahrenheit.

◄ **1.** Choose a sheet of cathedral glass, and cut out a 15¾ x 15¾-inch (40 x 40 cm) sheet from it. Cut out the ceramic fiber mat using gloves and a dust mask. Our sheet measures 12 x 12 inches (30.5 x 30.5 cm). Next, use a pencil to mark off the shapes that you want the glass to take on during thermoforming. (For our project, six shapes with wavy sides and a straight end are marked off.) Cut the shapes out with a very sharp hobby knife.

► **2.** After cutting out all the shapes (note that no two are the same), arrange them on the mat as shown in the photo so that a three-level slumping mold can be made.

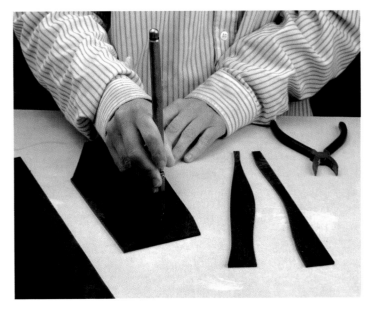

▼ **3.** Center the cathedral glass perfectly on top of the ceramic fiber mat.

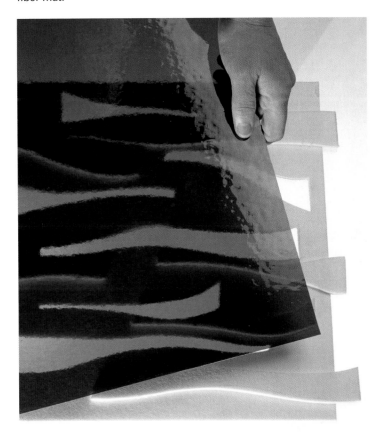

▼ **4.** Next, use cathedral glass from the same sheet. Make the pieces for the full fusing and place them on the glass by marking off pieces with curved sides, similar to the previous ones. Break them out with pliers.

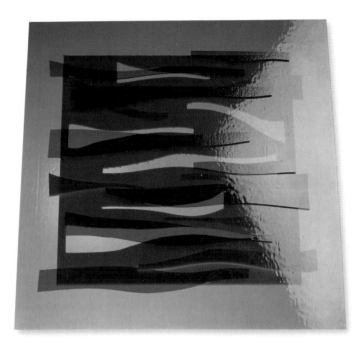

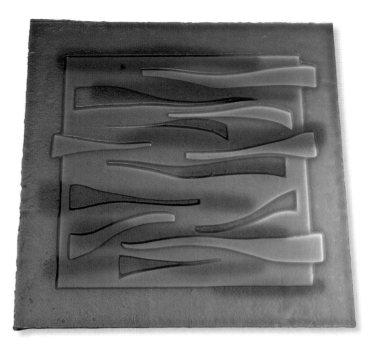

▲ **5.** Arrange these pieces on top of the other glass in such a way that they create different shades of color with darker and lighter areas.

▲ **6.** Place the ceramic fiber blanket into the kiln on a plate covered with ceramic paper, and place the cathedral glass on it in the desired design. The plate has to be properly leveled, and the paper slightly larger than the glass, since it will tend to shrink. Carry out the first firing. Notice that the piece exhibits some interesting contrasts in shapes and colors.

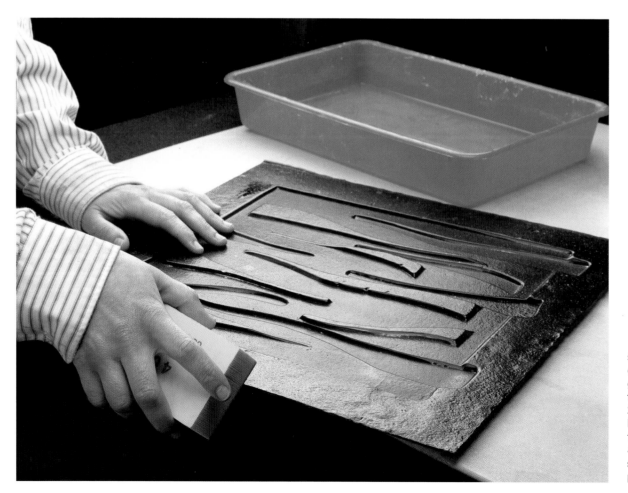

◄ **7.** Next, smooth the edges of the piece of glass. Abrade them with a 220-grit diamond block, and then finish it up with 400-grit, as shown in the photograph.

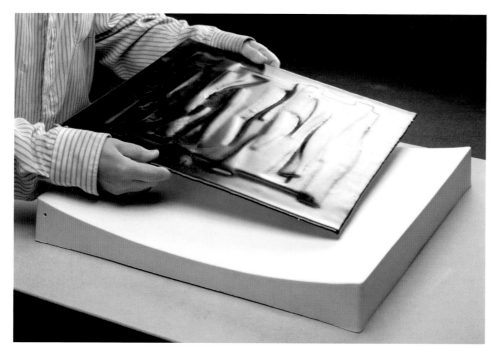

◀ **8.** Place the glass on the curved mold that has been prepared in advance. Place the face of the glass with the greatest relief in contact with the mold in such a way that the panel, once finished, has a convex shape on the face that is decorated with the relief. Then, place the mold inside the kiln and carry out the second firing program.

▼ **9.** The look of the finished panel. Note the interplay of shades and relief highlighted by the light behind the panel.

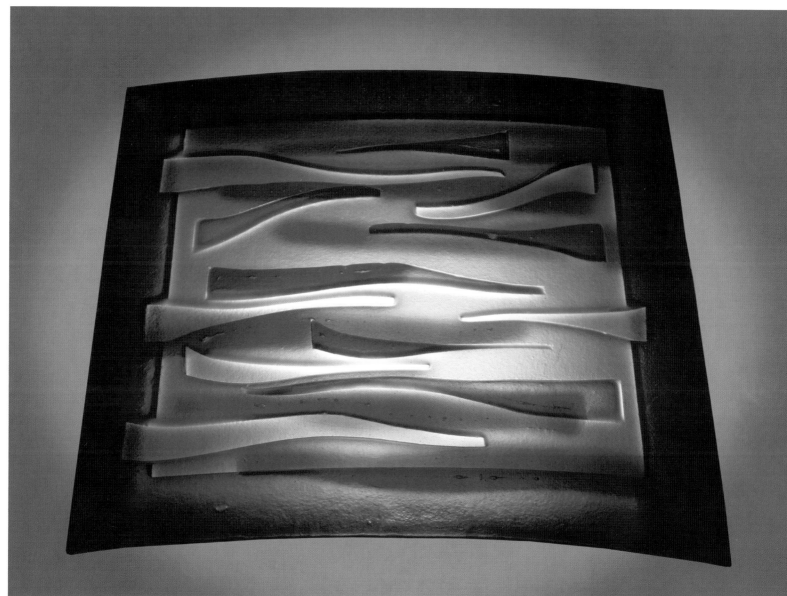

Bowl with Inclusions

*U*sing the instructions in this exercise, it's possible to make a bowl from
float glass with inclusions such as silver leaf, copper sheet and wire,
and aluminum foil.

*This project depends on cutting various pieces of glass properly. To this end,
it's absolutely essential to apply the information on float glass previously
presented: The need to avoid joining or fusing two faces that came into contact
with the tin bath during the manufacturing process. You'll see how it's
possible to add a touch of color using silver leaf and other inclusions, and
how they act inside the kiln.*

Firing

The temperature curve for proper programming of the kiln in the two firings is as follows: The first is for creating the fusion of the three layers constituting the thickness of the bowl (three layers of .117 inch/3 mm float glass). The other curve corre-

sponds to the thermoforming firing. The heat source is in the top of the kiln. You could fuse and slump in a single firing, but in this case, that might cause some problems. As we explained in a previous chapter, the glass is thermoformed at a temperature lower

than the melting point. So, if both techniques are done on this piece at the same time, the pieces might move toward the center of the bowl.

| First firing | | | | | | | | Second firing | | | | | | |
|---|---|---|---|---|---|---|---|---|---|---|---|---|---|
| Step | Time | Temp. (°C)* | Step | Time | Temp. (°C)* | | | Step | Time | Temp. (°C)* | Step | Time | Temp. (°C)* |
| 1 | 140′ | → 560° | 6 | 15′ | = 810° | | | 1 | 180′ | → 560° | 6 | 1′ | → 540° |
| 2 | 30′ | → 590° | 7 | 1′ | → 540° | | | 2 | 30′ | → 590° | 7 | 150′ | = 540° |
| 3 | 30′ | = 590° | 8 | 100′ | = 540° | | | 3 | 30′ | = 590° | 8 | 225′ | → 460° |
| 4 | 1′ | → 790° | 9 | 150′ | → 460° | | | 4 | 30′ | → 700° | | | |
| 5 | 30′ | → 810° | | | | | | 5 | 15′ | = 700° | | | |

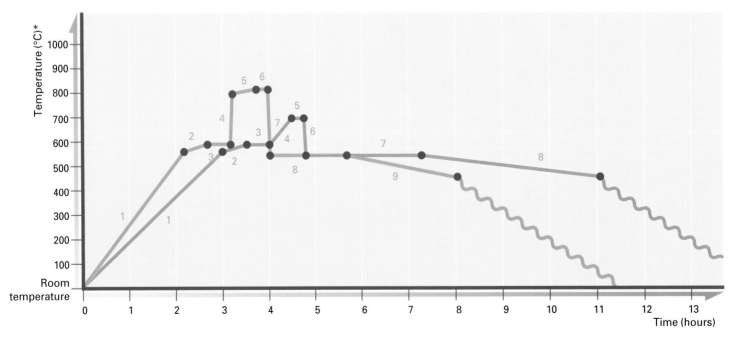

* See conversion chart on page 158 for Fahrenheit.

▶ **1.** First, use a compass to cut out three circles of float glass that are .117 x 14 inches (3 mm x 35.6 cm) in diameter, taking care not to turn them over. Next, clearly differentiate the faces containing tin, and mark them. Use a scrap of glass, which will be set aside, to conduct a simple silver stain test. Once this piece has been fired, compare how the tinned face causes the silver stain to turn red, while the face that has no tin keeps its natural yellow color. Use an indelible felt-tip marker to indicate the tinned face with a letter B, and mark the other face with an A.

▼ **2.** Draw the same-sized circle on graph paper, and mark off a square of 6¼ inches (15.9 cm) per side in the central piece of glass. This square will be equidistant from the edge of the circle by 3.9 inches (10 cm). Next, place the glass on the paper so that you can trace the cutting lines on it.

▼ **3.** Quarter the circle with the cutter (also called a tracing wheel or roulette), using the square as a guide. Use the marker to mark all the fragments with the letter A.

◀ **4.** Use the marking wheel and a square to make ⅜-inch-wide (1 cm) cuts on the square glass piece, using the graph paper pattern as a guide. These form the grid on the base of the bowl.

◀ **5.** Once the roulette has been used to mark off the lines, break out the glass with the aid of the pliers, carefully separating each strip. Mark the cutting lines evenly to properly and easily extract the strips so that they don't break or turn out uneven.

▼ **6.** Cut out the same number of strips in the same dimensions from the scrap glass previously set aside. The strips of glass are marked with the letters A and B to indicate the nature of the surface, so that they can be placed properly in the construction of the grid on the bottom of the bowl.

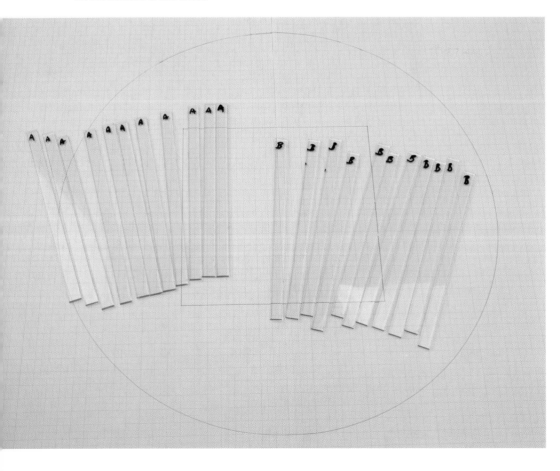

▲ **7.** You now have the glass cut out in different ways for the fusing: the base, the four circular pieces that will surround the central square, plus the strips for the grid, and the top circle. The next step involves cutting and arranging the materials that will be used for the inclusions. First of all, use a hobby knife to cut out strips of aluminum foil.

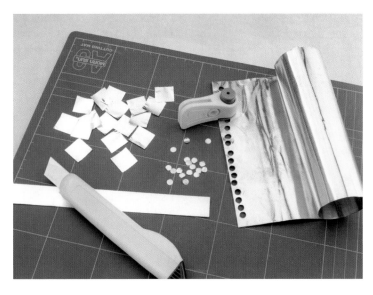

▲ **8.** Use a hole punch to cut out small circles of copper foil, and use a hobby knife to cut up the strips of aluminum foil into 1-inch (2.5 cm) squares.

▶ **9.** Before placing the inclusions onto the A face of the base, clean the two faces carefully. Once the lettering is removed, keep track of which side is which.

▼ **10.** Place the glass on top of the drawing on the graph paper, and use gel glue to glue the aluminum foil onto the desired spots to keep it in place while the inclusions are added.

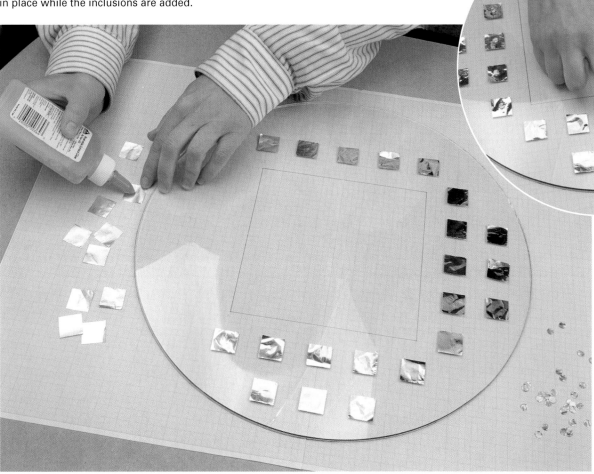

▲ **11.** Carefully center a small circle of copper on each square of aluminum foil.

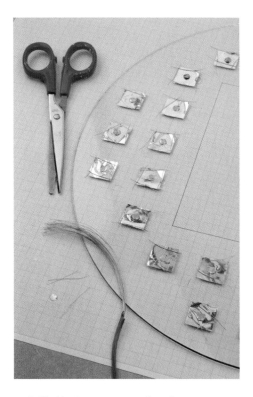

▲ **12.** Next, cut copper wires from an electrical cable and arrange them on the squares in the desired pattern.

▲ **13.** Once the inclusions are set in the desired pattern, cover the base glass with the four cleaned, circular, or lunette-shaped pieces previously cut out to form the central square. Place them with face B in contact with the inclusions.

◀ **14.** Use a spatula to place the sheet of silver leaf in the center of the central square, using great care when moving it from its paper sleeve to the glass. Since it is very thin, it could become creased and make this more difficult.

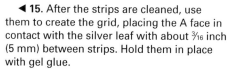

◀ **15.** After the strips are cleaned, use them to create the grid, placing the A face in contact with the silver leaf with about ³⁄₁₆ inch (5 mm) between strips. Hold them in place with gel glue.

▼ **16.** To complete the grid, place the remaining strips over the first ones, perpendicular to them, separated by ⅛ inch (3 mm) with the B face down.

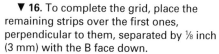
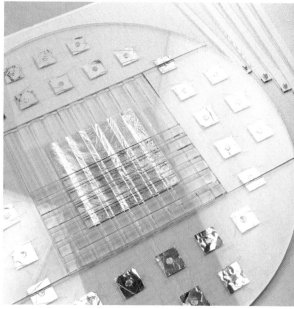

◀ **17.** Now, set the circle that will act as a cover or top layer for the bowl in place, with the A face in contact with the other pieces of glass.

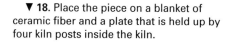

▼ **18.** Place the piece on a blanket of ceramic fiber and a plate that is held up by four kiln posts inside the kiln.

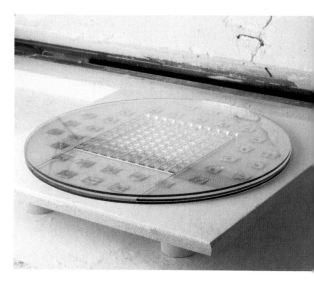

► **19.** For this project, use a kiln with a heat source in the top. Open the kiln quickly when you need to reduce the temperature, as indicated in the firing program.

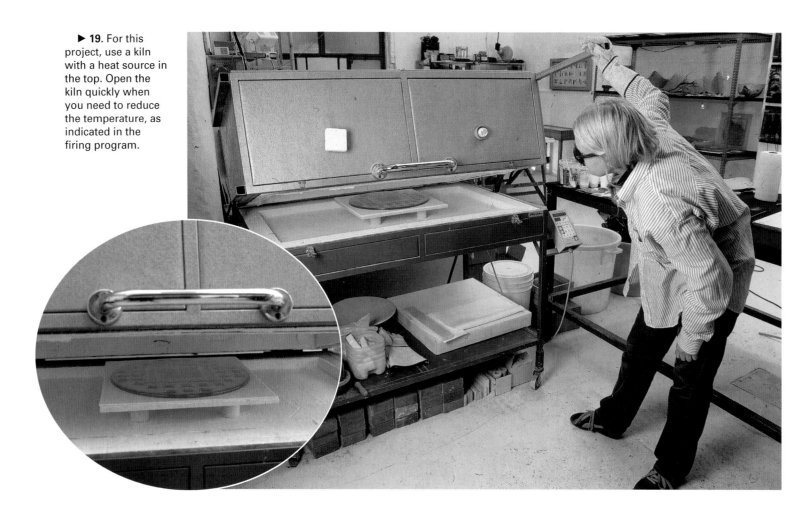

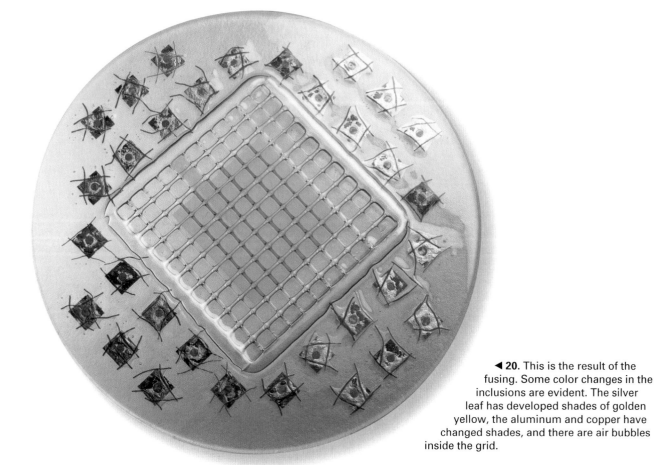

◄ **20.** This is the result of the fusing. Some color changes in the inclusions are evident. The silver leaf has developed shades of golden yellow, the aluminum and copper have changed shades, and there are air bubbles inside the grid.

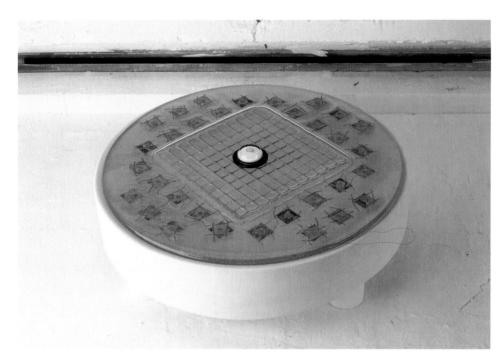

◀ **21.** Place the fused disk on a ceramic mold previously prepared with separator for thermoforming. Use a level to make sure the piece is perfectly level, and avoid problems when imparting curvature to the fused piece.

▼ **22.** The final result of fusing and thermoforming—a bowl or centerpiece of float or window glass that contains inclusions.

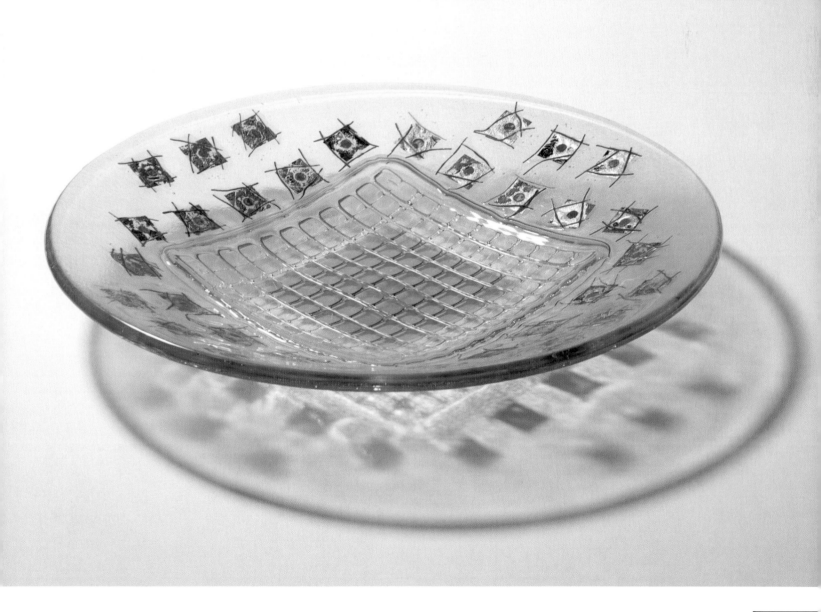

Vase of Mosaic Glass

*I*n this exercise, you'll learn how to create a vase of fused and thermoformed glass using free fall in the kiln. Compatible glass has been used, playing with different opaque colors and clear glass to create interesting transparent and opaque effects.

T his exercise uses different processes for making molds, using clay and plaster, plus several cutting procedures and three firing programs.

Firing

This chart shows three firing programs for the same steps in making the vase. The first one corresponds to fusing the different colors to make the multicolored plate from which the tiles will be cut. The second corresponds to a fusing exercise in which the multicolored glass plate is prepared, which will be slumped later in a kiln with heating elements on the sides, according to the steps in the third chart.

First Firing		
Step	Time	Temp. (°C)*
1	30′ →	540°
2	30′ →	590°
3	30′ =	590°
4	1′ →	790°
5	15′ =	790°
6	1′ →	530°
7	30′ =	530°
8	45′ →	450°

Second Firing		
Step	Time	Temp. (°C)*
1	150′ →	540°
2	30′ →	590°
3	30′ =	590°
4	1′ →	790°
5	30′ →	810°
6	15′ =	810°
7	1′ →	530°
8	120′ =	530°
9	180′ →	450°

Third Firing		
Step	Time	Temp. (°C)*
1	180′ →	540°
2	30′ →	590°
3	30′ =	590°
4	1′ →	670°
5	30′ →	690°
6	15′ =	690°
7	30′ →	710°
8	15′ =	710°
9	30′ →	725°
10	5′ =	725°
11	1′ →	530°
12	140′ =	530°
13	210′ →	450°

Between steps eight and 10, it's very important to watch the piece in the kiln so that you can skip to another step, if necessary.

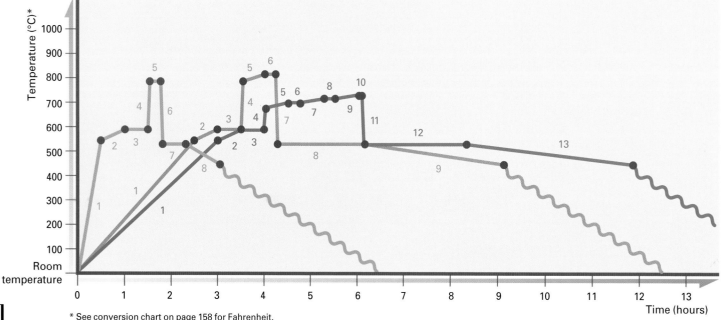

* See conversion chart on page 158 for Fahrenheit.

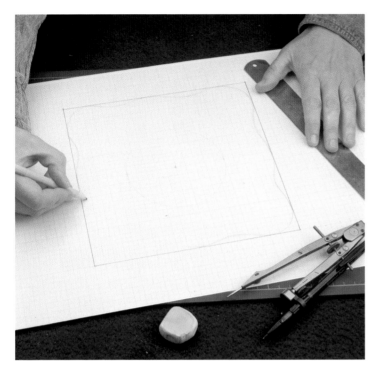

▲ **1.** Draw an 8-inch (20.3 cm) square on graph paper. On the inside, draw a lobed outline with the aid of a compass.

▲ **2.** Use carbon paper to transfer the drawn shape onto a piece of card stock.

▲ **3.** Cut out the card stock to make the template.

▶ **4.** Flatten out a layer of clay to make a mold. To create an even thickness, place two ⅜-inch (1 cm) strips of wood parallel on a chipboard base covered with melamine. Use the roller on top of them.

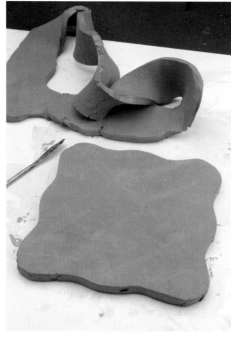

◄ **6.** If the last step was done correctly, the remainder of the clay will come off easily, and the result will be a well-defined clay model.

▲ **5.** Once the layer of clay is of an even thickness, draw the outline of the template on it with a spatula, pressing down to remove the excess clay.

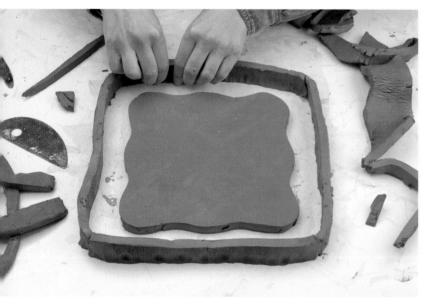

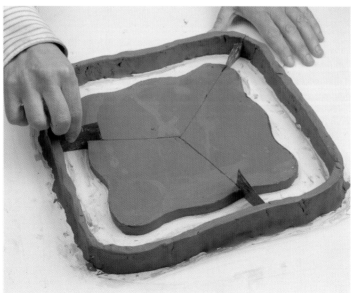

▲ **7.** You can use the clay removed in the preceding step to make the walls of the tray.

▲ **8.** Divide the clay model into three equal parts using a spatula and a square.

◄ **9.** Next, place a metal wedge in each vertex of the model to act as a separator in the plaster mold that will be made.

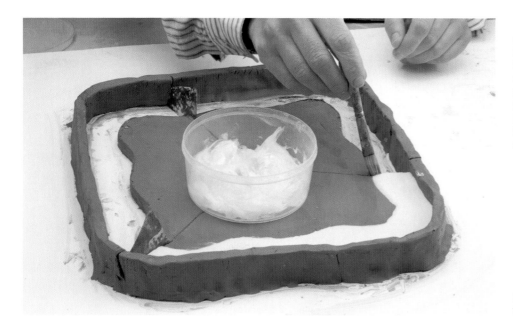

◄ **10.** Pour the mixture (1 unit of silicon and 1 of plaster) into one of the sections of the mold and allow it to dry. Remove one of the wedges, and apply petroleum jelly to the edge of the plaster that was in contact with the wedge; it acts as a separator and keeps it from sticking to the next section of plaster. Next, pour the mixture into another part of the mold, and continue in this way with this section and the third one.

▼ **11.** Once the procedure with the three parts of the mold is done, remove the walls of the tray.

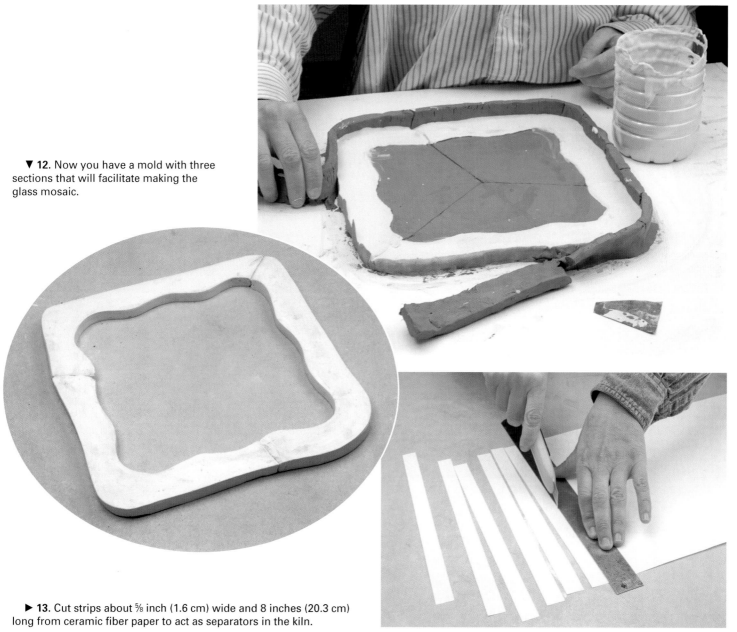

▼ **12.** Now you have a mold with three sections that will facilitate making the glass mosaic.

► **13.** Cut strips about ⅝ inch (1.6 cm) wide and 8 inches (20.3 cm) long from ceramic fiber paper to act as separators in the kiln.

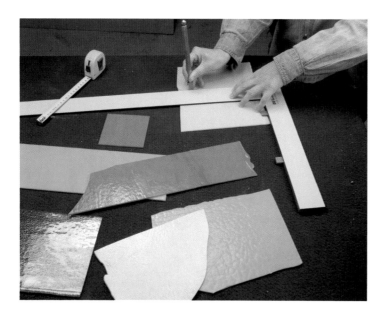

▲ **14.** Next, cut the different colored glass into small sheets about 4 x 4 inches (10.2 x 10.2 cm) using a cutting square and a cutter or roulette.

▲ **15.** For fusing, place the different colors in the kiln on a bed of thermal ceramic mat between walls made up of refractory plates, with a piece of ceramic fiber paper between the plates and the glass. To produce sections of colored glass, four models of equal plates are fused in different color combinations: lilac, green, and orange; orange, lilac, and green; clear, orange, and green; and finally, clear, lilac, and orange.

◀ **16.** Lower the temperature from 1454°F (790°C) to 1040°F (560°C) by opening the kiln a bit.

▼ **17.** Once the three layers are fused, cut the multi-layered glass into ¾-inch (1.9 cm) strips using a tile cutter.

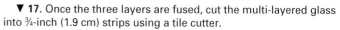

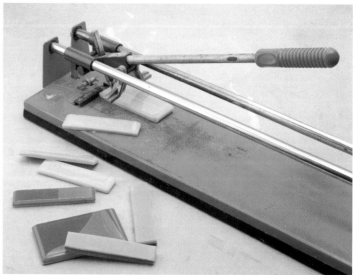

◀ **18.** A new type of glass has been created, whose side view shows the three colors stacked. Once again, use the tile cutter to cut the strips into small, fairly uniform tiles between ⅜ and ⅝ inches (1 and 1.6 cm).

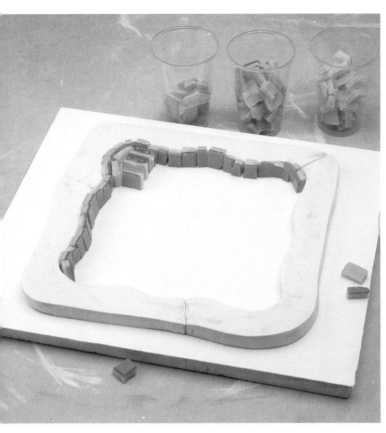

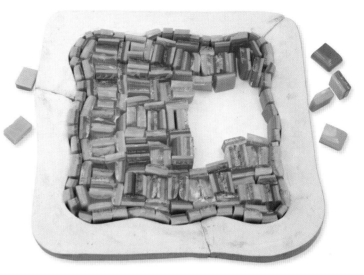

◄ **19.** Place the mold on a plate covered with ceramic fiber paper, and arrange the tiles around the inner perimeter. In this case, we've alternated green, lilac, and orange tiles with one lilac, green, and orange tile to create a chromatic rhythm along the outline of the vase.

▲ **20.** Set more tiles into place, always on edge, using the pattern shown in the photograph.

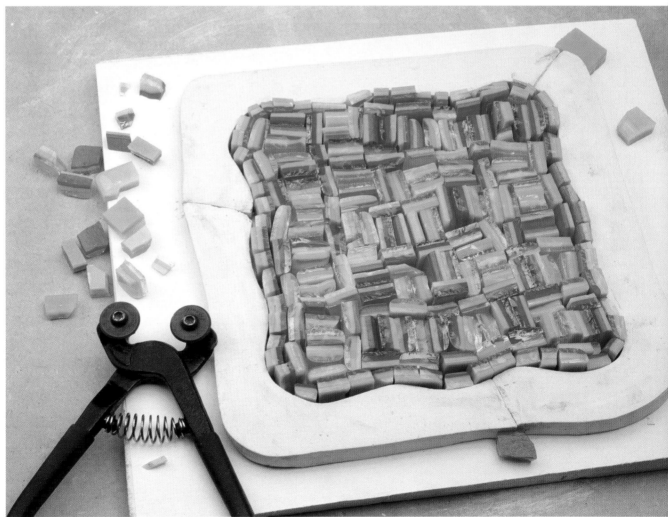

► **21.** Fill up all the space inside the mold so that it is ready for the second firing.

▲ 22. Once the fusing is complete, you'll have a plate of mosaic glass like the one shown in the photograph.

▲ 23. To prepare the mold for the final step in this exercise, mark a piece of ¾-inch (1.9 cm) ceramic fiberboard with a compass. Draw a circle with a diameter of 4 inches (10.2 cm); that dimension will determine the size of the opening in the vase.

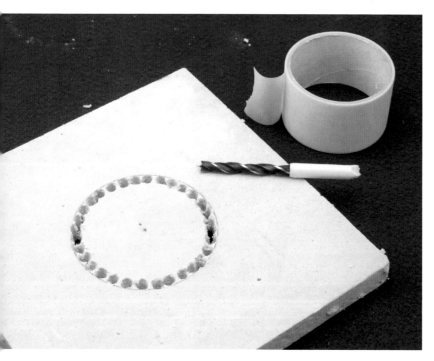

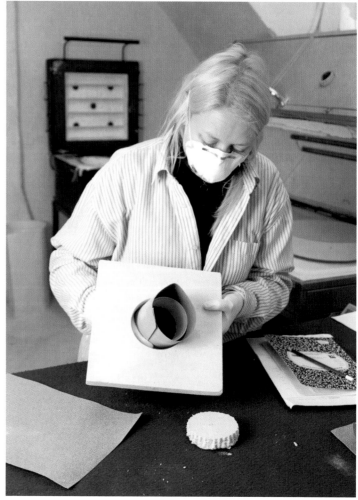

▲ 24. Apply tape to a drill bit so it can be handled safely, and mark off the inner profile.

▶ 25. Once the piece of fiberboard has been removed, smooth the inside edge with 120-grit sandpaper, using a careful rotating motion and holding the sandpaper at right angles to the inner profile to keep it nice and even all the way around.

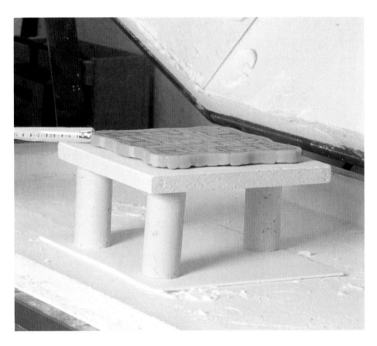

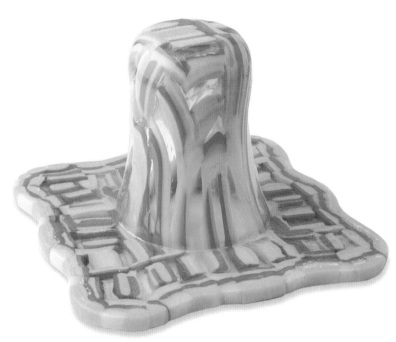

▲ **26.** Paint the plate with separator, and place it on three kiln posts inside the kiln. Before firing the piece, be sure that the fused plate is perfectly centered over the hole through which it will fall, in order to avoid creating an asymmetrical piece. Cover the floor of the kiln with ceramic fiber mat to keep the glass from sticking to it.

▲ **27.** This is a bottom view of the vase made with the free-fall technique. You can see how the distortion of the glass in free fall creates an attractive appearance.

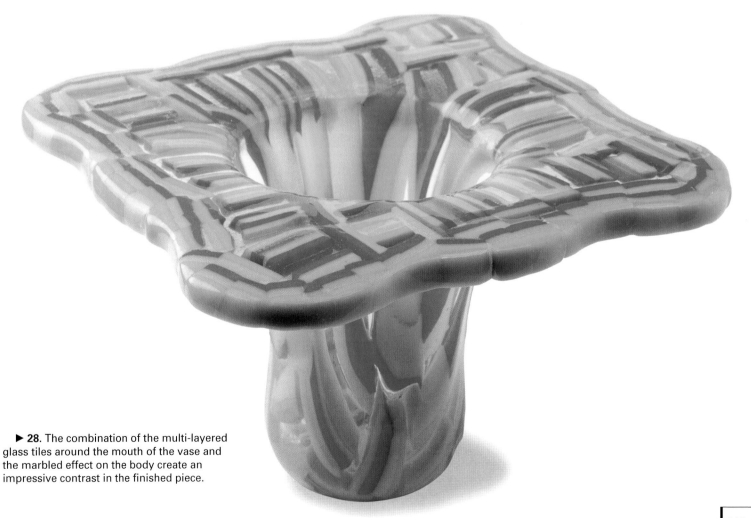

▶ **28.** The combination of the multi-layered glass tiles around the mouth of the vase and the marbled effect on the body create an impressive contrast in the finished piece.

Centerpiece

*I*n this last exercise, we'll show you the steps for making a centerpiece using pâte de verre and slumping. The shape of this decorative object is determined by a prefabricated ceramic mold used for the final slumping. It serves as a template for making a clay prototype, which is used to make the final mold for the pâte de verre, followed by the first firing program. Once the flat centerpiece is made from pâte de verre, a second firing program gives shape (slumping). Various granulations of compatible ground glass (frit) are used to make this piece. The paste mold is flat, and in this instance, the glass is mixed with water.

This chart shows the two firing cycles necessary to make this piece. The first one (in orange) represents the firing program for the pâte de verre. This technique requires a lengthy firing with an emphasis on drying the mold. There is a slight temperature increase of 50°F/10°C over 30 minutes up to the working temperature of 1472°F (800°C), which is held for a short period of 10 minutes. The second firing program (in blue) corresponds to the slumping of the pâte de verre piece, which has a working temperature of 1166°F (630°C) for 30 minutes.

First firing							Second firing					
Step	Time	Temp. (°C)*	Step	Time	Temp. (°C)*		Step	Time	Temp. (°C)*	Step	Time	Temp. (°C)*
1	120′	→ 200°	8	10′	= 800°		1	240′	→ 540°	8	240′	→ 450°
2	240′	= 200°	9	1′	→ 530°		2	30′	→ 590°	9	180′	→ 370°
3	240′	→ 540°	10	240′	= 530°		3	30′	= 590°	10	120′	→ 290°
4	60′	→ 590°	11	240′	→ 450°		4	30′	→ 630°			
5	60′	= 590°	12	180′	→ 370°		5	30′	= 630°			
6	30′	→ 790°	13	120′	→ 290°		6	1′	→ 530°			
7	30′	→ 800°					7	240′	= 530°			

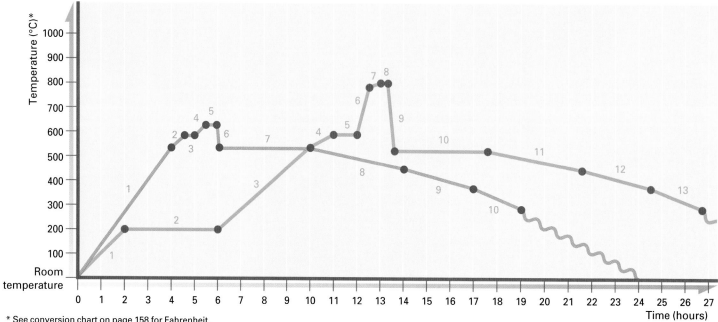

* See conversion chart on page 158 for Fahrenheit.

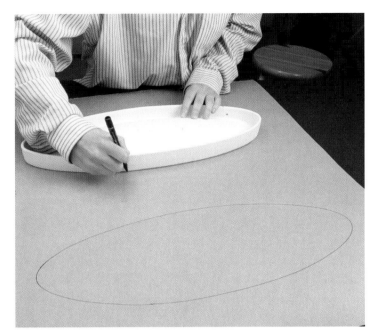

◄ **1.** The first step involves making the templates that serve as a guide for making the mold's prototype. Place the prefabricated ceramic mold (ours is 18 inches [45.5 cm] long and 6¼ inches [16 cm] across) on a piece of heavy paper. (This mold will be used for the final slumping.) Outline it with a marker, and then move it to the next space on the paper and outline it again. (Our ellipses are 18 inches [45.5 cm] long and 6¼ inches [16 cm] across.)

▼ **2.** Use a compass to mark a corresponding ellipse ³⁄₁₆ inch (4.8 mm) inside one of the two ellipses.

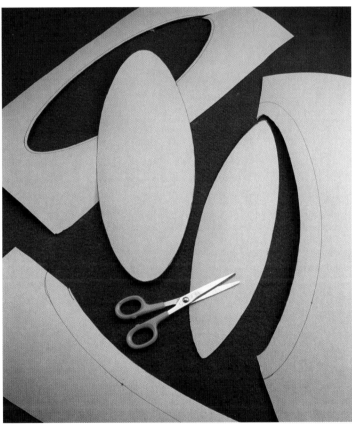

▲ **3.** Cut out this ellipse along the inner line. Then, draw an inner line inside the second ellipse, separated from the outer line by 2 inches (5.1 cm). Cut out the second shape. The result is two ellipses that are smaller than the ceramic mold, one by ³⁄₁₆ inch (5 mm) and the other by 2 inches (5.1 cm).

► **4.** Place the clay for making the mold's prototype on a work surface with a cloth on top of it. Then place a ³⁄₁₆-inch (5 mm) thick strip on each side of it and roll it out perfectly flat with the rolling pin. The strips act as guides for the roller and make it possible to create a uniform thickness.

▲ **5.** Next, place the template for the larger ellipse on the clay and hold it firmly in place (we are using a flat refractory support). Cut the shape out of the clay with a flat-ended spatula.

▲ **6.** Repeat this process to cut out a second ellipse; then remove the extra clay.

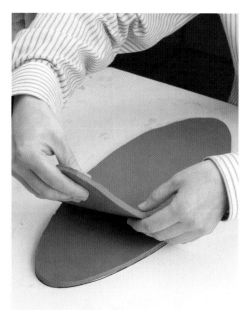

◄ **7.** Place one of the clay forms directly on top of the work surface (here we're working on a piece of chipboard covered with melamine). Next, trace the outline of the shape onto the board with a broad-tip marker. You'll use this mark as a guide to control the dimensions and shape of the form while the prototype is being made.

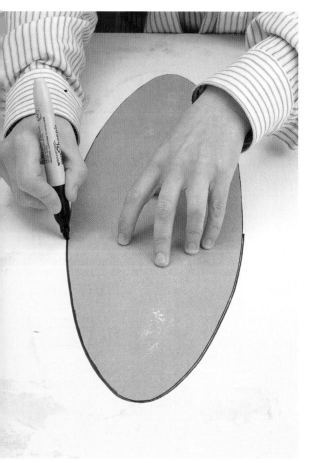

▶ **8.** Place the second clay ellipse on top of the first one so they coincide perfectly.

▶ **9.** Make a perfectly parallel double incision ⅜ inch (1 cm) from the edge. The incisions are also separated from each other by ⅜ inch (1 cm). Here, we improvised with a kitchen tool with two points, although other tools can be used.

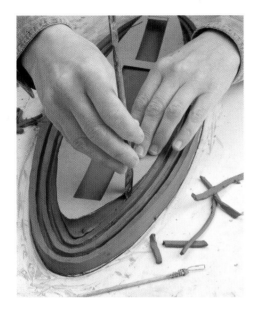

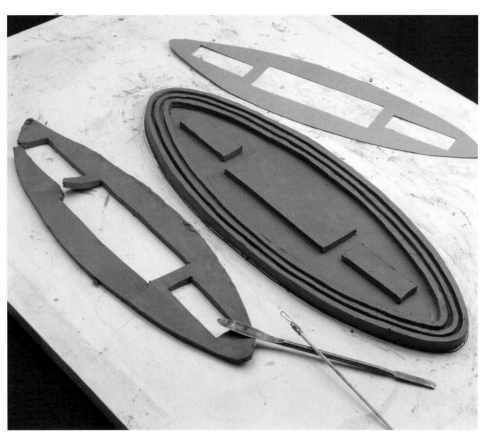

▲ **10.** Use a narrow loop tool (this one is made from a paper clip attached to a dowel) to gouge out clay between the incision lines, down to the piece of clay beneath. The result is two scooped-out areas that follow the shape of the ellipse. Next, cut out three rectangles inside the smaller paper template (two measure 3 x 1 inches [7.5 x 2.25 cm] and the other measures 6 x 1¾ inches [15 x 4.5 cm], separated by ⅝ inch [1.5 cm]). Center and align them. Place the template on the clay, and use a spatula with a smooth point to cut out the shape.

▲ **11.** Remove the extra clay from the top layer to reveal the three rectangular shapes.

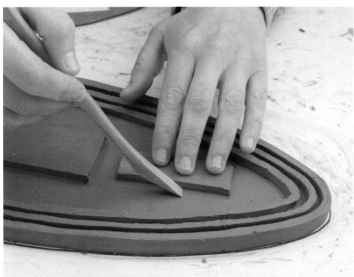

▲ **12.** Use a wooden spatula to smooth and join the edges of the pieces. With this step, the prototype is complete and ready for making the mold.

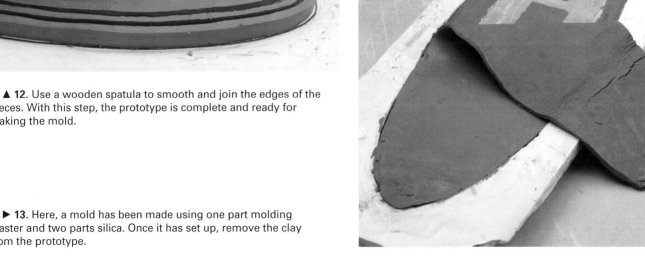

▶ **13.** Here, a mold has been made using one part molding plaster and two parts silica. Once it has set up, remove the clay from the prototype.

▼ **14.** Next, pâte de verre will be applied to the inside of the mold. Begin by mixing your ground glass. (We've used fairly coarse ground glass that's medium red orange and mixed it a container with an equal amount of clear ground glass that is one granulation up from powder (01), plus water.) Then, use spatulas to place the pâte de verre into the mold, and press it down so that it fills the mold up.

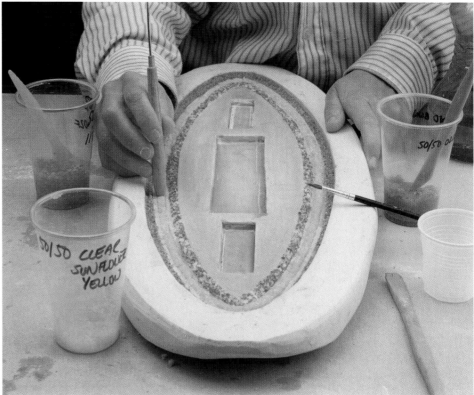

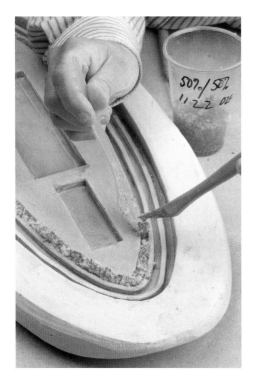

▲ **15.** Next, fill the central molding with paste. (We used 50% sunflower yellow that is one granulation up from powder, 50% clear glass, and water.) Finally, fill the exterior molding. (We used a mixture of 50% brown glass in a granulation similar to the yellow glass, 50% of the clear glass already described, and water.) Use the handle of the needle tool to press the glass paste into the mold and fill it completely. Dip a fine artist's brush in water to pick up tiny particles of glass.

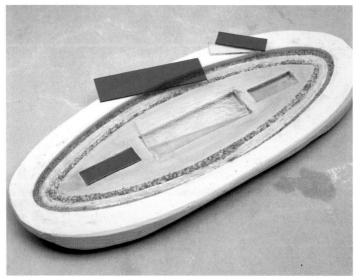

▲ **16.** Once the moldings are done, cut out three pieces of clear, compatible glass and three pieces of compatible colored glass that are the size of the central rectangles. (We used opaque medium orange-red, the same as was used in making the inner mold.) Arrange them as shown with colored glass on top of the clear.

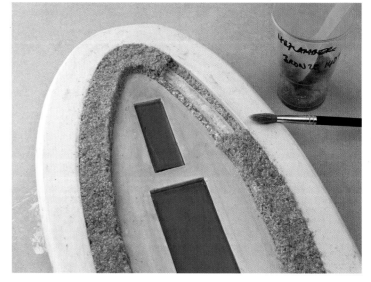

▲ **17.** The base of the moldings is made using paste composed of 50% transparent bronze color in a granulation similar to the previous ones, 50% clear glass of the same granulation, and water. Apply it so that it totally covers the three moldings up to the top edge of the mold.

▼ **18.** Next, cut three new pieces of clear compatible glass, and place them on the rectangles, covering the red pieces.

▼ **19.** The bottom of the center is made with glass paste (we used 50% transparent medium amber in a fairly coarse granulation, 50% clear glass in a similar granulation, and water). When you used the paste, cover the space between the moldings and rectangles completely, pressing down with the pestle to ensure that the glass particles fill the mold perfectly.

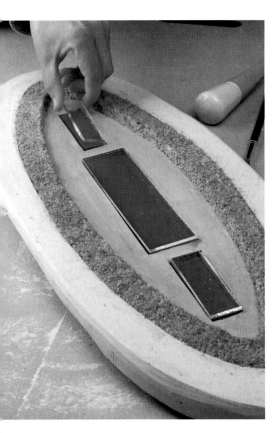

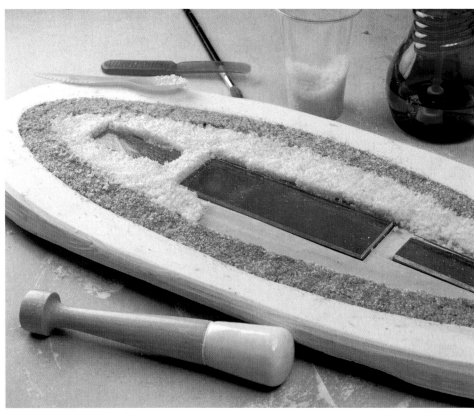

◄ **20.** Finally, cover the whole composition with glass paste made from clear glass one step up from powder. This glass paste amounts to one-third of the total volume of the mold. As in the previous steps, press the glass down firmly. We used a putty knife to do this job.

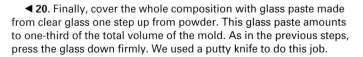

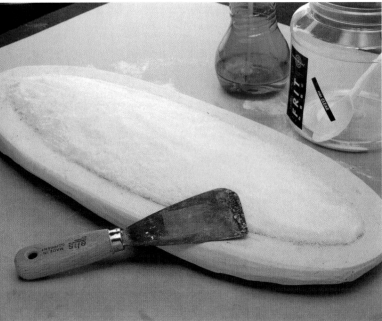

► **21.** Next, carry out the first firing at a working temperature of 1472°F (800°C). Place the mold inside the kiln, perfectly level, on kiln shelves held up by supports that keep it off the floor of the heat chamber. Placing sand between the mold and kiln shelves makes it easier to level the piece and encourages air circulation.

▼ **22.** Once the first firing is complete, remove the piece from the mold. This requires breaking the mold and removing any vestiges of the mixture stuck to the glass.

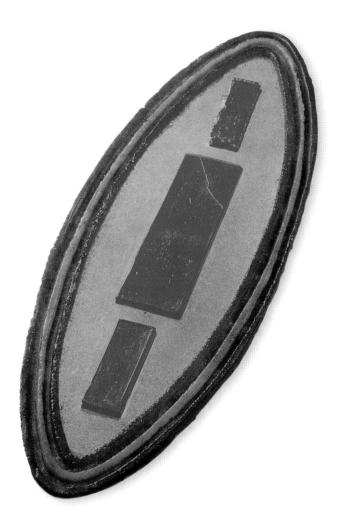

▲ **23.** When you make pâte de verre pieces, the mold will sometimes break. This isn't a major problem because it doesn't affect the overall integrity of the piece; it merely causes some small, superficial, raised lines. Remove these by polishing the glass.

▼ **24.** Next, smooth down the edges, rough spots, and surfaces of the object. First, remove the sharp points and excess pieces of glass by breaking them off with pliers, and break off small protrusions with great care.

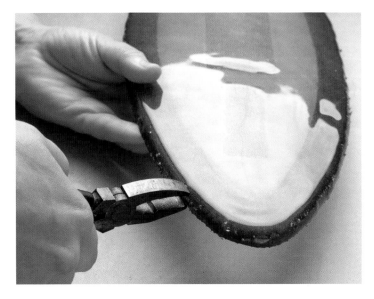

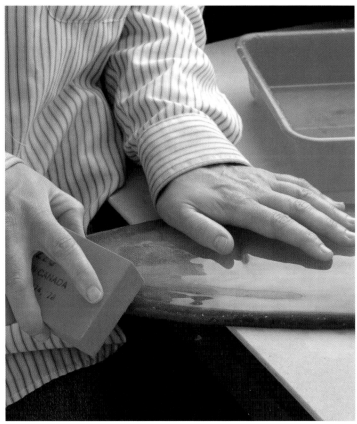

▲ **25.** Next, polish the edges with a moistened 220-grit diamond block. Then rub the glass to create a perfectly polished surface.

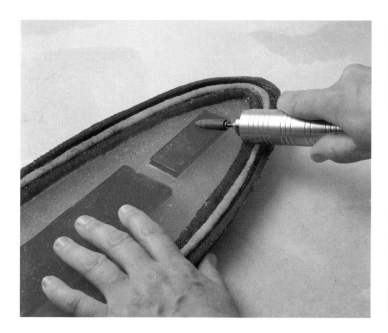

▲ **26.** To finish up, polish the top surface of the piece with a rubber-tipped motor tool until it's perfectly smooth. If there are sharp projections, use a motor tool with a diamond abrasive tip to grind them off.

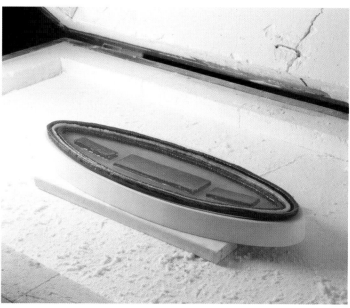

▲ **27.** Finally, slump the glass paste item at a working temperature of 1166°F (630°C). Place the piece on a prefabricated ceramic mold (the one that served as a model for making the mold and the object). Level it perfectly, and put it on a ceramic plate inside the kiln.

▶ **28.** The completed decorative centerpiece

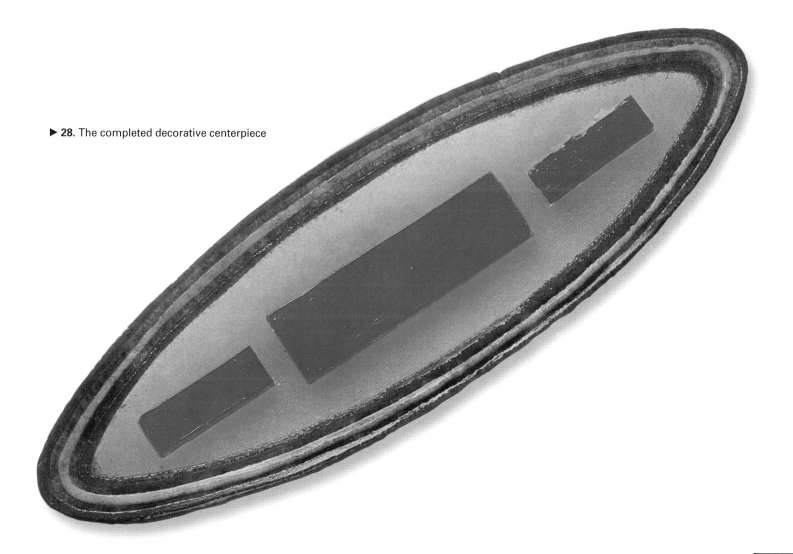

Gallery

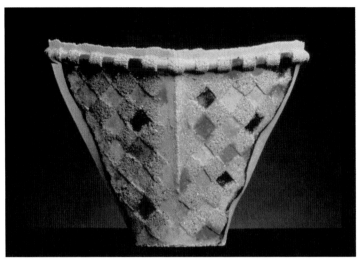

▲ Diana Hobson, *Progressive Series 5*, 1986. Pâte de verre with sand and ceramic coloring (6 inches/15.2 cm tall). Corning Museum of Glass, Corning, New York. Photograph by Richard Davies

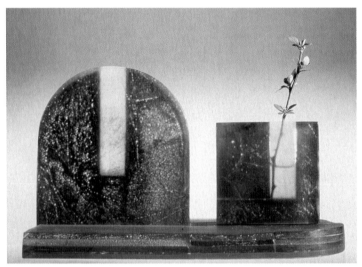

▲ Sara McDonald, *Flower Piece*, 2001. Laminated glass with gold and copper inclusions (4.75 x 6 x 5 inches/12 x 15.2 x 12.7 cm)

▼ Uta Majmudar, *Bowl*, 2002. Fused glass rods with metal inclusions (6 inches/15.2 cm thick, 26.5 inches/67.3 cm in diameter)

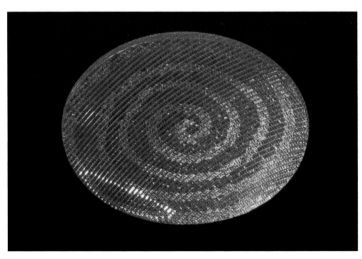

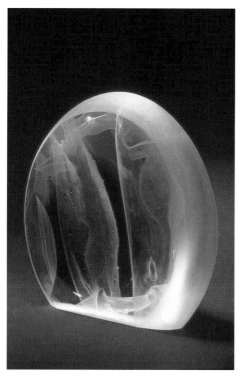

▶ Sally Fawkes, *Resounding Beyond II*, 2002. Cast glass worked cold (18.5 x 5 inches/47 x 12.7 cm)

◀ Diana Hobson, *Serpent*, 1986. Cast glass and bronze (25 inches/63.5 cm high). Photograph by Heini Schneebeli

◀ Sara McDonald, *Centerpiece*, 2001. Laminated glass with gold inclusions (22 inches/55.9 cm in diameter)

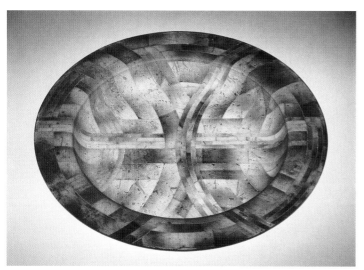

▲ Sandra Moenny, *Bowls*, 2002. Lost wax glass castings (2.25 x 3 inches/5.5 x 7.6 cm)

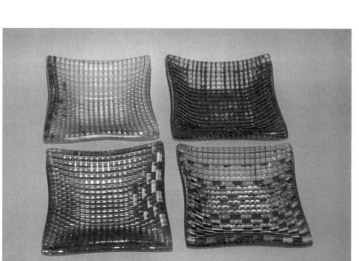

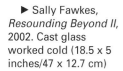

◀ Uta Majmudar, *Hoaxing*, 2001. Painted, fused glass rods (each piece 7 inches/17.8 cm square)

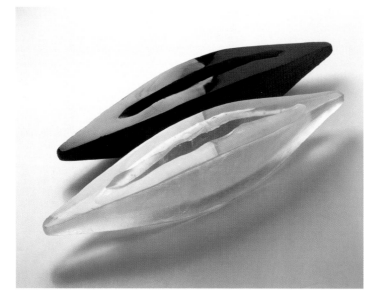

◀ Anna Marco, Untitled, 2002. Lost wax glass castings (17 x 3.25 x 3.25 inches/43.2 x 8 x 8 cm each)

▲ ▶ Yukiko Murata, Untitled, 2001. Fused glass, porcelain, wood, and window glass (7 x 7 x 1.25 inches/17.8 x 17.8 x 3 cm)

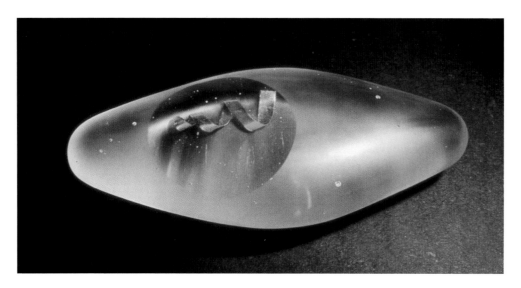

◀ Anna Marco, *Spiral Germ*, 1998. Pâte de verre with copper inclusion (13 x 4.75 inches/33 x 12 cm)

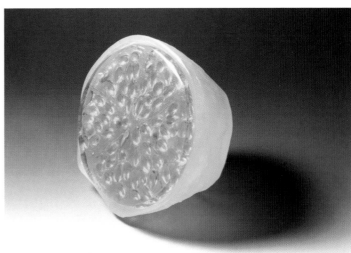

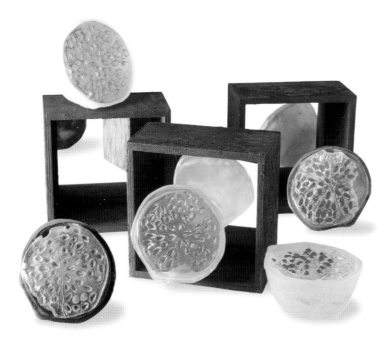

◄ ▲ Philippa Beveridge, *From the Newborn*, 2001. Lost wax glass castings, fused glass, mirror, and wood (each piece 4 inches/10.2 cm high by 5.5 inches/14 cm in diameter)

▼ Rene Culler, *No Cold Feet*, 2000. Fused glass, slumped and enameled, cast iron (12¾ x 10 inches/32.5 x 25.4 cm)

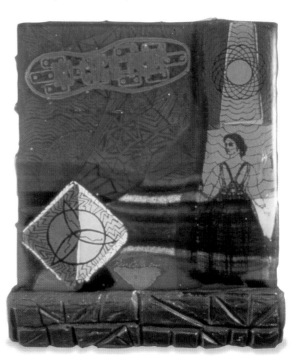

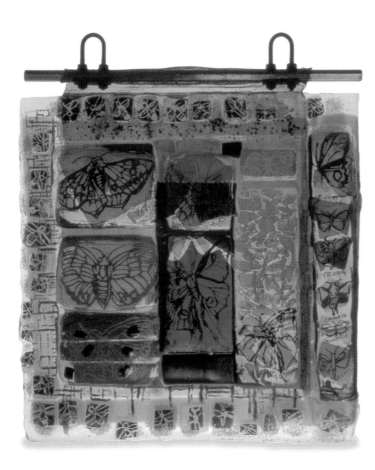

◄ Rene Culler, *Murpho Nights*, 1998. Fused glass, slumped and enameled, copper, and steel (19 x 18 x 5 inches/48.3 x 45.7 x 12.7 cm). Photograph by Robert Mueller

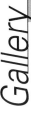
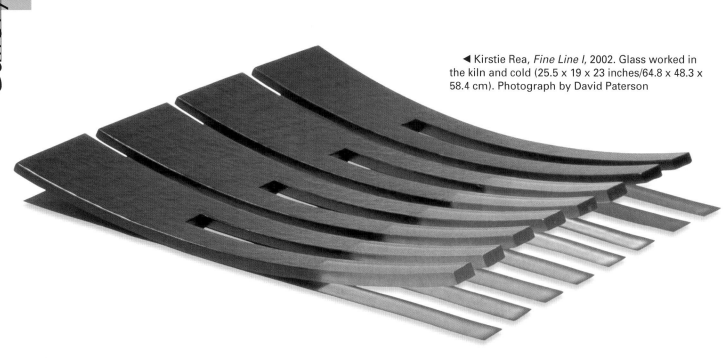

◀ Kirstie Rea, *Fine Line I*, 2002. Glass worked in the kiln and cold (25.5 x 19 x 23 inches/64.8 x 48.3 x 58.4 cm). Photograph by David Paterson

▼ Kirstie Rea, *Landmarks*, 2000. Glass worked in the kiln and cold (3.75 x 25 x 4.5 inches/9.7 x 63.5 x 11.4 cm)

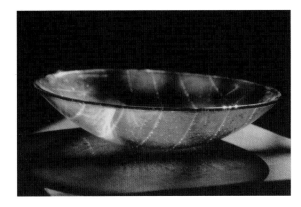

▲ Masaaki Yasumoto, Untitled, 2001. Fused and slumped glass (12 inches /30.5 cm in diameter)

▲ Mercè Mas, Untitled, 2001. Pâte de verre (8 x 8 inches/20.3 x 20.3 cm)

▲ Helli Aumann, Untitled, 2001. Fused glass worked cold, silver (2 x 2 inches/5.1 x 5.1 cm)

▶ Philippa Beveridge, *Longing for the Land of Your Memories II*, 2002. Lost was glass casting (37.5 x 22 x .625 inches/95 x 55.9 x 1.6 cm)

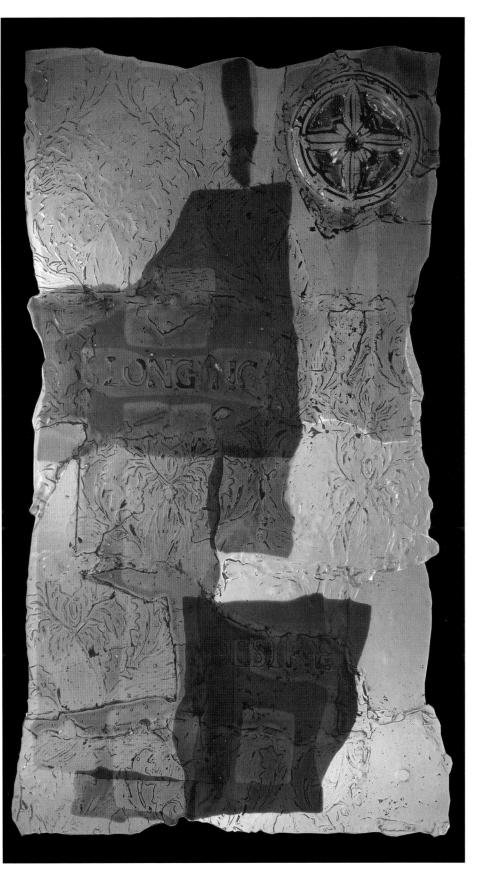

Glossary

Abrasive. Extremely hard material used for grinding, polishing, smoothing, rasping, or sharpening. Through friction, it removes or wears away part of the material.

Amorphous. A non-crystalline solid without definite form

Annealing. A phase in the firing program that encompasses the final stages, from maintenance cooling (the annealing point) until the glass reaches room temperature

Atom. The smallest constituent part of an element that is electrically neutral. Atoms are made up of protons (positively charged particles), neutrons (particles with no electrical charge), and electrons (negatively charged particles).

c

Cathedral glass. A type of pressed, textured glass that vaguely resembles some kinds of antique glass. Like all pressed glass, it has one textured and one smooth face.

Cast glass. A technique of making pieces or objects, generally heavy ones, in which the glass takes on the shape of a mold cavity.

Casting. A technique that involves making pieces in a mold. During the firing program, glass placed inside the mold becomes fluid enough to fill the mold's cavity. It's also possible to cast pieces by melting and pouring fluid glass into a mold.

Compatibility. A property exhibited by different kinds of glass when they're combined with one another. Compatibility depends on the viscosity and the expansion coefficient of the two kinds of glass.

Compression. The force of two equal, concurrent forces along the same line, but in opposite directions, that makes an object tend to shorten.

Confetti. Thin glass that's broken into irregular pieces of different dimensions. Some manufacturers market glass in confetti form, ready to use. It's useful for making inclusions, fusing, and other purposes.

Contraction. The reduction in volume that bodies experience due to a decrease in temperature.

d

Dalle. A brick-like piece of glass made by casting glass in a mold.

Density. The quotient that results from dividing the mass of a body or a substance by its volume that makes it possible to identify a substance and distinguish it from others. This parameter is commonly used in identifying different types of glass.

Diatreta glass. Glass that is worked using a complex and difficult cutting technique developed during the Roman era. It involves cutting thick-walled pieces of glass to create a grid with a decorative design on the surface.

Dilation. A volume increase, due to higher molecular movement, that happens in bodies when the temperature increases.

e

Expansion. Dilation that occurs in a fluid as pressure decreases

f

Filigree glass. A kind of glass characterized by glass thread inclusions (usually white, known as latticini) in the walls of the piece. These threads are used to create various shapes.

Fluid. Material that is in a sufficiently soft state so that it can slide and/or adapt to the shape of its container. Glass becomes increasingly fluid as the temperature increases.

Flux. A material mixed with other components in making glass to encourage glass formation, facilitating fusion of the materials and lowering the fusion temperature of the mixture as well as the silica's viscosity.

Fracture. The rupturing of a body by means of force when the body exceeds its plasticity limit.

Free fall. The technique, also known as draping, of allowing glass to hang freely on or from certain elements so that it takes on a new shape

Friction. Rubbing one material or body with another, creating resistance between the two contact surfaces.

Frit. Ground glass

Frozen glass. Also known as frosted glass, this glass has a cracked appearance. Production began in Venice during the 16th century. One way to create this effect involves submitting the piece of glass to thermal shock partway through the process of blowing it by plunging it into water before continuing the process.

Full fusing. Operation carried out with heat, in which the glass melts completely, the layers thin out, and the edges become completely rounded

Fusing. Technique based on joining two or more kinds of glass. Fusing is a generic term including various techniques with the common characteristic of creating flat pieces by superimposing various kinds of glass.

Fusion. The passage of glass from a solid to liquid state. Glass does not have a fusion point.

Glass paste. See pâte de verre.

Gilded glass. Glass that's been colored or decorated through the addition of gold. Gilded glass can be made by such techniques as painting cold, adding gold leaf laminate, and techniques requiring firing.

Inclusion. In crystallography, a term that's used to designate a substance engulfed in a crystal at the time it forms. By extension, in glass projects it designates the technique that consists of laminating one material between two glass plates.

Iridescent glass. Glass that possesses iridescence, i.e., its surface exhibits shades similar to a rainbow due to the phenomena of light interference or diffraction

Laminating. Making a structure of two superimposed layers or leaves, sometimes with another material between them

Latticini. White, opaque glass rod that is used to decorate glass with complex filigree designs while it is being made. The production of blown glass decorated with latticini began in Venice during the Renaissance.

Light, polarized. Light consisting of a polarized electromagnetic wave, i.e., one that maintains its specific orientation and has been modified by refraction.

Lines of weakness/scored lines. Lines cut on glass with a cutter that serve to weaken the glass and mark where it will break when force is applied.

Liquid. This is a state of matter. Liquids, like gases, are fluid; i.e., their molecules don't occupy fixed positions, but rather continually change place. Liquids are compact and incompressible, and like solids, have their own volume that expands as the temperature increases. But they don't have a particular shape; rather, they adapt to their container. The particles of a liquid have cohesive forces among them that are strong enough to keep them from separating. These forces are responsible for the properties of liquids.

Lost mold. A type of mold used just once to make a single piece. Once you've completed the firing program and the piece has returned to room temperature, the mold is broken to remove the glass piece.

Magnetism. A method for separating iron particles based on the attraction properties of a magnet

Marking gauge. A carpenter's tool comprised of a small board with two perpendicular, adjustable bars with a steel point on one end. It is used to mark parallel lines on a piece of wood. By extension, this is any instrument used to mark one line parallel to another.

Mineral spirits. A hydrocarbon, clear liquid product produced by petroleum distillation. It dissolves oils, grease, wax, paraffin, and natural rubber, and is not mixable with water.

Molecule. Groups of a certain number of atoms joined by chemical bonds

Niter. A chemical compound (potassium nitrate), in the form of powder or needles in a moist ground, that burns violently when it comes in contact with fire.

Opalescent glass. A glass with a milky, iridescent appearance

Opaque. A body or material that doesn't allow light to pass through it and is impossible to see through

Pâte de verre. The technique of making pieces or objects from ground glass in a mold. The glass is mixed with water or a glue solution to form a thick paste, which is the origin of the technique's name.

Polishing. The action and effect of grinding, burnishing, and refining the surface of glass with various abrasives to produce a smooth, transparent surface

Reflection (diffuse). The irregular reflection of light when it strikes a rough surface. The rays aren't reflected in a parallel fashion, but rather in a disorganized one, i.e., in all directions.

Reflection (of light). A phenomenon in which light rays can't continue traveling in a straight line because some obstacle is in the way. The rays change direction, i.e., they bounce off (as in the case of a mirror, for example). Reflection can be specular or diffuse.

Reflection (specular). Light reflection when it strikes a polished surface such as a mirror. The light rays that arrive in parallel form are also reflected in parallel.

Refraction (of light). A directional change in light as it passes obliquely from one medium (air) to a different medium (such as water or glass).

Reserve. An area on the surface of glass protected by some means to shelter it from abrasive (in the case of sandblasting) or chemical products (in the case of acid cream).

Resistance. The ability of a body or material to withstand a force

Ruby glass. A type of manufactured red glass made mostly using a mixture of cadmium and selenium, and sometimes lead. This type of glass requires a longer annealing time during firing programs.

Separator. A substance placed on a surface to keep it from sticking permanently to some other material. Separator is applied in the form of a fine film onto a surface, protecting it and keeping the material on it from sticking to it.

Solid. A rigid, compact state of matter in which the particles that make it up are free to move in only by vibrating around a point. Solids are incompressible, i.e., a significant increase in pressure produces only a limited change in volume. However, temperature produces effects on the volume of solids, causing expansion as it increases.

Specific gravity. A quotient involving the weight of a substance and the volume it occupies. This is different from density but mathematically related to it.

Stabilizer. A material used in conjunction with other components for making glass that counteracts the solubility of the mixture and contributes hardness to the glass.

Super-cooled liquids. Liquids that can be cooled to temperatures lower than their freezing point. When they reach the solidification temperature, their molecules are too disorganized and don't have the right orientation to create a crystalline structure; as a result, the temperature of the liquid can continue falling below the fusion point without solidifying. Glass is a material that looks like a solid, but its molecular structure is that of a super-cooled liquid.

Surface tension. A force that tends to keep molecules on the surface of a liquid in contact with one another. The unit used to measure surface tension is the dina/cm (unit of force per centimeter of length).

Synthesis material. A product produced chemically by the combination of the elements that comprise it.

Tempering. A phase in the firing program encompassing the two stages from the annealing point to the stress point

Thermoforming. Also known as slumping, this technique involves shaping glass using a mold and an increase in temperature.

Thixotropic. A colloidal compound that becomes liquid when it is shaken and can return to its original solid state when no longer shaken. Compounds of this type are mixed in certain preparations to keep the material from coming loose in vertical applications.

Traction. A force to which a body is subjected when two forces are applied of the same module and orientation, different directions, and toward the outside of the object, which tend to lengthen it.

Translucence. Quality of being translucent

Translucent. An object or material that allows the passage of light through it and through which it is possible to see what's beyond it, although not clearly

Transparent. An object or material that allows the passage of light in such a way that it is possible to see objects clearly through it.

C°	F°
200	392
290	554
370	698
450	842
460	860
530	986
540	1004
560	1040
590	1094
630	1166
670	1238
690	1274
700	1292
710	1310
725	1337
790	1454
800	1472
810	1490

Unguentarium. A container in the shape of an elongated vase intended to hold unguents or perfumes.

Valence (of an element). The reactive capacity of an element in forming chemical bonds with other atoms that is the equivalent of the number of bonds it can form.

Viscosity. The resistance offered by a fluid to the movement of its molecules that depends on and varies directly with temperature.

Vitrifier. A basic material mixed with other components and used in making glass by fusion. Silica is the vitrifier par excellence, and the most abundant one.Annealing, 24

Index

Bibliography and Acknowledgments

BATTIE, Davie, and COTTLE, Simon. *Concise Encyclopedia of Glass.* Octopus Limited, London, 1991.

BRAY, Charles. *Dictionary of Glass.* A&C Black Publishers, London, 2001.

CUMMINGS, Keith. *Kiln-formed Glass.* A&C Black Publishers, London, 1997.

DRAHOTOVA, Olga. *The Art of Glass in Europe.* Libsa, Madrid, 1981.

FERNÁNDEZ-NAVARRO, José Maria. *Glass. Composition. Manufacturing. Properties.* C.S.I.C. Institute of Ceramics and Glass, Madrid, 1985.

HALEM, Henry. *Glass Notes. A Reference for the Glass Artist.* Greyden Press. Columbus, 1994.

KLEIN, Dan, and Lloyd, Ward. *The History of Glass.* Crescent Books, New York, 1984.

LIEFKES, Reino. *Glass.* V & A Publications, London, 1997.

LUNDSTROM, Boyce. *Kiln firing Glass. Glass Fusing Book One.* Vitreous Publications, Colton, 1994.

LUNDSTROM, Boyce. *Advanced Fusing Techniques. Glass Fusing Book Two.* Vitreous Publications, Colton, 1991.

Technotes. A Technical Supplement to the Bullseye Bulletin and Tipsheet. Bullseye Glass Co., Portland.

The authors wish to thank the following:

Parramón Publishing, Inc. and Maria Fernanda Canal and Tomas Ubach for their faith in us on this project. Also, Joan Soto and the whole team of Nos & Soto for their dedication and help.

The people, professionals, and institutions that cooperated and provided valuable technical advice:

Elena Arnau Vives, Carme Colomé Cuñat, José Luis Navarro Muñoz, Mireia Patiño Coll, and Montse Pinar

Fundació Centre del Vidre
Comptes de Ball-lloc, 192, 08014 Barcelona, Spain
www.fcv=bcn.org

The companies that collaborated with us:

Bullseye Glass Co.
3722 SE 21st, Portland, OR 97217, USA
www. bullseye-glass.com

Creative Glass, M.H.
Sowersby, Kienzlstrasse, 13, A-4600 Wels, Austria
www.creative-glass.com

Cristall Badalona, S.A.L.
Orient, s/n, 08911 Badalona, Spain

His Glassworks, Inc.
91 Web Cove Rd., Asheville, NC 28805-1937 USA
www.hisglassworks.com

Monica Lloberas
Sepúlveda, 19, 08015, Barcelona, Spain
222.anper.extendnow.com

Muntatges Industrials per Ceràmica, Inc.
Poligon Industrial Mas Aliu, Sector Rejoleria, 2, 17181 Aiguaviva, Spain
www.isuni.net

Saint-Gobain Cristaleria
Paseo de la Castellana, 77, 28046 Madrid, Spain
www.buildnet.es/cristaleria, www.saint-gobain.com

Vidrafoc
Badajoz, 50, 08005 Barcelona, Spain
www.vidrafoc.com

The artists who collaborated with us, and without whom this book would not have been possible:

Susana Aparicio

Helli Aumann

Rene Culler
www.reneculler.com

Sally Fawkes

Mark Ferguson

Diana Hobson

Sara McDonald

Uta Majmudar

Anna Marco

Mercè Mas Corretge and Masaaki Yasumoto

Dandra Monneny

Fabien Moudileno

Yukiko Murata
www.dattra.com

Kristie Rea

La Ventana indiscreta
www.philippaveveridge.com